TOTAL PHOTOGRAPHY

TOTAL PHOTOGRAPHY

ANDREAS FEININGER

AMPHOTO
AMERICAN PHOTOGRAPHIC BOOK PUBLISHING
AN IMPRINT OF WATSON-GUPTILL PUBLICATIONS
NEW YORK

First published 1982 in New York by Amphoto Book Publishing: An imprint of Watson-Guptill Publications, a division of Billboard Publications, Inc., 1515 Broadway, New York, N.Y. 10036

Library of Congress Cataloging in Publication Data
Feininger, Andreas, 1906-
 Total photography
 Bibliography: p.
 Incudes index.
 1.Photography. I.Title.
TR146.F434 1982 770 82-11613
ISBN 0-8174-3531-X

Manufactured in the U.S.A.
1 2 3 4 5 6 7 8 9/86 85 84 83 82

Books by Andreas Feininger

Industrial America (Dover, 1982)

Feininger's Chicago, 1941 (Dover, 1980)

New York in the Forties (Dover, 1978)

Experimental Work (Amphoto, 1978)

The Mountains of the Mind (Viking, 1977; reissued by Dover, 1981, under the title Nature Close Up)

Light and Lighting in Photography (Amphoto, 1976)

Roots of Art (Viking, 1975; to be reissued by Dover, 1982, under the title Nature and Art)

The Perfect Photograph (Amphoto, 1974)

Darkroom Techniques, Vols. I and II (Amphoto, 1974)

Principles of Composition in Photography (Amphoto, 1973)

Andreas Feininger, with text by Ralph Hattersley (a Morgan & Morgan Monograph, 1973)

Photographic Seeing (Prentice-Hall, 1973)

Shells, with text by Dr. W. Emerson (Viking, 1972; to be reissued by Dover, 1982)

Basic Color Photography (Amphoto, 1972)

The Color Photo Book (Prentice-Hall, 1969)

Trees (Viking, 1968; reissued by Penguin Books, 1978)

Forms of Nature and Life (Viking, 1966)

Lyonel Feininger: City at the Edge of the World, with text by T. Lux Feininger (Frederick A. Praeger, 1965)

The Complete Photographer (Prentice-Hall, 1965; Revised Edition 1978)

New York, with text by Kate Simon (Viking, 1964)

The World Through My Eyes (Crown, 1963)

Total Picture Control (Crown, 1961; Amphoto, 1970)

Maids, Madonnas, and Witches, with text by Henry Miller and J. Bon (Harry N. Abrams, 1961)

Man and Stone (Crown, 1961; reissued by Dover, 1979, under the title Stone and Man)

The Anatomy of Nature (Crown, 1956; reissued by Dover, 1979)

Changing America, with text by Patricia Dyett (Crown, 1955)

The Creative Photographer (Prentice-Hall, 1955; Revised Edition 1975)

Successful Color Photography (Prentice-Hall, 1954)

Successful Photography (Prentice-Hall, 1954; Revised Edition 1975)

The Face of New York, with text by Susan E. Lyman (Crown, 1954)

Advanced Photography (Prentice-Hall, 1952)

Feininger on Photography (Ziff-Davis, 1949)

New York, with text by John Erskine and Jacqueline Judge (Ziff-Davis, 1945)

New Paths in Photography (American Photographic Publishing Co., 1939)

Contents

I dedicate this book to

JESSICA,

a friend of many years, a charming, vivacious lady and mother of three beautiful children now in their teens. Jessica is one of the world's most uninhibited, exuberant, and worst photographers. She is the proud owner of three late model cameras, shoots with abandon, wastes a shocking amount of color film and has, as far as I know, never made a first-class photograph. As a matter of fact, most of her pictures are photographic disasters. This, however, has never discouraged her. She tries again and again, always with the same infectious enthusiasm and total lack of success. And she fails, not because she is unable to afford the latest equipment and unlimited amounts of film, not because her subjects are unphotogenic, not because of lack of photo-technical knowledge (which she does not have but also does not need since her automated cameras do all her "technical thinking" for her and a commercial photo-lab does the rest), but because she has not the slightest idea about the WHAT and WHY and WHEN of photography.

It was her helpless floundering, always with a smile, always hoping that this time at least some of her shots would turn out all right, that inspired me to write this book.

ANDREAS FEININGER

Preface

Total Photography was written specifically for modern men and women—intelligent, creative, ambitious, disdainful of photographic clichés—who, with a minimum expenditure of technical knowledge, wish to take fullest advantage of the enormous creative potential inherent in automated cameras in conjunction with custom photo-lab services.

Total Photography's concept is unique in several respects:

It is the first photo manual based upon the holistic view according to which an entity—in this case, the picture—is more than merely the sum of its parts.

Contrary to traditional custom, it begins with a discussion of the subject. Why? Because the subject is the most important factor which decides the outcome of a photograph—it is the reason why we take pictures. Yet most photo guides treat it very cavalierly if at all.

It is the first fully integrated photo guide. Each factor is discussed at the moment it occurs during the process of picture-taking rather than listed schematically and treated out of context, as is the case with traditional manuals.

Here, everything the student photographer must know unfolds in logical succession. The How of the picture-making process—the "technique"— is always discussed in relation to the WHY—the purpose and nature of the picture—and the WHEN—the moment decisions must be made. The result is that the reader is never left in the frustrating position of having acquired information he does not know how to use. Instead, each piece of the puzzle falls into its

proper place at the proper time until, in the end, the making of effective photographs becomes routine.

Total Photography is not encumbered with how-to pictures on the kindergarten level because its readers are "visually literate" men and women to whom I can talk about photography without having to belabor the obvious. Besides, it has been my experience that how-to pictures are by their very nature too subject-specific, making it actually more difficult in practice to apply universal principles to subjects other than those depicted in the demonstration photographs. On the other hand, presenting such principles by means of words instead of pictures stimulates the imaginative and creative faculties of the reader who now must visualize in his mind all the different applications rather than passively accept a single ready-made version in picture form.

If you have noticed that something is not working in your photographs; if you have learned from experience that a beautiful subject does not necessarily make a beautiful picture; if you have realized that with today's automated cameras even the greenest beginner can produce technically perfect photographs merely by following the instructions that accompany his camera; and if you have come to the conclusion that even a technically perfect photograph can be a meaningless and boring picture, then you have arrived at the point where reading this book might help you. Because I wrote it specifically for you.

ANDREAS FEININGER

Introduction

What makes this book so different from every other photo guide? Two things:

 it starts where other guides leave off—with the subject
 it adopts a holistic attitude toward photography.

Let me explain.

No matter how much or how little you may know about photography, you do know that its purpose is to make *effective* pictures. An ineffective photograph is boring, a waste of the photographer's energy and the viewer's time. So the problem is: how can you make your photographs effective?

The solution is simple: Begin by analyzing other people's photographs you've admired and find out what the elusive quality is which makes these pictures "effective." Invariably you will arrive at the conclusion that the cause of their effectiveness is an interesting subject presented in a graphically striking form. Already you have isolated the two most important factors which make a photograph effective:

 subject selection
 subject presentation.

Where do you go from here? You reason: Before I can present anything in a graphically striking form, I must have something to present—a subject. Therefore, as a photographer, I must start with the subject because it is the most important element in the process of creating pictures. Consequently, the first of the following chapters will deal with THE SUBJECT.

What makes teaching "photography" so difficult is that innumerable factors can decide the outcome of a picture: camera, lens, filtration, film, *f*-stop, shutter speed, sensitized paper, enlarging technique; light, color, contrast, sharpness, depth of field, perspective, subject motion, distance between subject and camera, angle of view, background, foreground, you name it.

Traditionally, the custom in teaching photography has been to divide the material into chapters beginning with a discussion of equipment: cameras, lenses, light meters, color filters, tripods, photolamps, etc. This was followed by chapters on techniques: focusing, exposing, developing, printing, etc.; specific factors that influence the picture such as light, color, contrast, perspective, motion rendition, etc.; composition, style, graphic qualities, and so on. This system enables a writer to present each subject thoroughly and efficiently but has the serious disadvantage of treating it out of context with the rest. This might lead the reader to believe that, if only he selects "the best of everything" and then combines the technical items of his choice, he should "automatically" arrive at the best possible solution to his pictorial problems. Unfortunately, this is not true. Almost invariably, the price of gaining an advantage in one respect is a corresponding deterioration or even loss of another desirable picture quality. Therefore, this material is presented in a new form which discusses each aspect of photography in context with all the others because the whole—the picture—is *more* than merely the sum of its parts: THE HOLISTIC VIEW.

Total Photography is a condensed but fully integrated introduction to *good* photography in which the How (the technical requirements) must always be considered in relation to the:

WHY—the purpose of the picture
WHEN—the moment of application
WHAT—the subject.

Traditional photo-manuals teach you only the technical aspects of photography then leave it up to you to make the best of what you learned; in contrast, this book, in addition to teaching you the How, also gives you the reason for everything you learn, explains your options, and shows how every photographic problem can be

solved in many different ways, some of which are bound to be more effective than others, thereby enabling you to

transform knowledge into performance.

p. 127

This book contains *everything* I consider necessary to give you a good working knowledge of the principles and practice of *good* photography in accordance with my conviction that subject selection, "photographic seeing," and graphically effective rendition are no less and perhaps even more important than flawless "technique." In my opinion, a photograph which shows an interesting subject well "seen," even though it may not be completely satisfactory in technical respects, is always stimulating and occasionally perhaps even great. But a photograph having nothing to offer except "technical excellence" is a bore.

I furthermore believe that (1) most of what you need to know to make "technically perfect" pictures is already contained in the instructions for use which manufacturers of photographic equipment and materials customarily enclose with their products; (2) that modern automated photographic equipment already does most of your "technical thinking" for you; and (3) that the degree of technical knowledge and skill required for the making of *good* photographs, has declined to the point where all that is asked of the photographer is to make an intelligent choice among a number of available technical options in accordance with shooting conditions, the nature of the subject, and his or her specific ideas, then implement this decision with the aid of more or less automated equipment on the basis of instrument readings and guide numbers derived from the manufacturer's instructions. And for those of us who do not wish to bother with darkroom work, excellent custom photo labs are available, if not directly, then by mail. As a result, the need for photo-technical knowledge is constantly diminishing while the importance of pictorial-creative awareness grows.

Let me tell you of an observation I made while working as a staff photographer for *Life* Magazine. During these years I met many of the world's foremost photographers. And believe it or not, some of the very best had only the most rudimentary knowledge of photographic technique. As a result, developing their films and printing

their negatives sometimes drove the lab technicians up the walls. Yet the resulting images were often so powerful they made *Life* the greatest picture magazine on earth. Why? Because these men and women felt compassion for their subjects, they were interested in what they saw and did, they became involved, they cared, they had the "photo-eye" and knew how to "see in terms of photography." *p. 127* They were artists aware of the qualities which make a picture great: capturing the decisive moment of an event, the interesting pose, the meaningful expression; the most significant angle of view, the unexpected yet telling perspective, the subtle nuances of color and light which set the mood of the scene—the mood that "makes" the picture. These photographers were not brain-washed into respecting photographic taboos, nor were they burdened by too much knowledge of what could have gone wrong. The *Life* photographers simply felt and reacted to a situation as sensitive human beings, aimed their cameras, and shot, not giving a damn whether the rule book said the picture could or couldn't be done. Their attitude was "let the lab technicians worry about technicalities (that's what *Life* pays them for). Results are what count." And, as anybody knows, the results were magnificent.

Now, I don't want you to get the idea that I consider disregard of photo-technical considerations the mark of a great photographer. Not at all. But I do want you to realize that subject concept takes precedence over "technique." Let me repeat for emphasis: A well conceived photograph is always interesting; a picture that has nothing to recommend it except "technical perfection" is a waste of film, money, and time.

Though this volume is in itself a complete guide to taking good pictures, *Total Photography* must be augmented by supplementary reading to be most effective, for the following reasons:

A great amount of indispensable photo-technical information is relatively short-lived. Our medium is in a constant state of flux since manufacturers of photographic equipment and material are always working to improve their products. As a result, data change, instructions for use vary with each new model or process, information pertaining to specific operations (like color film devel-

opment) varies from brand to brand and sooner or later becomes obsolete as the product improves. Rather than loading this guide with information that perhaps may be outdated by the time this book comes off the press, I entirely omitted such ephemeral data. This is by no means a loss since this kind of information is already available free of charge in the form of instructive literature which manufacturers of cameras, speedlights, light meters, films, developers, color developing kits, etc. routinely enclose with their products—and *that* information is guaranteed authentic, pertinent, and complete. Studying the instruction manual immediately upon acquiring a camera or other photo-related purchase is the sign of an intelligent photographer.

In this connection, I'd like to draw particular attention to the inexpensive *Kodak Professional Data Books* and *Kodak Information Books.* The booklets dealing with color photography are especially useful and virtually indispensable to anyone interested in this subject. In my experience, as far as nuts-and-bolts technical information is concerned, Kodak literature is unsurpassed.

In my opinion, other indispensable supplementary sources of photo-technical information are the photo magazines. Subscription to a good one is a "must" for any ambitious photographer. They are invaluable sources of "photographic news"—new products and techniques, updates, test and lab reports, critical comparison of different products and materials. Subscription to a photo magazine insures you of always being up-to-date as far as your medium is concerned.

And now, I must ask you to forget everything you ever heard or read about photography. Prepare yourself mentally for a completely new start. Let your mind go blank, rid yourself of any prejudices, misconceptions, and fixed ideas you may have had about photography and enjoy the next chapter. You are on the road to good photography.

I. The Subject: The Reason Why We Photograph

As far as their attitude toward photography is concerned, I like to distinguish between two basically different types of photographers:

the technically oriented photographer
the subject-oriented photographer.

Members of the first group seem mesmerized by cameras, lenses, and the intricacies and mysteries of the whole photo-technical complex. They behave as if a camera were a love object rather than a tool for making pictures. They usually own the finest equipment and regularly "trade up" to the latest models. They routinely make tests to reassure themselves of the sharpness of their lenses and the fine grain capability of their developers. They are walking encyclopedias of photo lore and proudest of the fact that their 16x20-inch enlargements from 35mm negatives are all but grainless. They know everything about the advantages and shortcomings of the different "system cameras," talk knowingly about the pros and cons of aperture-preference versus shutter-preference in exposure-automated cameras and about the potential of "multimode exposure automation." But this group of photographers rarely produces a worthwhile photograph because their entire interest remains focused on the means of making pictures—their equipment—instead of the end—the photograph. As far as they are concerned, a subject—any subject—is merely a justification for exercising their equipment.

Exactly the opposite attitude is that of the photographer whose interest is in pictures or, more accurately, in the subjects which he photographs. Unlike the equipment-oriented photographer who is

attracted by gadgets and technology, he is fascinated by people, street scenes, cities, landscapes, nudes, objects of nature, modern architecture, Roman ruins, sport events, scenes from daily life. . . . And because he is enamoured of his subject, he wants to capture it in picture form so he can possess it, take it home, enjoy it again and again and share his interest and love with other people. As far as he is concerned, photography is merely a means to an end and a camera holds no more fascination for him than a typewriter for a novelist. He considers the demands of photo technique almost a "necessary evil" which stands between him and the things he loves. And only because he is smart enough to realize that any subject can be photographed in countless different ways and that some of the resulting images are bound to be more powerful and effective than others does he get involved with photo technology—the means and techniques indispensable for the creation of good photographs. Yet despite this cavalier attitude toward the photographic medium, it is he and not the technical wizard who creates the kind of picture that commands attention—the images one remembers.

To further impress upon you the importance of the role which the subject plays for the outcome of a picture, let me draw a parallel between photography and writing. Both are forms of communication—photography is sometimes called "picture language" for good reason. Now, no serious writer would reach for the typewriter unless he was convinced he had something worthwhile to say, something of interest to his readers. But photographers constantly reach for the camera even if they have "nothing to say." Such pictures, devoid of subject interest, are nothing but "visual prattle." This, I'm sure, is not the kind of photograph you had in mind when you reached for this book in the hope that reading it might improve the quality of your work.

It should now be obvious that the main factor which determines whether a photograph is interesting or dull, whether a photographer succeeds or fails, is the subject. But this is not the entire story. For no matter how interesting a subject by itself may be, unless it is rendered in picture form with feeling and understanding in a graphically effective way, the picture will be disappointing. One

more ingredient is needed: interest on the part of the photographer in his subject.

Interest in a subject is the reason why we photograph, the spark that energizes our crative faculties. It makes a photographer come to life, gets him excited, opens the gates of feelings and creativity. Without the stimulus of interest, photography sinks to the level of mindless routine. Only when working in the interest-generated state of heightened awareness can a photographer hope to create pictures that convey what he felt to the viewer.

As an amateur photographer, you have one priceless advantage over the "pro": you are your own boss. You can choose and photograph only what pleases you—the subjects that appeal to you, move you, catch your interest. Nothing will improve the quality of your work faster than abiding by this motto:

Unless a subject interests me, I'll pass it over and save my film for better things.

It obviously is impossible to compile a list of "interesting" subjects because what interests one person may leave another one cold. Interest is a very personal feeling. But no matter how unusual your interests (I, for example, am interested in broken seashells, in which I see a wealth of sculpturally fascinating forms and have photographed this certainly unusual subject extensively), as long as your interest is genuine and not merely aroused because a subject is fashionable at the moment, you are on the right track and should proceed, no matter how other people may react.

As far as the photographer is concerned, the influence of the subject makes itself felt in just about every phase and aspect of photography. Among others, it also decides the type of camera which should be used for *best* results. Please note the emphasis on "best," because almost any type or make of camera will yield pictures of almost any subject, but the difference in picture quality can be great. For no matter what the ads may say, "the camera that can do everything" simply doesn't exist.

p. 22-28

An analogy with carpentry comes to mind. A saw, for example is not simply a saw; there are saws for firewood, carpentry work,

metal, butchers, plastic, foam rubber, concrete; straight saws, circular saws, jigsaws, chain saws, band saws; and so on. Each was specifically designed to do one job particularly well, and the same applies to cameras and photography. We have large, medium, and small format cameras; view cameras, rangefinder cameras, single lens reflex cameras, twin-lens reflex cameras, fisheye cameras, panoramic cameras, and so on.

With this in mind, I want you to distinguish between two main types of subjects:

dynamic subjects
static subjects.

Dynamic subjects

Characteristic of these subjects are motion and action, which cause their physical appearance to change from moment to moment, often rapidly and sometimes dramatically. In this category belong, among others,

people, street scenes, candid portraits
pets, wildlife
action and sports photography
news events and reportage.

It is imperative that the photographer be prepared to act quickly in order not to miss what Henri Cartier-Bresson, the famous French photojournalist, so aptly called "the decisive moment." This requires preparedness and a camera that can shoot lightning-fast.

The camera types best suited for this kind of work are the 35mm single lens reflex (SLR) and the 35mm rangefinder (RF) cameras. Among these, the fastest in regard to operation are those which, in addition to automatic (electronically controlled) exposure determination, also offer automatic focusing. When working with this kind of tool, all a photographer has to do is to preset either the diaphragm aperture or the shutter speed (depending on the design of the respective model), point the camera at the subject, and shoot, secure in the knowledge that his camera will present him with a sharp and correctly exposed negative or slide

any time, any place, no matter how much or how little he knows about technique. Nor does it matter whether one moment he works in the deepest shade and the next in bright sunshine, whether his subject is distant scenery or a person six feet away—his automatic camera will do all his technical thinking for him, thereby leaving his mind and attention free to concentrate on the all-important creative aspects of photography.

I know that some professional photographers still reject the fully automated camera as a threat to their creativity—they feel the photographer should make the decisions, not some electronic brain. I believe this objection is invalid because such cameras are always equipped with an override control, making it possible to switch from automatic to manual operation. Furthermore, exposures can be prolonged or shortened at will either with the aid of a built-in plus-or-minus exposure adjustment dial, or by feeding a somewhat lower or higher ISO or ASA (film speed number) into the camera. *p. 110* The only reservation I have in regard to automated cameras is their fantastic internal complexity which makes them more prone to breakdowns than manually operated models, and the fact that their batteries can run out. But, in photography, an advantage on one side usually involves a drawback on another.

Selection of a 35mm camera should be governed by the following considerations:

Don't fall into the "overkill" trap by buying a more expensive camera than you need. All 35mm cameras costing approximately 175 dollars and up are capable of yielding negatives and transparencies of satisfactory technical quality. Furthermore, I am convinced that a photographer who cannot produce effective pictures with a hundred-dollar camera would do no better with a fifteen hundred-dollar model. It is not the technical quality of his camera which decides the value of his pictures, but whether or not it is suited to the job at hand. What makes the differences between good and bad photography is the basis on which a photographer selects his subjects, the way he "sees" his subjects, and the specific techniques he chooses for their rendition—all matters which have nothing to do with either the brand name, the quality, or the cost of a camera.

Why, then, you may ask, the enormous span in price between outwardly similar 35mm SLRs of different brands? The answer is: mechanical quality, manufacturer arrogance and snob appeal. Expensive cameras are more solidly built than less costly ones—qualities which can be fully utilized only by photographers to whom reliability and durability are vital considerations because they run literally hundreds of rolls of film through their cameras year after year. The average amateur simply does not need this kind of super quality and precision, and would do better to buy a less expensive brand (or last year's top-of-the-line model in used condition) and invest the savings in one or two additional lenses and, especially, in film. Because the more you shoot, the more you learn. The more you learn, the better your pictures. And the better your pictures, the better and more fulfilled you feel.

Another important consideration before choosing your equipment is how a camera "feels" in your hands and how its viewfinder suits you. Despite outward similarities, differences in this respect can vary considerably, making one camera "fit like a glove" and another feel as if it were all sharp corners, angular protrusions and misplaced controls. Eyeglass wearers in particular should make sure that viewfinder construction is compatible with their glasses because the design of certain viewfinders seriously restricts the field of view unless the eye is brought in closer contact than glasses permit.

A third consideration is the "system capability" of a camera—the more or less diverse line of available accessories like the number of interchangeable lenses of different focal lengths and speeds, interchangeable viewfinders, motor drives, aids for use in conjunction with specific photographic fields such as close-up photography, extreme telephotography, photomicrography, medical or dental photography, and so on. All better cameras, of course, are designed to accept wide-angle and telephoto lenses, extension tubes or bellows, color filters, and so on; but some models offer a wider choice in this respect than others.

Many expensive cameras generally accept only lenses of their own brand, thus limiting a photographer's choice. On the other hand,

less costly cameras are usually fitted with lens mounts permitting the use of lenses made by independent manufacturers. As a rule, such lenses are considerably less expensive than top brand name products yet are perfectly capable of fulfilling the legitimate expectations of all but the most finicky photographers.

As far as design differences like aperture-preference versus shutter-preference, the location of the light-sensitive cell within the camera body, the type of battery required, and so on, are concerned, experience has shown that among cameras within the same price range there is little difference in regard to performance, and in equally capable hands, all will perform equally well. In such cases, when forced to make a choice, a photographer should pay more attention to the "feel" of the camera than to specifics of design.

Static subjects
Immobility is characteristic of this sort of subject. In this category belong, among others

landscapes, seascapes, cityscapes
buildings exteriors
interiors
all kinds of inanimate objects
formal portraits and posed fashion shots
still lifes and reproductions.

The fact that static subjects hold still facilitates the photographer's work in several respects:

it gives him all the time he needs to do a perfect job
it enables him to use a tripod for maximum sharpness
it permits him to work with larger-format cameras.

Obviously, with virtually unlimited time at his disposal, a photographer can do a better job than when forced to shoot in a hurry. He can deliberately study his subject in depth, from various sides and angles, in different kinds of light, under different atmospheric conditions. He can mount his camera on a tripod and work with otherwise "impossible" small diaphragm stops for maximum extension *p. 28*
p. 112

pp. 40-41

of sharpness in depth since the corresponding long exposure times would no longer present a problem, since the tripod would avoid accidental camera movement during exposure, which would cause blur. He can take as many pictures as he wants, all slightly different, each having something the others lack. Later, with the finished "take" (series of all the pictures taken of one subject or event) in front of him, he can leisurely assess his work and pick what is best. Any aware photographer will take full advantage of these opportunities.

The camera types best suited for static-subject photography are 2¼x2¼ and 2¼x2¾-inch single-lens reflex (SLR), twin-lens reflex (TLR) cameras and 4x5-inch or even larger view cameras. In comparison to 35mm cameras, these types are larger, heavier, more conspicuous, and slower in regard to operation, qualities which basically make them unsuitable for any kind of work where mobility and speed are of the essence. And view cameras cannot be used hand-held but require the use of a tripod.

These cameras are particularly well suited to static-subject photography because the larger the film format, the potentially better the quality of the image. What does it matter that these cameras are relatively slow in operation? Static subjects hold still, speed on the part of the photographer is not important. What is important is technical quality, which will be the better, the less the final picture has to be enlarged. Why? Because any film emulsion consists of minute grains of silver embedded in gelatin. These grains are invisible under normal conditions, but can show up clearly and objectionably when sufficiently enlarged, giving the picture a coarse and granular ("grainy") appearance. Furthermore, no matter how "sharp" a lens, if the negative or transparency is sufficiently enlarged, the picture will no longer seem sharp, but more or less blurred—absolute sharpness does not exist. Hence, the lower the degree of enlargement, the smoother and sharper the image. Now, to make an 11x14-inch enlargement, a 35mm negative must be magnified more than ten times (linear), whereas a 4x5-inch negative requires less than three times enlargement.

When speaking about static subjects, there is an important distinction to be made between:

subjects which do not contain straight or parallel lines
—most objects of nature
subjects which do contain straight or parallel lines
—many man-made objects.

These two types of static subjects may require the use of different types of cameras. Why? Because natural subjects (except for certain crystals) never contain perfectly straight lines, while man-made subjects often do. For example, straight lines, such as the horizontal and vertical lines in a building, usually appear in multiple parallels and are subject to "perspective," that is, when seen at an angle, they converge toward vanishing points. Now, such convergence of parallel lines seems perfectly natural in picture form in the horizontal plane, as in the apparent convergence of railroad tracks toward the distance. However, it often appears "unnatural" if it occurs in the vertical plane—consider the "converging verticals" in angle shots of buildings where walls are rendered approaching each other toward the top of the picture, giving the appearance of a building about to collapse.

p. 209

In cases where such convergence of actually parallel lines is undesirable, it can often be avoided, and actual parallels restored in the picture, if the photographer exerts perspective control. The most common means for accomplishing this is the view camera, which has an individually adjustable front and back enabling the photographer to render, within certain limits, actually parallel lines *parallel on the film*, even in "angle shots."

Let me repeat for emphasis: Although, of course, any camera will produce some kind of picture of any type of subject, in specific cases, some camera types will give technically better results than others. As far as static subjects are concerned, 35mm cameras are not recommended because their negative format is unnecessarily small and the normally required degree of film enlargement too great to yield optimal results. Static objects of nature can satisfactorily be photographed with any camera having a film size of

2¼x2¼ inches (6x6 cm) or larger. For man-made static objects, using a view camera will give best results because of the perspective control this type of camera provides. In the long run, the only criterion of the practical value of any camera is

suitability.

If it is suited to the job at hand, it is good; if not, it isn't, no matter how impressive its price, how fast its lens, or how illustrious its maker's name.

Having discussed the importance of choosing a suitable camera, I'd like to add a thought about tripods. Today, in the age of superfast lenses and films, emancipated photographers, and candid photography, the word "tripod" has an anachronistic ring. Actually, even today, no expert photographer could function without a tripod.

A word about tripods. A tripod not only broadens the scope, but also improves the quality of any photographer's work. In extreme close-up photography as well as in ordinary copy work, for example, differences in distance between subject and camera of only fractions of an inch can make the difference between a sharp and an unsharp picture; without a tripod, this accuracy of focus is normally unobtainable. In extreme telephotography, only a hefty tripod can assure the steadiness of the rig without which even normally unnoticeable vibrations would blur the picture because the magnifying power of a telephoto lens enlarges possible inaccuracies of focus and accidental vibration to the same extent it enlarges the image. You can easily convince yourself of this by mounting a camera equipped with a telephoto lens on a tripod, observing the viewfinder image, then touching the end of the lens barrel lightly with your fingertip; the image will instantly wobble.

Night-time shots as well as many made indoors would be impossible without the aid of a tripod to steady the camera during the required long exposure times. But even under ordinary circumstances, a tripod can improve the quality of your work by giving you sharper pictures. All the photographs in my books *Trees* and *Shells,* for example, were made with the camera mounted on a tri-

pod to assure the ultimate in sharpness and detail. Even pictures shot with a 35mm camera at 1/125 second will often be sharper if made with the camera tripod-mounted rather than hand-held. This might seem like going to unnecessary extremes; but it is an easily verifiable fact (just make a few comparison shots and you'll be convinced) and in cases in which negatives must be blown up to photo mural size or transparencies projected on huge lecture screens, the reward would be professional-quality images that are uncompromisingly sharp instead of so-so.

Should you decide to buy a tripod, don't be stingy; make sure it is a strong one featuring a center post ("elevator"). Unfortunately, good tripods are both heavy and expensive. On the other hand, a cheap, weak, and wobbly tripod is nothing but a nuisance to carry, useless when it counts, and always a total waste of money.

In addition to making the distinction between dynamic and static subjects, experienced photographers distinguish among the following types of subjects:

photogenic and unphotogenic subjects
photographic and literary subjects
tangible and intangible subjects
"so-what" subjects and photographic clichés
unphotographable subjects.

Photogenic subject qualities, techniques, and effects

You've probably heard the term "photogenic" and know that photogenic subjects make better pictures than unphotogenic ones. But do you also know which are the qualities that make a subject photogenic, or why certain qualities cause a subject to appear appealing and impressive when photographed while others lead to pictorial disappointments?

Briefly, the dichotomy between photogenic and unphotogenic subjects is the result of inherent differences in the way the human eye and camera "see." To give you an example: an arrangement of roses may delight us with its glowing deep red and green. But photographed on black-and-white film, the colors which enchanted us in reality, would appear in picture form as more or less identical

pp. 127-144

shades of gray. The contrast between rose-red and leaf-green would be lost because both colors would be rendered in similar, drab tones, and the photograph would be monotonous and disappointing, containing nothing of the essence of the subject. Why? Because eye and film reacted differently to the same stimulus—in this case, color.

Let's take another example. Imagine that you took a trip into red-wood country, were overcome with the grandeur of these trees, and took a series of shots to remind you of this experience forever. But when you looked at your pictures afterward, you were dismayed—those collossal redwoods looked like ordinary evergreens. What *pp. 208, 210* happened? Your treatment of the subject lacked scale. There was nothing in your pictures to indicate the size of these trees—their outstanding characteristic and the quality that inspired you to take your photographs. Again, you and your camera "saw" differently.

A third example. You went to an automobile race. You got excited, got carried away, and shot pictures of the cars screaming past your stand at 150 mph, using your highest shutter speed to get sharp pictures. And you succeeded—to a point. The pictures were sharp, but precisely because the cars were rendered in sharp focus, they looked as if they were standing still. Gone was the spirit of the race, the excitement, the speed—the essence of the event. What was left was another set of disappointing pictures without flair or feeling. Again, you and your camera reacted differently to the same event.

p. 127 I'll come back to the subject of "photographic seeing" in a later chapter, where it will be discussed in depth. What I want you to realize at this point is that you cannot simply point your camera at a beautiful or interesting subject, shoot, and expect to be rewarded with a beautiful and interesting picture. In essence, even a picture of a beautiful girl is not necessarily a beautiful picture. Why not? Because "beauty" is not necessarily a "photogenic quality" (as in the case of the red roses); nor, for that matter, is "interest" (proof: the case of the racing cars). The three examples cited above were either beautiful or interesting or both yet all turned out disappointingly in picture form. Where does that leave you as a photographer intent on making effective pictures?

It leaves you with the realization that an "interesting" subject, although a prerequisite for making "interesting" photographs, is by itself no guarantee that such photographs will also be effective pictures. Because, as I mentioned in the beginning of this book, a graphically effective rendition is an indispensable ingredient of any effective photograph. But in order to be graphically effective in picture form, an interesting subject must also possess photogenic qualities.

p. 16

What are those mysterious qualities which make a subject photogenic or unphotogenic? The answer is not easy to formulate because it depends to some degree on the artistic outlook of the person you ask. Blonde hair, blue eyes, or an arrangement in the form of an S-curve or pyramid used to be considered photogenic qualities in the eyes of tradition-bound photographers. But today's more visually sophisticated individual can understand these concepts in a much wider sense. Here are what I consider the most important photogenic subject qualities:

 simplicity
 order and clarity
 pattern, rhythm, and repetition of similar or identical forms
 contrast: high or low
 large and decisive forms
 surface texture
 color
 spontaneity.

Simplicity heads the list of photogenic subject qualities. Few things photographic seem worse to me than a picture overcrowded with too much subject matter. One of the most common mistakes of the beginner is failing to realize the graphic consequences of the fact that the camera "shows everything" within the range of the lens while the eye is selective—people usually are interested only in specific aspects of a scene. But whereas the control center of the brain makes them overlook or disregard uninteresting subject matter in reality, the relatively small, easily scannable area of the photograph literally forces the eye to pay equal attention to important as well as distracting picture elements, thereby diluting if not destroying the graphic effect of the picture.

p. 127

Consequently, the first thing I do when confronted with a subject is to ask myself: How can I free it from distracting elements in its surroundings? How can I isolate it, condense it, simplify it, reduce it to essentials? What is important for achieving the effect I visualize, to capture in their purest form those qualities which made me want to photograph this subject? How can I "clean up" the scene—literally as well as figuratively speaking? And then I go to work, doing the best I can in accordance with the situation. When possible, I physically remove distracting subject matter out of the field of view of the lens (for example, by "cleaning up" the background for a portrait or family group in a home). If a subject is, say, a small sculpture, I may move it and place it in front of a more suitable background. If this can't be done, I provide my own background, perhaps a sheet of white cardboard or background paper. And if I cannot clean up in the literal sense, I "figuratively" clean up the scene and concentrate my efforts on the essence of the subject by one of two always effective means: either, I move in closer with my camera and allow the subject to fill the entire frame of the picture, thereby crowding out undesirable marginal picture elements; or if going closer is either impossible (example: photographing a tiger in a zoo) or undesirable (because it might lead to perspective distortion), I use a lens of longer than standard focal length, a method which creates a close-up effect from a distance.

Order and clarity. A subject can present itself well organized or in a messy condition. Needless to say, the former state is conducive to the creation of effective photographs while the latter is not. An experience of mine will clarify this: while I was working on my book *Trees* (Viking Press, 1968; reprinted by Penguin Books, 1978), many well-meaning people told me about beautiful trees they had seen and where to find them. But without exception, when I followed up such a lead, it turned out that, although the tree was there and indeed an exceptionally beautiful specimen, disturbing outside influences rendered it hopelessly unphotogenic from the discriminating photographer's point of view. The tree was either hemmed in by other trees which obscured its silhouette; or the background was graphically unacceptable because it merged

in tone and color with the tree; or powerlines, telephone wires, or buildings interfered with the clarity of presentation, making even the most beautiful tree useless for my purpose.

Pattern, rhythm, and repetition of similar or identical forms. These subject characteristics automatically insure good picture organization. Consequently, "pattern shots" are rightfully a favorite with most photographers. However, pattern shots made merely for the sake of abstract pattern effects, without any further justification or purpose, easily become boring clichés. However, patterns that form an integral part of the subject, especially if presented with emphasis on structural or functional aspects, become photogenic subject characteristics which almost automatically guarantee effective pictures.

Contrast: high or low. The overwhelming majority of photographs consists of pictures in which contrast is average. In this respect, such pictures are boring, while those showing subjects with unusual contrast potentially have the opposite effect because they are rare. Consequently, contrary to popular belief, abnormally high or low contrast are photogenic subject qualities if handled skillfully by a sensitive photographer, a claim substantiated, for example, by backlighted subjects (abnormally high contrast) and scenes photographed during a snowfall, in rain, or in fog (abnormally low contrast). Any creative photographer knows that these make some of the most effective pictures.

Forms that are large, bold, and decisive generally lend themselves better to the creation of effective photographs than multitudes of small, complex, or soft-edged and indistinct forms.

Surface texture skillfully brought out by raking sidelight or backlight is an asset to most photographs because of its informative value: it tells the viewer whether a surface was, say, stone or concrete, wood, bark, metal, glass, fabric, paper, or fur. This ability to convey pictorial information makes characteristic surface texture a photogenic subject quality.

p. 84

Color presents a special problem because, photographically speaking, it can be an asset as well as a liability. Up to now, all the photogenic qualities listed were assets as far as both black-and-white and color photographer are concerned. With color, matters are different, because color can make a subject photogenic as far as the color photographer is concerned and unphotogenic to those who work in black-and-white, and vice versa. For example, the vivid colors that arouse our admiration in certain flowers, birds, tropical fish, or butterflies are a characteristic quality which makes these subjects extremely photogenic—from the color photographer's point of view. But for the black-and-white photographer, rendered in black-and-white, these subjects would be all but unrecognizable due to the absence of their typical colors—colors which, transformed into gray shades, would blend with one another, make the picture ineffective, by creating a drab and false impression. Consequently, photographers working in black-and-white should avoid subjects whose most outstanding quality is color. No matter how skillfully photographed, in terms of black-and-white such subjects will always be disappointing in picture form, and may even be unrecognizable except in a general way.

But even to a color photographer, color as such is not necessarily a photogenic subject quality. Colors and color combinations that to the eye appeared pleasing and even beautiful can be banal or boring in a color slide or print. Consider green fields under a blue sky—that picture postcard kind of prettiness. On the other hand, some of the most stunningly beautiful color photographs derive their special effect from colors that are so subtle and pale as to be almost "colorless," as exemplified by pictures shot on hazy days or in rain or fog. If one can generalize at all, one could perhaps say that, as far as the color photographer is concerned, color is a photogenic quality if it is unusual—unusually saturated and strong or unusually pale and delicate; that a few harmonizing color shades can be very photogenic while a jumble of strong unrelated colors appears gaudy and unphotogenic; and that a few large areas of color usually are more effective than many smaller ones.

Spontaneity is a highly photogenic quality of animate subjects. It is difficult to define except, perhaps, by saying that it is the opposite of posed, contrived, faked—qualities which are extremely unphotogenic. Spontaneity gives a picture the stamp of authenticity, honesty, and truth. It can never be forced. It has to happen spontaneously and the photographer must capture its visible effects before they fade away.

p. 43

The techniques and effects which I find most photogenic are:

 backlight
 close-ups
 telephoto lenses.

Backlight, a technical effect rather than a subject quality, in addition to being potentially the most photogenic type of light, is one of the most effective means of photographic creation. Skillfully handled, it can turn common subjects into enchanted things and glorify the most ordinary events. It is relatively easy to handle in black-and-white but difficult to use in color, where the much more limited contrast range of the film increases the chance of failure.

Close-ups, as a rule, represent a more photogenic subject approach than long shots and overall pictures, which have a tendency to show "too much." They automatically eliminate distracting or superfluous marginal detail and, by means of tight cropping, concentrate the viewer's attention on the subject proper which they present in larger and more effective scale than pictures taken from a greater distance.

Telephoto lenses offer highly photogenic means of automatically producing pictures with excellent perspective. As a matter of fact, the longer the focal length of the lens relative to the size of the film, the lower the degree of perspective distortion, the more monumental the effect of the subject, and the more accurate the size relationship between near and distant picture elements.

Unfortunately, most photographers believe that the only purpose of telephoto lenses is to render distant subjects large enough to make them pictorially effective. This, however, is only part of the story. In my opinion, a telephoto lens, whenever suitable, is always superior and thus preferable to a lens of standard focal length, even in cases which traditionally have been the province of standard lenses, like shots at relatively short subject-to-camera distances, street scenes (nowadays usually shot with moderate wide-angle lenses), portraits, and close-ups.

Unphotogenic subject qualities, techniques, and effects

As certain qualities make a subject photogenic, so others make a subject unsuitable to rendition through photographic means because, no matter how hard a photographer may try, such subjects will always be disappointing in picture form. Here are the qualities, practices, and effects which, in my opinion, are unphotogenic and should be avoided:

insipidity
disorder
unsuitable background
meaningless foreground
misplaced or unsightly shadows.

Insipidity and lack of viewer interest in the subject are the two most common causes of pictures that elicit reactions like "Why did he make it?," "What does it mean?," "What did he want to say?," or simply a derogatory "So what?"

Disorder, excessive complexity, and lack of graphic organization (poor composition) are probably the second most common causes of ineffective photographs. Such pictures are the unavoidable consequence of thoughtless, unplanned shooting by photographers who got carried away by the sight of an interesting subject never considering that the camera faithfully records everything within the field of view of the lens, no matter how pointless, superfluous, distracting, ugly, or just plain dull. The remedy: next time, before you shoot, temper your enthusiasm with contempla-

tion—critical evaluation of the foreground and background of the subject and artistic considerations.

An unsuitable background can spoil the effect of even the most photogenic subject. I mentioned already an example from my own experience—highly photogenic trees made "unphotographable" by unsuitable backgrounds. Since the background is the second most important picture element (the subject, of course, is first), it should be given the attention it deserves. A background may be unsuitable for several reasons:

p. 32

 objectionable subject matter
 it blends with the subject
 its color or pattern is too obtrusive.

All of the following constitute objectionable subject matter that can ruin a photograph: telephone wires or powerlines crossing an otherwise pristine sky; utility poles; trees or branches that interfere pictorially with the subject; distant buildings that spoil the impression of remoteness in a landscape photograph; and in interior shots, electric cables leading to the photo lamps, a light meter left accidentally on a table, or an equipment case not quite outside the field of view of the lens.

Another reason a background may be unsuitable is that it blends with the subject in regard to color, tonal shade, or pattern. Photographers working in black-and-white often neglect the fact that colors the eye perceives as strongly contrasting, such as red and blue, may appear as virtually identical tones after transformation into gray shades. And in color photography, a background in a color similar to that of the subject is often overlooked because it is far away, though in the resulting picture the background may blend with the subject.

A background which is too obtrusive in regard to color or pattern may also be unsuitable. Some photographers seem to think they must make up for a "lack of color" in a subject characterized by delicate color shades by placing it against a strongly colored background—too often a fire-engine red—which kills the effect of the subject. This seems to be particularly common in photographs of pottery, chinaware, jewelry, seashells, and female nudes.

Meaningless foreground is a waste of valuable picture space, usually caused by shooting from too far away—a typical mistake of the beginner. Overcoming this fault is simplicity itself: move in closer toward the subject, or use a lens of longer focal length.

Misplaced or unsightly shadows can ruin a picture. Particularly objectionable are: the photographer's own shadow accidentally appearing in the picture and unintended shadows cast by an object or person on the background. (To avoid this mistake, increase the distance between the shadow-throwing object and the background accordingly; if this is impossible, change the position of the lamp casting the ugly shadow. Attempts at "burning out" the offending shadow with the aid of an additional lamp are futile and only result in the creation of another shadow.) Also objectionable: shadows cast by more than one light source pointing in different directions; shadows crossing one another; and secondary shadows cast by fill-in lamps within the primary shadows. These typically amateurish and extremely unsightly effects are caused by faulty lamp placement when working with two or more light sources.

p. 182

In portraiture, the most important shadow is that cast by the nose; it must never cross or even come close to the lips. Other shadows to watch are those around the eyes and beneath the chin which, if too dark, should be lightened with softly diffused fill-in illumination to avoid harsh and ugly effects. Readers wanting to know more about the principles and practice of good lighting are referred to the author's book, *Light and Lighting in Photography* (Amphoto, 1976), which I recommend as supplementary reading.

p. 94

Unphotogenic lighting techniques. Photographers working with artificial light should be aware of the following lighting problems which can ruin your pictures:

flash at the camera
indiscriminate shadow fill-in illumination and overlighting
poor use of multiple lamp illumination.

Flash unit on or near the camera as the only source of illumination should normally be avoided unless the subject is photographed in

color and has relatively little depth. Otherwise the subject and its immediate surrounding might be correctly exposed but everything behind it would be more or less underexposed and appear too dark or even black because the effect of the flash diminishes rapidly with distance. Furthermore, the subject would appear "flat" since front light casts almost no visible shadows (they are hidden behind the subject as seen from the camera position), and properly placed shadows are the most effective means for the creation of the illusion of depth within the two-dimensional plane of the picture. A flash unit used on or near the camera in an auxiliary capacity provides excellent shadow fill-in illumination at moderate subject distances. As the only light source it is acceptable for snapshots but totally inadequate where more ambitious photographic efforts are concerned.

Indiscriminate shadow fill-in illumination and overlighting should be avoided. Close-up photographs taken outdoors in bright sunlight easily turn out so contrasty that the shadow areas of the subject appear in the picture as solid black. If this is undesirable (though occasionally, it can be very effective), such shadows may be lightened to any degree with the aid of daylight flash fill-in illumination. However, care must be taken not to use too bright a fill-in lamp since this would make the shadow appear unnaturally transparent, create secondary shadows within the primary shadow cast by the sun, and destroy the mood of the scene by giving it an artificial look. When in doubt, experienced photographers know that especially in color photography, underlighting is better than overlighting (this must not be confused with underexposure and overexposure), while beginners just pour it on, thereby irretrievably washing out the colors of their slides.

Multiple-lamp illumination must be employed with skill or it can result in ugly effects. Just because artificial light permits the simultaneous use of any number of light sources is no reason to use all the available photo lamps at once, as many photographers seem to think. Experienced photographers know that just the opposite is true: the smaller the number of photo lamps employed simultaneously, the greater the chance for success and the smaller the danger of overlighting, of shadows pointing in different directions, and

p. 187

of secondary shadows appearing within primary ones. Theoretically, a single photo lamp in conjunction with a large reflecting surface for shadow fill-in illumination is better than two photo lamps (one main light plus one shadow fill-in lamp), two lamps are preferable to three, and three are easier to handle than four, and so on—a principle of good lighting that beginners cannot learn too soon.

Bad habits. In a sense, the following common habits (which are typical of beginners) belong in the category of "unphotogenic techniques" because they are the cause of many picture-spoiling effects:

 shooting from too far away
 accidentally moving the camera during exposure
 sloppy focusing
 tilting the camera laterally
 perspective distortion
 disregard of the direction or quality of light.

Shooting from too great a distance is, perhaps, the most common mistake of beginners. Again and again one sees people taking photographs of members of their family in front of monuments or public buildings, on the beach, or in the street from distances so great that faces will be rendered in a size so small that they are all but unrecognizable in the picture. Apparently, such photographers were motivated by a desire to include in addition to their loved ones as much of the surrounding scenery as possible. This tactic simply does not work—unless, of course, you are satisfied with snapshots instead of *pictures.* You have to make up your mind: either take close-ups of faces or shoot scenery.

Moving the camera accidentally during the exposure. This is the most common cause of unsharp pictures. It can be recognized by the fact that blur in the photograph is *directional*, that is, manifested in the form of double contours appearing on the same sides of the various picture elements. Apart from extreme cases, this form of blur is normally too indistinct to be seen in the negative or slide without the aid of a magnifier but will appear glaringly in an

enlargement or on a screen. There is no remedy. To avoid accidental camera motion, follow these simple rules:

Always shoot at the highest practicable shutter speed. The slowest shutter speed normally considered safe for hand-held exposures is 1/125 sec. or 1/100 sec. Before making the exposure, brace yourself by standing securely with feet slightly apart, press both elbows against your ribs and the camera against your nose and cheek. If possible, lean your back or hip against a solid object for additional steadiness—or rest the camera on whatever make-shift support may be available, or press it hard against the side of a wall, a lamp post, a tree trunk, the fender or roof of a car, or any other suitable object. When shooting from a lower angle, don't squat on your heels. Instead, rest your right knee on the ground, place your left foot firmly on the ground and your left elbow on your left knee; press your right elbow against your ribs and press the camera, firmly held in both hands, against your nose and cheek. Take a deep breath, let it out halfway, hold it, then gently "squeeze" the shutter release button with a steady downward pressure. Never stab or jab at the shutter release—this may jerk the camera at the most critical moment and cause the picture to be blurred. Stay cool.

Sloppy focusing produces pictures which are not critically sharp. In contrast to blur due to accidental camera movement during the exposure, this fault can be recognized by the fact that unsharpness is *non-directional*—everything is more or less fuzzy and there are no double contours. There is no remedy.

To avoid this mistake, take your time when focusing. Move the lens back and forth until you are sure the part of the subject on which you focus is critically sharp. If possible, use the microprism grid or split-image rangefinder built into the viewfinder of your SLR or a focusing magnifier when focusing on a groundglass. Focusing is easiest if the subject has relatively strong contrast and contains at least some sharply delineated forms. When photographing a face, focus on the eyes or eyelashes. If no sharp outlines exist (for example, when shooting outdoors on misty or foggy days), check your focus against the distance scale engraved on the

p. 112

lens; in addition, create a "safety zone" of sharpness in depth by working with relatively small diaphragm stops.

If the picture or slide is only partially sharp, the diaphragm aperture was too large to create sufficient sharpness in depth. Next time, use a smaller *f*-stop.

p. 123

If a subject in motion appears blurred while the stationary background is sharp, the shutter speed was too low to "freeze" the subject's motion. Next time, use a higher shutter speed.

Tilting the camera laterally yields photographs in which everything tips slightly to one side. Such pictures make a sloppy impression. This mistake can, of course, be corrected if the picture is to be printed, but then, a certain amount of valuable negative area will have to be sacrificed, especially regrettable when using 35mm film, where every square millimeter counts. A much better measure is training yourself to hold the camera level laterally unless, of course, you are deliberately shooting at an angle to achieve a planned effect.

Perspective distortion, unless deliberately used to symbolize nearness or create caricaturish images, is another apparently insignificant yet actually quite ugly fault that may be easily avoided. Its most common manifestations are heads, noses, hands or feet that appear unproportionally large in the picture, creating grotesque impressions.

Perspective distortion is the combined result of three factors: a wide-angle lens, a three-dimensional subject with relatively great extension in depth, and a subject-to-camera distance that is relatively short. The wider the angle of the lens, the more extensive the subject's depth, and the shorter the subject-to-camera distance, the more pronounced the distortion effect. Accordingly, to avoid perspective distortion, use a standard lens or, better still, a moderate telephoto lens rather than a wide-angle lens. This will automatically force you to keep a healthy distance between yourself and your subject. The reward will be an effective, natural-appearing perspective instead of something grotesque.

Shooting without regard for the direction or quality of the light is another common mistake of the beginner. Among others, it accounts for most black-and-white negatives where contrast is unprintably high and color transparencies where overexposure of the lightest subject areas and underexposure of the darkest subject areas occur within the same slide.

To avoid this fault, pay attention to the direction and quality of the incident light. For most natural-appearing color rendition (but not necessarily for the best overall effect), a frontal subject-illumination (light-source more or less behind the photographer's back) is unsurpassed. To create impressions of three-dimensionality, volume, and depth, light striking the subject more or less from one side or the back is most effective. For outdoor portraits, sunlight on a hazy day or diffused by a thin, even overcast, or daylight in the open shade, normally give the best results. When taking color shots in the open shade, however, a pale-red "warm-up" color filter should normally be used to compensate for the excessive blue content of the illumination which in such cases consists almost entirely of light reflected from a clear, blue sky.

p. 83

p. 201

A type of illumination which, at least in my opinion, should always be avoided is top light—light more or less from above—the typical summer noonday light. Although beloved by beginners and even many amateurs who ought to know better because it is "so nice and bright," it actually is one of the least photogenic types of light because vertical surfaces are insufficiently illuminated for good rendition (especially disastrous if color film is involved) and shadows are badly placed and too small to create effective impressions of depth. This is exactly the opposite of early morning or late afternoon light when the sun is relatively low in the sky and casts long, slanting, highly photogenic shadows. I'll have more to say about this subject later.

p. 85

p. 89

Faking vs. posing. As we shall see in a later chapter, control is an essential aspect of good photography. But what, precisely, is meant by "control"? How far should a photographer go in controlling the form in which a subject or event will appear in the picture? A prac-

p. 169

tical example should clarify what I mean. Imagine that a person wants to shoot an informal portrait of his wife at home. He wants familiar surroundings included in the picture to provide "atmosphere." Everything is ready to go when a last, critical look through the viewfinder reveals a potted plant in the background which seems to grow right out of his wife's head. Placing the plant outside the field of view of the lens is, in my opinion, a legitimate act of "control." But when the photographer wants to elicit a smile from his model and commands her to say "cheese," this, in my opinion, is no longer "controlling" but "faking." Such a forced smile is not genuine—and will look it, giving a face that pained expression of synthetic gaiety seen in too many advertising photographs.

The line between controlling and posing is a very thin one, and where it should be drawn will largely depend on the personal attitude of the photographer. The last thing on my mind is to tell a sensitive photographer how to create. But as teacher, I see it as part of my job to alert you to possible pitfalls.

Because of the different ways in which the eye and the camera react to the same stimulus, *control in photography is an indispensable prerequisite for success.* The different means of control and the *pp. 171-232* forms they can take will be discussed later. What I want to emphasize here is that control can easily be misused, intentionally as well as inadvertently. In the first case, control is tantamount to faking; in the second, to blundering. In either case, the result would be a phony picture.

The way I see it, control is equivalent to directing. In movies, as far as the artistic success or failure of the film is concerned, the most important factor is the director. The same holds true in photography. The director is the great coordinator who determines which subject to shoot and how to shoot it. It is the director who decides the form and extent of control. To be successful, he must be sensitive, have an artist's eye, and have taste. He is the moving spirit who alone can make a picture great.

The gimmick. In our sated and superficial society, one of the few remaining sure-fire devices for drawing attention is "newness." Uncritical or opportunistic photographers exploit this phenom-

enon by making use of every means and gimmick they can think of, no matter how farfetched and even detrimental they may be to the purpose of their pictures (which presumably is communication). Shots made through diffraction gratings, image multipliers (prisms), or the grid of an exposure meter; extreme perspective distortion and nonrectilinear perspective when there is no justification for use of these means; indiscriminate application of the Sabatier effect (pseudo-solarization), and placing colored gelatins in front of photo-lamps for the creation of gaudy effects, are some of these "novel" techniques which, based upon a confusion of means and meaning, usually yield nothing but incomprehensible photographs in bad taste.

pp. 216-222

Photographic and literary subjects

"One picture is worth a thousand words" is an old saying. This may be true in some instances, but in others it is not. For example: No verbal description of, say, a face, can evoke in the mind of the listener as valid and true an impression as that elicited by a good photograph. The verbally created image may be vivid and exciting but is often sadly imprecise and usually deficient in regard to those apparently minor details which nevertheless make the difference between impression and fact. The eye and mind of the person providing the description would most likely overlook what to him are unimportant aspects of the face in favor of more prominent ones which he would exaggerate. In contrast, the incorruptible eye of the camera would come up with a picture of this face precisely as it actually appears at the moment of exposure. A face, therefore, at least in my opinion, is a good example of a "photographic" subject—the kind of a subject the "story" of which can be "told" better in picture form than with words.

On the other hand, a photograph of, say, a memorial commemorating a person or an event, no matter how accurate in every detail, is apt to be a boring picture. Why? Because it cannot tell a story. This kind of photograph is a symbol of a symbol. In the first place, every photograh is ipso facto a "symbol" of reality, in the same sense that a word is a symbol for an object, a concept, or an act, and a letter is a symbol for a sound. But on top of this, any memorial is

also a symbol because it stands for something else—the person or event it was erected to commemorate. To get its meaning, the viewer must know its background story—who was the person?, what was the event? A photograph cannot do this. It can only be accomplished by means of words. Hence, a monument is an example of a "literary" subject—the kind of subject which will always be unsatisfactory in picture form because its meaning cannot be expressed photographically.

To put it another way, a verbal description is restricted in regard to detail because it consists of a limited number of words. What it does not include is lost as far as the listener is concerned because attempts at inferring the missing information are apt to lead to erroneous or, at best, speculative, conclusions. A photograph, on the other hand, contains all the visual information available at the moment the picture was made, and what is overlooked by the viewer at the first examination can subsequently be picked up in the course of further, more intensive study. When visible aspects are sufficient to adequately tell the story of a subject, the subject is "photographic" and the photographer has a chance to make an effective picture. But if the subject's meaning is mainly symbolic, a photograph can only present a superficial account and the picture is apt to be unsatisfactory unless supplemented by writing. Such "literary" subjects are basically unsuited to photographic rendition because, at best, the resulting pictures serve as aids to memory but are intrinsically unsatisfactory in regard to content and meaning.

Why am I going into this rather theoretical discussion of what is suitable to photography and what is better left to words alone? Because I have observed that many photographers waste their film on "literary" subjects such as war memorials, statues of civic heroes, birthplaces of famous personalities, various beds that President Washington is supposed to have slept in, and places recognizable by plaques proclaiming, "Here stood . . ." or "Here lived. . . ." All of these subjects are symbolic and many have a fascinating story to tell but they are, in themselves, of unphotogenic and more or less insignificant objects nobody would look at twice were it not for their historical connotations. If you still insist on photographing

such subjects (personally, I would rather buy a picture postcard and save my film), try at least to make the picture more interesting by introducing some kind of pictorially symbolic element. Here are some suggestions: Photograph a war memorial against a threatening sky with rays of light shooting forth from black and thundrous clouds while the setting sun floods the scene with blood-red light. Or, photograph the equestrian statue of a dictator from below (instead of choosing a more horizontal view), using the distortion of a wide-angle lens to emphasize the hoofs of his rearing horse threatening to stamp the observer into the dust, symbolizing oppression and contempt for human life.

Tangible and intangible subjects

Now I can almost hear you ask in wonder: "Intangible subjects—what does he mean? Ghosts?" Not quite—and instead of "intangible subjects" I probably should have said "intangible subject qualities." Here is what I mean:

Although many subjects are exactly what they seem to be—for example, a car is a car and an elephant is an elephant—some subjects, in addition to their obvious tangibility, have other, "intangible," qualities. Such intangible qualities include beauty, sex appeal, honesty, reliability, power, tenderness, femininity, reverence; but also cruelty, vindictiveness, shoddiness, weakness, phoniness, and so on. It is important to be aware of this aspect of photography because indication of appropriate intangible subject qualities can add greatly to the power of a photograph. For example:

There are zillions of photographs of girls—an always interesting subject—made by photographers who apparently thought: "A girl is a girl is a girl, so what? Here she is, that's the way she looked; the camera does not lie." I find this attitude pitiful. Girls, at least potentially, are lovely human beings, embodiments of beauty, sex appeal, and life. Unless these "intangible" qualities are brought out photographically, pictures of girls are incomplete, ineffectual and dull, drops in the bucket of photographic blah.

In this particular case, we are on sensitive ground, because the difference between sex appeal and obscenity can be a fine one. What constitutes sex appeal for one person may already be "pornog-

raphy" to another. However, in my opinion, the sensuous swell of a youthful breast, a lovely curve, or the barely perceptible indication of a nipple pushing against restraining cloth can give the picture of a young girl an indescribable feeling of femininity and "sense-appeal" without arousing even a trace of "prurient desires." As a matter of fact, these symbols of femininity, sensitively used, evoke in me such an overwhelming feeling of sheer beauty that nothing else matters—all I experience is an emotional wave of purest compassion and love combined with an aesthetic sense of wonder that such perfection exists. On the other hand, those dime-a-dozen pictures of girls displayed in every fashion magazine or catalog, no matter how alluring the synthetic smiles or provocative the poses, leave me ice cold. This is a typical example of how expressing an intangible quality—here, sex appeal—can elevate a photograph from being a run-of-the-mill snapshot to an aesthetic experience.

Actually, every good photograph contains intangible qualities whether or not their makers are aware of them. Every picture of a landscape that has a special mood—a mood being an intangible subject quality, without which it would be dull—proves my point, as does every portrait of a face showing emotion (worry, concern, anguish, love, hate, fear, and so on) coming through in the picture. Such photographs never leave the viewer cold. On the other hand, faces that don't reflect emotions are lifeless and dull, as every identification or passport picture proves.

Art directors at advertising agencies are the people who are most aware of the importance of intangible qualities insofar as the impact of a photograph is concerned. The pictures they look out for and use are "dead" without this quality. Who would look at the advertisement of, say, an automobile, if the accompanying picture didn't evoke such intangible qualities as power, elegance, prestige, distinction and style, and capacity for speed? Who would do anything but yawn at TV commercials about deodorants or detergents unless the faces of the people demonstrating them mirrored intangible qualities like satisfaction or pleasure? Who would look at anything as dull as pictures of lipsticks or bottles of shampoo if the lovely ladies demonstrating these products didn't seem aglow with sex appeal?

In fact, it often is the "intangible subject" (*not* subject *quality*) which makes the difference between a boring picture and one that commands attention. A mood, for example, can be the subject proper of a picture while the landscape without which this mood could not be portrayed is merely a means to an end. The same can be said of sex appeal. In the case of pin-up pictures, for example, the subject proper is sex appeal while the vehicle necessary to convey this subject in photographic form is an anonymous girl of no particular importance.

Photographs which evoke certain feelings are ever so much more effective than ordinary record shots that confine themselves to "facts." In order to imbue your pictures with feeling, you first must experience such feelings yourself. This, in turn, is possible only if you take an interest in your subject, feel compassion for it, love it, understand it and want to share these emotions with other people. In the last analysis, therefore, it is involvement on your part with what you want to photograph which is the basis for success. Without genuine interest in your subject, your work will never rise above the level of competent routine.

"So-what" subjects and photographic clichés

In my experience, photographers can roughly be divided into two groups: creators and imitators. The creators go their own ways, are inventive, flaunt tradition, and break new ground. The imitators follow and try to cash in on the success of these leaders. The consequence is that, sooner or later, any novel approach to photography becomes vulgarized by hordes of more or less talented imitators, until eventually it is reduced to a cliché.

I realize that imitation is an essential part of the learning process— any young animal, any child, imitates its more experienced elders and thereby learns to compete and survive. While this may be adequate for everyday living, where routine, preservation of the status quo, and mottoes like "don't rock the boat, don't tamper with success" are the foundation that guarantees a successful if unexciting life, in the field of creative photography this attitude does not work.

I most certainly don't want to discourage any of my readers from photographing subjects that have been successfully "done" before. This would not only be stupid, but also impossible because generations of photographers have been and still are rightfully interested in the same types of subjects. What I want to impress on you at this point is the difference between imitation and stimulation.

Look at as many photographs as you want. Admire them, study and analyze them, find the ingredient that made them so effective that they caught your eye; then use what you discover for your own work in your own way. This is stimulation—one of the driving forces on the road to personal fulfillment and success. This is learning in the best sense of the word. It also is the opposite of "imitation."

None of us is so creative that he is not, in one way or another, indebted to those who taught him. Newton said in essence, "If I was successful in my work, it was because I was standing on the shoulders of giants." This is what I mean: let yourself be inspired by other photographers' work, then go out and try to top them. Continue where they left off; branch out; use the means you find effective in new and different ways for the creation of still better photographs—images that carry *your* stamp of personality.

How many times have I seen a photograph and thought: why didn't I make this picture? But then I realized: too bad, too late, the thing is done, and done so well that it would be foolish and a waste of time to attempt this subject again. Instead, I enjoyed it and did something else. Yet frequently, after a while, this picture suggested something to me, the germ of an idea for a work which, though totally different, in some indefinable way owed its existence to that other photograph. This is stimulation.

Imitation, on the other hand, is slavishly following in the footsteps of others, wasting your time on subjects that have already been "done to death," "so-what" kind of subjects—the eternal photographic clichés. The nature of these clichés changes with the times—from angle shots and "worm's-eye views" to pattern shots to distorted reflections in mirrorlike surfaces to photographs of stacks of lobster pots and coiled ropes to greased nudes and

bearded bums to "available light photography" (especially admired if virtually no light was available) to shots taken from the window of a moving car (this gimmick even rated an exhibition at New York's prestigious Museum of Modern Art) to passers-by in the street shot with interestingly "distorting" wide-angle lenses to fisheye-lens photographs to blurred and completely "symbolic" pictures to photographic "happenings"—there is virtually no end to the strange, occasionally fascinating and exciting, but more often merely gimmicky and senseless approaches to subjects photographers have dreamed up, sometimes in the interest of better and more expressive pictures, but too often merely to attract attention by being "different."

What all this boils down to is this: As a beginning photographer, don't let yourself be overly influenced by other people's work, no matter how much you may admire it. Don't bother with what I call "so-what" subjects—the photogenic but meaningless landscapes, still lives, nudes, etc. that result in pretty pictures we have seen countless times before. Who cares? ... Don't fall for currently fashionable photographic clichés. Instead, pay attention only to those subjects in which you take a genuine interest—after all, that's why you took up photography: to create images of the things you love. And when you photograph, go your own way, no matter how contrary your directions is to tradition, to what other people may say, even to anything in this book. The only thing that matters is knowing what you want, knowing how to achieve it, and then doing it.

Unphotographable subjects

It may sound strange, but the more I know about photography and the more I photograph, the more frustrated I feel. I seem to retrogress. I still remember with pleasure how happy I was as a beginner. Then, photography was a great adventure, and I was getting better all the time. When, after years of learning and hard work, I finally felt like a master, there seemed to be nothing that was beyond my power to photograph, and photograph well. And if I needed proof, I found it in the fact that during the twenty years I worked as a staff photographer for *Life*, I had more full-page and

double-spread pictures published in the magazine than any of my colleagues. I obviously was "good."

Then came the moment when I decided to devote full time to my personal work. I had become interested in subjects that were beyond the interest and scope of *Life*—trees and crystals and shells; the structural relationship between totally unrelated objects of nature like leaves, feathers, and insect wings; or dendrites and the growth patterns of certain kinds of plants; or feathers, ferns, and frost on a windowpane. I learned about the mysterious Fibonacci series of numbers and their occurrence in certain kinds of flowers and seeds. I began to photograph structural details of plants—the umbrella-like support of the florets of Queen Anne's lace and parachute-like dandelion seeds. As I delved deeper into these fascinating objects of nature I became increasingly discouraged with my photography because, no matter how hard and often I tried, how different my ways of approach, despite considerable technical experience, I frequently found myself unable to capture the essence of things I loved on film and sensitized paper.

As I became more and more critical, I looked with new eyes at paintings and "discovered" that artists like van Gogh, Monet, Turner, and my own father, Lyonel Feininger, had captured and successfully expressed in their works many of the emotions I had felt when confronted with certain subjects—emotions which I knew to be "unphotographable" because I could in no way known to me express them in photographic form. I had discovered the "unphotographable subjects." I had come to the end of the line.

Why do I talk to you about these very personal experiences? Perhaps to make you take photography more seriously, to work harder, to put more of yourself into your work . . . perhaps to make you realize that there are limits to our craft beyond which we cannot progress.

A face in a crowd glowing with vitality and happiness flashing into awareness momentarily, then gone . . . dew drops on morning-fresh grass sparkling like diamonds, shooting rays of purest spectral color at my eyes, ruby, emerald, topaz, sapphire, magically changing from color to color as I almost imperceptibly turn my

head . . . thistle seeds floating past me on gossamer parachutes, the most delicate structures imaginable, threads of purest sunlight solidified, traveling by air to propagate their kind . . . swallows crisscrossing the sky like black lightning, arrows on wings, their matchless superiority in the realm of flight filling my soul with nameless joy, bringing tears of happiness to my eyes . . . a pencil-thin ray of light at sunset penetrating the woods, targeting a single yellow flower, a black-eyed susan, turning its yellow rosette for seconds into an incandescent star that forms the center of my universe . . . an accidental combination of moving shapes in a city street forming the perfect combination, balanced as on a knife's edge for milliseconds, then dissolving, never to be repeated again . . . all moments of supreme awareness, experiences to be treasured as memories but never to be preserved in picture form because they are "unphotographable."

Yes, now I remember what made me want to talk about the limits of photography; it was the memory of two photographic experiences:

The first was a picture I took at the beach that didn't work. I was still young at that time, but already I loved the beach with the same fervor I feel today. I wanted a photographic record of the whole experience—the happiness; the feeling of sea, sand, and sun; the heat, the taste of salty spray, the coolness of the water, the smell of the kelp; the thunder of the waves as they shattered, foaming on the beach; the happy crowds, the suntanned girls, colorful beach umbrellas, gulls and terns flying overhead, calling. I had loaded my camera with black-and-white film, made a series of shots, developed the film in happy expectation, printed the negatives, and got the worst shock of my young photographic life: my pictures were indescribably dull! There was absolutely nothing of what I had seen and felt—nothing but boring shades of contrastless gray drabness, and monotony. At that time, I blamed my failure on lack of photographic technique. Today I know better. Technically there had been nothing wrong with my work. My mistake was that I had attempted to photograph the unphotographable: sense-impressions that were not visual, that nobody could have photographed. The only point in regard to which I could have done better would

have been to use color film instead of black-and-white but, unfortunately, this was in 1929, before the time of color photography.

The second experience concerned a photograph I saw at a gallery. This one, too, was a beach scene in black-and-white. It caught my eye because it was so unbelievably dull—nothing but a strip of sand and a strip of sky with a strip of ocean between, the horizon dividing the picture into equal parts. Overall contrast was extremely low, film grain extremely prominent, and the only subject matter other than sand, water, and sky was a clump of strand grass in one corner. I thought I had never seen anything more boring and monotonous. I couldn't understand why anybody would bother to photograph such a "nothing" scene.

But just as I was about to turn away, bored, it struck me that this was precisely what the photographer had wanted to express: loneliness, monotony, the grandiose expanse of sea and sand and sky, the drabness of a rainy day in November when harsh northeasterly winds swept the empty beach and veils of driving scud and mist created a mood of desolate monotony. He had succeeded admirably! And there I had been, almost missing the message because my mind was still too much influenced by traditional standards of photography which prohibit the division of a picture into two equal parts (that is considered "dull" and "unimaginative"); which demand a certain minimum degree of contrast (otherwise the picture is "flat"); which judge graininess as amateurish, proof of lack of "technique" (although, today, we know that "grain" is a potentially powerful means of creative expression); and which reject as "boring" any picture which doesn't contain a minimum amount of "acceptable" subject matter.

Visualize these two photographs in your mind and give them some thought. You will emerge a better photographer.

Defining which subjects are "unphotographable" and which are not is, of course, a matter of personal opinion. Anything can be photographed in one way or another. The question is: how well—and is it worth the effort? Here are my reasons why a subject can be "unphotographable":

The subject is hopelessly unphotogenic. The view from a *p. 36* lookout point encompassing miles and miles of scenery, for example, can be breathtakingly spectacular in reality, yet may be unspeakably dull in picture form—because such views are notoriously unphotogenic subjects. On the other hand, artists like Turner, Lyonel Feininger, and Monet have shown repeatedly in their works that even subjects as insubstantial and intangible as air and empty space can be symbolized graphically in marvellously convincing form.

The decisive characteristics of the subject are "invisible" ones. Think about the first beach scene described above: its *p. 53* sound, smell, taste, tactile and many emotional sensations were "unphotographable" because they could not be symbolized through photographic means. If this kind of sensation turns you on and tempts you to take a picture—forget it. The result would never satisfy you unless all you want is a record shot, an aid to memory.

The subject is too ephemeral. Some events just happen too fast, too unexpectedly, to be caught on film: a face in the crowd and sometimes the perfect composition cited above are examples. No- *pp. 52, 53* body can have a camera handy at all times ready to shoot at a split second's notice. Even with a fully automated, self-focusing camera, you probably would find that other factors such as disturbing background matter, light that is unsuitable in quality or direction, excessive subject distance, or any one of a number of other pictorially undesirable factors would make the resulting picture unacceptable.

There are inherent shortcomings in the photographic process. Light, for example, is radiant; but when photographing a source of light, the best we can accomplish in picture form is to show it as a blob of white; the difference between reality and image would be the same as that between radiant (direct) and diffused (reflected) light. Therefore, all phenomena involving radiant light (like my backlighted, floating thistle seeds) are ipso facto "unphotographable" since the effect of the print can never equal the actual

experience except by indicating "radiance" with graphic-symbolic means like halation, star patterns, or deliberate utilization of the manifestations of lens flare, as I'll explain later.

p. 189

Another limiting factor is the inherent unsharpness of all photographic images. In reality, if I examine a flower stalk through a magnifier, I see a wealth of almost microscopically fine hairs; if I use the same magnifier on my print, I see film grain. Gone is that exquisite precision of the original. It is replaced by unsharpness which, upon closer examination, resolves itself into a sandpaper-like texture having nothing to do with the subject of the picture.

p. 109

As you progress as a photographer, you will encounter an increasing number of subjects which, to a greater or lesser degree, are "unphotographable." In some cases, refined, sophisticated techniques based upon the utilization of graphic "symbols" will still enable you to produce acceptable images. (I'll tell you more about these techniques in the chapter that deals with control). In other instances, the subject is better left unphotographed. Enjoy it in reality to the fullest, and save your film.

pp. 169, 171...

Conclusions

The subject of your photographs and your attitude toward it are the two most important factors in the success or failure of your pictures. Next in importance is the suitability of your camera. If it is suitable for the job at hand, it is good; if not, it isn't, and you will not be able to realize your full potential in photo-technical respects.

pp. 22-28

If you intend to photograph subjects belonging to both classes—static and dynamic subjects—and expect to produce pictures of the highest technical quality, you will need two or more cameras of different types (like, for example, a 35mm SLR, a 2¼x2¼-inch TLR, and a 4x5-inch view camera and a tripod. And if you wish to branch out even further and go beyond the scope of everyday photography, you will need still more specialized equipment, such as telephoto lenses, extreme wide-angle and fish-eye lenses, macro lenses, for extreme close-up photography, extension bellows, and so on.

But not even the finest equipment will do you any good unless you have a reason and a goal; unless you know not only How to use it but also WHY and WHEN; and unless you do your own work in your own personal way. Let yourself be stimulated by everything likely to further your aspirations but be extremely careful to avoid the trap of imitation, that shortcut to artistic death.

In short, whatever you do, be true to yourself.

II. A Total Concept of Photography

Any good photograph is more than merely the image of a subject built up of grains of silver on paper or colorful dyes on a strip of Mylar in accordance with the rules of photographic technology. It is more because all the basic ingredients (like subject selection and approach, camera, film, development, etc.) were brought together in a specific way for a specific purpose—the picture—by one additional intangible yet all-important factor: the personality of the photographer. It is his spirit and creativity as manifested in his attitude toward his medium—photography—and his ideas in regard to selection and rendition of his subject, which "make" the picture. Seen in this light, any good photograph is a "holistic" entity, the result of adopting a "total" view of photography.

According to the holistic concept, an entity is more than merely the sum of its parts. Applied to photography, this means that a good picture is more than merely the result of an automatic sequence of mechanical steps executed in compliance with specific rules; and more than a conglomeration of desirable picture qualities like sharpness, correctness of exposure, naturalness of color or gray values, contrast that is neither too high nor too low for best characterization of the subject, freedom from graininess and blur where neither one is wanted, and so on. Because if combining these elements were all that is required, any photograph executed in accordance with traditional standards of photography would be a good picture. That this is not necessarily the case is proven daily by millions of technically competent photographers who produce

millions of photographs which may be unassailable in photo-technical respects but are pictorially ineffective.

Let me give you a simple example: On a sunny day, a certain type of color film may yield technically perfect slides if exposed 1/125 second at $f/11$. This is the standard exposure of the beginner? While it may be undeniably correct as far as color rendition under certain light conditions is concerned, the result may be totally unsatisfactory in regard to the extent of the sharply covered zone in depth or the form in which subject movement is presented. If, for best subject characterization, depth is an important factor, an exposure of, say, 1/30 second at $f/22$ may be needed to produce a satisfactory result. On the other hand, if rapid subject motion is to be "stopped," an exposure of, say, 1/500 second at $f/5$ may be needed. All three exposures would, of course, yield slides with identical color rendition—but what a difference there would be in the pictorial or informative aspects of the three images!

One reason many photographers fail in their work is that they don't see "the entire picture," literally as well as figuratively speaking. Their minds are so preoccupied with technicalities that they completely forget to pay attention to two other aspects which influence the effect of any picture to the highest degree: meaning and form of presentation. These photographers see a subject they like and shoot it without giving any thought to such factors as background, foreground, the sky, the quality and direction of the light, color relationships, peculiarities of perspective like degrees of foreshortening and distortion, treatment of subject motion, and so on. Not to mention the fact that these pictures are often meaningless insofar as they were executed without thought or purpose—the WHY was not considered at all.

To further clarify this line of reasoning, let me tell you of a friend's experience on a recent trip to Italy. When he came upon a Renaissance statue which really excited him with its power and beauty, he studied it from all sides to find the most expressive angle, then made the shot. But back home, when he projected his slides, he was

dismayed—the image contained nothing of the feeling he wanted to express. What had gone wrong? Let's analyze his picture:

In the first place, the subject (the statue) and the background (the venerable buildings behind it) blended together visually because graphic separation in terms of color and brightness was inadequate. Both being stone of more or less the same color and texture identically illuminated by the sun, they merged in picture form. In reality, they had been separated by space; projected onto film, this space effect was lost as a result of the differences in "seeing" between the eye and the lens: the eye's view is stereoscopic—space appears to have "depth"; the camera's view is monocular—space is rendered "flat." Photographers who, like my friend, fail to take this *pp. 72, 164,* difference into account and don't make allowance for it by "sym- *209* bolizing" space with photographic means shouldn't be surprised if their pictures look "flat."

A second mistake that contributed to the disappointing impression of my friend's slide was that he hadn't paid attention to the direction and quality of the light. It had been a beautiful day, the sun was shining brightly and there was plenty of light for a hand-held exposure. What more could a photographer ask? He should have asked two significant questions: (1) What is the quality of the light? *pp. 71, 72* and (2) What is its direction? Light is perhaps the most important single "non-technical" factor which determines success or failure in photography—via its brightness, direction, contrast, and color, qualities which decisively affect a picture's three-dimensional impression and mood. This is a subject so important and extensive that I have devoted a special monograph to its discussion, *Light and Lighting in Photography* (Amphoto, 1976). At this point, I want to direct your attention to two facts:

Direct sunlight—the type of light in which my friend took his picture—is harsh and contrasty. As a result, it often is photographically undesirable because it can increase subject contrast to the point where it exceeds the exposure latitude of the film. As a result, detail and color are lost in the lightest or darkest areas of the picture, overexposure (of the brightest subject parts) and underexposure (of areas in deep shade) can occur together in the same

negative or slide, and the picture gives a harsh and unnatural impression. Experienced photographers know this and, particularly for outdoor portraits and close-ups of people, prefer light from a slightly hazy or overcast sky to direct sunlight at midday.

The second fact my friend overlooked in his eagerness to find the most effective angle of view was that the interplay of light and shadow is the most powerful graphic symbol of space. Now, extent and location of these all-important areas of light and shadow are governed by the position of the light source relative to the position of the camera—the direction of what is called "incident light,"—the light falling on the subject. In my friend's case, there was a conflict between two equally important considerations: the demand for the best angle of view with respect to the physical-spatial aspects of his subject—its "front" or most important side, perspective, relationship and overlapping of its forms, foreshortening, and diminution—and the way in which these characteristics were brought out and emphasized or obscured and obliterated, by light and shadow. Because if the illumination is too frontal, or too much from the back, or too much from above, relative to the positions of subject and camera, it is impossible to arrive at a "perfect" solution. You may change the camera position in order to see the subject in a better light, but the price would probably be a less effective angle of view or a less desirable background. If this is the case (and, as any photographer knows, this is a most common experience), a photographer has three options: (1) he can come back at a different time of day when the position of the sun is more suitable or the sky is slightly overcast; (2) he can try to make the best compromise between the demands of angle of view, background, and direction of the light; or (3) he can forget the whole thing, save his film, and buy a picture postcard.

I think the foregoing should make it clear how inseparably, as far as the effect of the picture is concerned, the four factors

angle of view
background
foreground
light

are interrelated. A completely satisfactory result can never be achieved, no matter how sharp the photograph or how natural or brilliant its color, unless each can be resolved in a way that is consistent with

the nature of the subject
the concept of the photographer
the purpose of the picture.

What can you do as a photographer to find the pictorially best solution to this problem? That depends on the nature of your subject and especially whether it is "movable" (like a person or an object of reasonable size and weight) or stationary (like a statue, a building, or a tree). In the first case there is no real problem since you can always place the subject in front of a more suitable background or change its position relative to the direction of the light. In the second case, you have a problem which can be solved only by analyzing the angle of view, background, foreground, and light in accordance with the following discussion, then making the best possible compromise.

Angle of view

This term is used here in the widest sense to include

subject distance
direction of view.

Let's consider them one at a time.

Subject distance. The shorter the distance between subject and camera, the larger the subject will appear in the picture, but the smaller the subject area that will be shown, and vice versa.

Perhaps the most common mistake made by beginners is staying too far away from their subjects, producing pictures in which, for instance, a person appears so small that the face is all but unrecognizable. Therefore, one of the first rules of good photography is: decide *precisely* how much of a given subject you want to include in your picture, then go close enough with your camera to make this chosen area fill the full width of your viewfinder. When photo-

graphing a person, for example, having decided you want a good likeness of the face, don't stay so far away that you get most of the figure on the film, but go at least close enough to have a head-and-shoulder image fill your viewfinder. If circumstances make it impossible for you to get sufficiently close to your subject (for example, if you want to take a headshot of a tiger in a zoo or a panorama of a city skyline across a river), you can still get an image in the desired scale by using a lens with a correspondingly longer-than-standard focal length (telephoto lens). Focal length and image size are directly proportional; from the same subject-to-camera distance, a lens with twice the focal length of another will produce an image twice the size on film.

Direction of view. Most photographic subjects are three-dimensional. As a result, they can be seen in innumerable different views, depending on how we look at them. The impression made by any three-dimensional subject is the combined result of all the views we experienced when exploring it visually from different sides and angles. In picture form, however, we usually have to confine ourselves to only one impression. It is the task of the photographer to choose from all possible camera positions the one which will give him the best result—the picture which will most effectively characterize his subject.

Choosing the best camera position is a process of elimination: of the infinite number of theoretically possible camera positions, discard those that are obviously impossible or impracticable and from the remainder select "the best one" in accordance with the following considerations. (Please note that, again, it makes a difference whether you deal with a "movable" or "fixed" subject. A movable subject is much easier to photograph effectively because the photographer's options are almost unlimited in that he can select *separately* the best angle of view, the most suitable background, the most effective type of light and form of lighting, then combine the three by placing the subject in front of the chosen background in the correct position in regard to angle of view and direction of the incident light if he works outdoors, or arrange his photo lamps accordingly.)

For fixed subjects, whose positions cannot be changed, begin your search for the best camera position—the best angle of view—by observing the following two "rules":

> **The first impression of a new subject is not necessarily the best. Seen from a different angle or under different conditions it might look even better.**
> **Always study a three-dimensional subject with one eye closed.**

Study your subject from as many sides and angles as practicable: front, side, back, and, if possible, from above looking down and from below looking up, before you make your decision. Close one eye in order to convert your stereoscopic vision into monocular vision—the vision of the camera—so as not to be misled into thinking that your future picture will "automatically" convey the same impression of "depth" as the scene in front of your eyes. In the two-dimensional plane of a photograph, the effect of "depth" can only be created with the aid of symbols—light and shadow, "perspective" in the form of the apparent converging of parallel lines, overlapping of forms, foreshortening, diminution, distortion, and so on. You must look for these phenomena in your subject and, having found and evaluated them, use them to create the illusion of three-dimensionality and depth in your picture. This is the moment where the creative process takes over, and a very subjective process it is indeed, a process without "rules" where results are often judged differently by different people. The only help I or anyone else can give you in this respect is to make you aware of what is involved—the factors listed above and discussed in more detail later. How you deal with them is up to you.

The background

Not every photograph has a "background" in the strict sense of the word, which implies that a picture consists of two basic elements: a subject in front of a background. The interior of a living room, for example, has no background as such since the back wall of the room is part of the subject itself. And the only background in most landscape photographs is the sky. Therefore, in the following, when I speak of "the background," I want it understood that what I have in mind is that picture element in front of which a specific subject is seen.

The word "background" seems to imply something that is of secondary importance. Theoretically, of course, this is correct; relative to the subject, as far as the message of the picture is concerned, the background is of secondary importance. In practice, however, things aren't quite that simple. For, as many a photographer has found out to his dismay, an unsuitable background can completely spoil an otherwise excellent picture.

A good photographer pays as much attention to the background as to the subject itself because he knows that all his efforts in regard to selecting, arranging, and lighting it may be wasted if an unsuitable background destroys the effectiveness of the picture. Specifically, he should consider the following.

A good background is one that is unobtrusive and neither competes, interferes, nor blends with the subject in regard to color, gray tone value, or overall design. In black-and-white photography, if the subject is light in tone, the background should normally be dark (exception: the so-called "high-key" pictures which are more or less white-on-white); if the subject is dark, the background should be light (exception: "low-key" pictures which are more or less dark-on-dark). If the subject is illuminated by sidelight so that one side is lighter than the other, as is often the case in portraiture, the background behind the light side should be dark and behind the dark side, light; this can easily be arranged by placing the light sources accordingly. In other words, one of the prime requirements for any satisfactory subject-background relationship is *adequate graphic separation*, which is most easily achieved in black-and-white photography by means of contrast between light and dark, and in color photography through color differentiation.

Adequate graphic separation between subject and background, however, is only part of what is required to achieve a satisfactory effect. Equally important is that the background should be unobtrusive enough not to draw the viewer's attention away from the subject. Unfortunately, this is more often the case in color photography, where the color of the background, although sufficiently different from that of the subject to assure graphic separation, is so aggressive that it overwhelms the subject. Common examples of this fault, as mentioned earlier, are color photographs in which

small and delicate or subtly colored subjects (most often, jewelry, shells, or female nudes) are placed against a bright red background, the photographer apparently trying to make up for a lack of brilliant subject color by setting the background on fire. Needless to say, such tasteless displays kill the effect of the subject.

A bad background is anything located behind the plane of the subject as seen from the camera position which blends in tone or color with the subject, makes it less clear, distracts from it, or competes with it in regard to color, gray tone, pattern, form, or viewer interest; anything that does not belong in the picture and only clutters up the scene; anything that does not contribute to presenting the subject in its graphically clearest and most attractive form.

Attention should also be given to "ugly" picture elements like telephone wires or powerlines crossing the sky; a fence introducing an alien element in an outdoor scene; dark foliage with "holes" through which the bright sky shows, creating unpleasant glare which detracts from the subject and makes the picture look "busy"; a tree or telephone pole appearing behind a person's head; or areas filled with sharply rendered fine details which have nothing to do with the subject.

Needless to say, a bad background has to be improved one way or another by the photographer if the picture is to amount to anything more than a snapshot. In this respect, he has the following options, not all of which may be available to him in every case:

If the subject is movable, place it in front of a better background. This applies to most small objects and especially to people. Alternatively, if conditions permit, substitute a suitable background for an unsuitable one (for example, place a sheet of white or light gray cardboard between a small object and the offensive "background" of a busy room interior). Use your imagination to find the most appropriate solution.

In black-and-white photography, use of an appropriate color filter often makes it possible to achieve satisfactory tonal separation in cases in which subject and background have different colors of more or less similar brightness which, in an unfiltered shot, would

be rendered as similar of identical gray tones. To the photograph-
ically untrained eye, for example, a bright red flower in front of
light green foliage may stand out splendidly in vivid contrast. But
photographed in black-and-white, flower and foliage would
merge, since red and light green would be transformed into vir-
tually identical shades of gray. In such cases, that is, where more or
less complementary color pairs are involved (like blue and yellow,
or red and green), use of an appropriate color filter brings about
the desired tonal separation by transforming one color into a
lighter shade of gray, and the other into a darker one. The rules for
achieving satisfactory tonal separation in black-and-white are:

**To transform a color into a lighter shade of gray, use a filter of
the same (or closely related) color.**

**To transform a color into a darker shade of gray, use a filter in
the complementary (or a near-complementary) color.**

In the case of the red flower in front of the green foliage, a red filter
(or, to a somewhat lesser degree, an orange or a yellow one) would
render the flower in a lighter shade of gray (or even white) against
a darker (or even black) background. Conversely, a green filter
would have the opposite effect and make the flower stand out
darker (or black) against light (or white), depending on the exact
hue and density of the filter. This technique is most often used in
outdoor photography to make clouds stand out more vividly
against the "background" of a blue sky. In such instances, a filter in
the complementary color—a yellow, or to an even greater extent,
an orange or a red filter—would make the blue sky appear darker
in the photograph than would have been the case if no filter had
been used; as a result, white clouds would stand our more vividly
in contrast, as white remains unaffected by a color filter.

If you work indoors by artificial (that is, controllable) light, a
simple way to achieve good tonal separation between subject and
background is with the aid of light and shadow. To prove this to
yourself, perform the following experiment:

Take a small white object (perhaps a plaster-of-Paris figurine) and
place it in front of, but not too close to, a sheet of white cardboard.
Then, simply by adjusting your photo lamps, take a series of five

photographs in which object and background appear, respectively, as white against white, gray against gray, black against black, white against black, and black against white. This will convince you that, through skillful manipulation of his photo lamps, a photographer can achieve any desired degree of tonal separation between objects in different planes merely with the aid of light. This technique can, of course, be used in black-and-white as well as color photography.

Outdoors, the same principle can be applied in landscape photography on a sunny day when passing clouds temporarily obscure the sun. By waiting until a cloud shadow darkens one area of the landscape (perhaps a distant mountain range or a group of trees in the foreground) while other areas remain in full sunshine, tonal separation between near and far objects can be greatly improved.

Another way to improve graphic separation between subject and background is by focusing carefully on the subject and making the shot with the largest available diaphragm aperture, which produces the narrowest zone of sharpness in depth. This technique, called selective focus, achieves separation through contrast between sharp and unsharp—the subject appears in sharp focus in front of a more or less unsharp background. In addition to providing the desired graphic separation, this method also creates a particularly strong feeling of depth in the picture. Both effects are the more pronounced the longer the focal length of the lens, the larger the diaphragm aperture, the nearer the subject to the camera, and the greater the distance between subject and background.

Still another method of controlling the subject-background relationship makes use of changes in perspective.

pp. 212-214

Let's take an example: Imagine that you want to photograph a monument in the middle of a piazza in Rome. The background consists of buildings. You can control the relative sizes of monument and background to a considerable extent by taking the picture with the lens of a longer or a shorter focal length in conjunction with a greater or shorter distance between the monument and your location. In this case, the greater the difference in size between the monument and the background buildings, the wider the angle of the lens and the shorter the distance between camera and monument, and vice versa.

This technique can be successfully applied in any case in which the distance between subject and background is fixed. However, there is one drawback: the danger of perspective distortion. The shorter the focal length of the lens relative to the film size (and, as is usually the case, the shorter the distance between subject and camera), the higher the degree of "distortion," not only in regard to differences in apparent size between subject and background, but also in the "perspective" of the subject itself.

A different way to deal with an unsuitable background is to make the shot from a lower-than-normal camera position, thereby positioning the subject in the picture so that it appears against the sky instead of the unsuitable background which will then fall partly or entirely outside the lower edge of the picture.

This brings to mind another point: Outdoors, the best of all possible backgrounds is normally the sky, though not necessarily a blue sky with fleecy white clouds. The appearance of the sky in the picture can often be controlled with the aid of filters. In black-and-white photography filters enable the photographer either to emphasize the clouds (yellow or red filter), or to subdue them (blue filter of greater or lesser density) in cases where a complex subject (perhaps the "skeleton" of a leafless tree in winter, or the Eiffel Tower) must be shown against a more or less uniform and neutral sky for greatest clarity of rendition.

In color photography, a pale blue sky can often be darkened in the transparency with the aid of a polarizer, a special colorless filter which does not affect the other colors in the picture. Like polarizing sunglasses, a polarizing filter diminishes and, under certain conditions even eliminates, glare—in this case, the sky glare which tends to "whiten" a clear blue sky.

pp. 98, 193

Two or more of the approaches and techniques discussed above may be combined to produce more or less extreme results.

The foreground

As not every photograph contains a "background," so not every picture has a "foreground" in the generally accepted sense of the word because, in many cases, the subject itself is the "foreground" as, for example, in portraiture. But if a foreground is involved, it

deserves as much attention on your part as any of the other picture elements if the resulting image is to be effective. In this respect, I suggest you consider the following:

Taking photographs from *unnecessarily* great subject-to-camera distances is a common mistake of beginners. Such photographs suffer from two faults: (1) the subject itself (most often a person) is rendered too small to be effective in picture form, and (2) a large part of the valuable negative area is wasted on pointless foreground matter. Since, in most cases, this foreground does not contain anything that may enhance the effect of the picture, it is pictorially valueless.

Keep this in mind every time you approach a potential subject and act accordingly: go close enough to fill the entire frame of your viewfinder with interesting subject matter, or use a lens with a focal length long enough to give you an image in the desired size.

This approach has two advantages: (1) You get a pictorially more interesting image. (2) If you work in black-and-white or use negative color film, you get a sharper print. Why? Because you can use a lower degree of magnification when making your enlargements since the negative area you are interested in is already larger (and therefore requires less magnification). A shot made from a greater distance, on the other hand, will need more or less extensive cropping to yield the same kind of interesting print. And the more you enlarge any negative (no matter how apparently grainless and sharp), the fuzzier and coarser the print.

Subject matter shown in the foreground of a photograph is obviously closer to the camera than the background. Pictorially speaking, this makes the foreground matter symbolize nearness in the same sense that the background symbolizes distance. Now, out of the contrast between something near and something far evolves a feeling of depth and space. Experienced photographers utilize this fact to give their pictures greater "depth" by treating the foreground accordingly: by partly or entirely filling it with interesting subject matter, they turn it into a springboard for the eye to take off into the distance, into space, the upper part of the picture, toward the horizon and the sky. This, of course, can be done in in-

numerable ways depending on the nature of the subject and the intentions of the photographer. The effect of this method of enhancing the depth impression of the picture is strongest if the foreground surrounds the more distant subject areas as a frame would—for example, in views shot through a window, a doorway, an arch, an arrangement of branches, whereby the window, doorframe, and so on are shown along the four edges of the picture, "framing" it. Although this principle is generally known and overused, it is as effective as ever and, applied by a creative mind, is still capable of novel solutions.

If you wish to emphasize the foreground in your picture, your best tool to achieve this is a wide-angle lens—the wider the angle, the more pronounced the effect. Unfortunately, if used at relatively short subject-to-camera distances, wide-angle lenses "distort," that is, "exaggerate" perspective by rendering nearby subject matter disproportionately large and distant subject matter disproportionately small. But it is precisely this exaggerated contrast between near and far subject matter which creates those exceptionally strong impressions of depth.

However, here's a word of warning: in the hands of the inept, a wide-angle lens is a sure invitation to pictorial disaster. It requires a fine photographer to take best advantage of this potentially very effective tool. Therefore, if you consider a second interchangeable lens for your camera, unless you *specifically need* a wide-angle lens, buy a telephoto lens instead as it is, in my opinion (admittedly not shared by all photographers), a much more useful instrument than a wide-angle lens.

Light
Most photographers think of light in terms of brightness—it is the factor which determines their exposures. This is the "quantitative" approach to light—how much light? how bright?—which, with today's automated cameras, no longer presents a problem. Therefore, we can take correctness of exposure for granted. But despite its undeniable importance for the production of technically perfect photographs, a correct exposure in no way guarantees the creation of expressive pictures. In photography, technique is only a means

to an end—the implementation of the photographer's ideas. But if a photograph doesn't express the character of the subject or the intentions of the photographer, not even the most refined technique can make it good.

Now, at least in my opinion, light is the most important of the non-technical factors which decide whether a photograph will succeed or fail. Therefore, as far as attitude toward light is concerned, to progress beyond the snapshot level it is imperative that the photographer complement the quantitative approach with the "qualitative" approach—that is, by asking what *kind* of light?

The way I see it, light, in addition to enabling us to take photographs by making the subject visible, has three equally important functions, as far as our medium is concerned:

 it creates **the illusion of space and depth**
 it determines **the mood of the picture**
 it produces **designs of light and dark.**

The manifestations of light are so manifold that they offer a knowledgeable and sensitive photographer virtually unlimited opportunities for creating specific effects—precisely those effects which are needed to render a subject, a scene, or an event in its most telling form. Needless to say, the functions, qualities, and forms of light listed above can be used in a staggering number of different combinations. The following is a brief analysis of what these characteristics mean to you as a photographer and how you can exploit their potential.

Light creates an illusion of space and depth. Reality is three-dimensional, but a photograph has only two dimensions; the third—depth—is missing. Therefore, in photography, depth can only be expressed indirectly by means of symbols. The most powerful of all the various depth symbols is light.

If you place a sheet of white stationery on a flat surface and illuminate it uniformly, no matter what the brightness, color, direction, or contrast degree of the light, the paper will have the same tone all over. It will always look two-dimensional and flat. But if you crinkle this sheet of paper and make it "three-dimensional," no

matter how you light it, it will no longer appear in a uniform tone or flat, but broken up into a multitude of areas of light and shadow which, together, are irrefutable proof that the object has "depth."

Here is the whole secret of creating illusions of depth with the aid of light: highlight elevations and fill depressions with shadow. In other words: create contrast—contrast between light and dark.

Now, while this may be the basic principle underlying all illusions of depth created by means of light—the "technique" or the "How"—it is the way in which you apply this technique—the "WHY" and the "WHAT"—which decides whether your pictures will be effective or ineffective as far as conveying the right kind of depth illusion is concerned. This is the moment when the technician in you needs the assistance of the artist who, to a greater or lesser degree, lives in all of us. By telling the technician not only how to distribute light and shadow in such a way that a three-dimensional subject will seem to have "depth" in the picture (this is easy) but also by showing him how to use light and shadow as a means of emphasizing characteristic aspects of the subject (this requires feeling and sensitivity) the artist becomes the indispensable catalyst which transforms a snapshot into a picture.

For example, lighting a face or a statue so that it appears three-dimensional is easy; indeed, it is virtually impossible to illuminate them in such a way that they appear completely "flat" in the picture, although using a flash unit on or near the camera comes close to accomplishing this feat. But lighting them in such a way that characteristic features are emphasized in a convincing manner requires the perceptiveness and "eye" of an artist. Similarly, any kind or form of light will make, say, a building, appear three-dimensional. But to bring out the characteristic texture of its surface may require a very special form of raking sidelight, as another form of light might render the surface less distinct or textureless.

In a nutshell: before you release the shutter, make sure that light strikes your subject in such a way that its characteristic forms are emphasized, that its surface texture is brought out, and that subject and background are graphically separated so that they don't blend.

Light determines the mood of the picture. Most people are quite sensitive to the character of illumination—whether it is, say, glaring and harsh or muted and moody, contrasty or softly diffused, bright or dim, and so on. Everybody notices the difference in feeling induced by light between, say, a Gothic cathedral where colored light softly penetrates stained-glass windows, and a New England church flooded by sunlight streaming through clear glass panes. Similarly, there is a very different feeling between the same landscape experienced in early morning light and at noon; between daylight on a sunny, a hazy, and an overcast day; between the brutal illumination in a cafeteria and the intimate lighting arrangement in a bar. In short, each different type of light or form of lighting has its own specific quality and conveys a different mood toward which people react accordingly. Strange, then, how many photographers can be so insensitive in the course of their work—all they seem to care about is whether the light is bright enough for a hand-held exposure and, if not, whether their flash will go off. Only when they see their dismal pictures or slides does it occur to them that they must have done something wrong.

Where they went wrong was that they pursued the quantitative approach to light to the exclusion of the qualitative approach. They only asked themselves, "How bright? "while forgetting to supplement that question with, "What kind of light?" And if the light level was too low for their purpose, they banged away with flash or brought in photo lamps to flood their subjects with light, effectively killing whatever mood existed before they barged in. Needless to say, pictures taken under such conditions convey about as much feeling as a dime store "diamond."

In contrast, sensitive photographers are aware that light is one of their most effective means for expressing "feeling," and that to capture the essence of any subject they must pay attention to and, if necessary, preserve the character of, the specific quality of the available or auxiliary light. Frequently, it is the "mood" itself of a scene evoked by a special kind of light which moves them to make a picture, rather than the subject which, in such cases, merely is the vehicle necessary to carry the mood.

To a good photographer, mindlessly banging away with flash at the camera is as unthinkable as firing a gun in church. He realizes the high degree to which any emotional response to his pictures depends on the quality of the light. He knows when to use a harsh or a more or less diffused form of light and when to use a brighter or a more somber type of illumination. To him, daylight is not the same in the morning and at noon, on a sunny and an overcast day, in the form of frontlight, sidelight, or backlight. And if he works with artificial illumination, he knowledgeably distinguishes between light emitted by a spotlight, a photoflood lamp, or flash. In short, he will select the quality of the illumination in accordance with the character of the subject, his feeling toward it, and the mood he wishes to create—outdoors as well as indoors, whether he works with natural or artificial light. If he cannot have the kind of light he wants, rather than making an undistinguished picture, he will refrain from making the shot.

Light produces designs of light and dark. Regardless of its subject content, a black-and-white photograph can be seen as a design consisting of lighter and darker forms. Now it is a fact that light and dark tone values affect us differently—they evoke different feelings: white and light tones generally suggest and create gay and carefree moods, while black and dark shades are associated with more serious feelings. As photographers, we can utilize such associations in order to produce specific viewer reactions: basically, if we want to infuse a picture with a light or joyous mood, we must keep it light in color and overall tone; if a serious or dramatic effect is desired, we must use darker colors or tones. This, of course, is greatly assisted by appropriate distribution of light and shadow, either one of which can easily be made to dominate a picture, thereby giving it a lighter or darker appearance.

Another useful aspect of light and dark is their association with feelings of space and depth. Outdoors, especially on hazy days, distant objects appear lighter in tone than nearby ones, which appear darker. This phenomenon is called "aerial perspective." Lightness, therefore, becomes a symbol of distance, and darkness of close-

ness. Needless to say, such associations can be used to strengthen the depth illusion in a photograph—perhaps by shooting an outdoor photo through a blue filter to increase the haze effect, or by "framing" a light and airy view with dark foreground matter. In this way, a kind of "funnel effect" is created which leads the eye toward the center of the picture and on into the distance.

However, the lightness/distance, darkness/closeness order is reversed in photographs made with a flash unit near or on the camera. The flash shows nearby objects proportionally lighter than objects farther away because the brightness of the flash "falls off," or diminishes rapidly with increasing distance between object and flash. The result is often pictorial confusion, since our subconscious mind associates "light" with "background" and "darkness" with "foreground." This, plus the fact that the flash unit on or near the camera produces a virtually shadowless illumination which makes three-dimensional subjects appear unnaturally "flat" is why this type of light represents the least desirable form of illumination from a creative photographer's point of view. (Exceptions are flash as shadow fill-in and "bounce" light, which will be discussed more thoroughly in a subsequent chapter.)

p. 94

Other factors being equal, white or light areas in a photograph normally attract the eye more than darker ones. This fact deserves attention because it has several pictorial consequences. For example, by distributing light and dark areas in the picture accordingly, a photographer can direct the viewer's attention toward high interest areas or, conversely, prevent the eye from straying to less important picture areas by keeping them darker. In this way, a portrait, for example, can be made to appear light and its surroundings or background dark. The opposite effect—face dark and background light—can be achieved by photographing a head in backlight illumination against the sky; this would create a totally different and, pictorially speaking, opposite effect.

Another consequence of the emotional aggressiveness of white is the fact that small white areas along the edges of a photograph can have a rather disturbing effect by drawing the viewer's eyes away from central parts of the scene.

In addition, light has five qualities which, if we know how to select and control them, enable us to create specific predetermined effects:

brightness
color
direction
contrast
the ability to cast shadows.

Brightness. As far as photographers are concerned, this quality of light has two consequences:

it influences **the mood of the picture**
it determines **the exposure.**

Other factors being equal, a bright illumination creates a more joyous, matter-of-fact, or positive mood than dim or diffused lighting, and is normally preferable in cases where "facts" are more important than "feelings."

Also, bright light has a definite advantage over dim or diffused light in that it is more conducive to natural-looking color rendition.

Basically, the brighter the light, the shorter the film exposure; and the dimmer the light, the longer the exposure. For consistently good results, the exposure should normally be determined with the aid of a photo-electric light meter. Such meters are either built into the camera where they perform more or less automatically, depending on the design of the respective model, or come in the form of hand-held instruments belonging to one of two types: meters for measuring *reflected* light, and meters for measuring *incident* light (although nowadays most light meters can quickly be converted from one type to the other with the aid of a small accessory).

Meters for measuring reflected light measure the brightness of light reflected by the subject. All exposure meters built into cameras are of this type. For use, they are pointed at the subject from the camera position. Compared to incident light meters, they have

the valuable advantage of enabling a photographer to take separate brightness readings of the lightest and darkest parts of the subject, thereby establishing its contrast range.

Meters for measuring incident light integrate the light that falls upon the subject from all sides and measure it directly. Such meters are pointed at the camera from the subject position or, if the subject is far away, from its direction. They are particularly useful where the illumination consists of two or more light sources (as may be the case indoors or in the studio) but don't permit the photographer to establish the contrast range of the subject by taking individual readings of areas of different brightness—for example, brightness readings taken in front of a white blouse and black skirt of a model would be identical.

Which meter is best for you? If you use the exposure meter built into your camera you have, of course, no choice. However, many photographers like to check the exposure data determined with their built-in reflected light meter against data established with the aid of an incident light meter, as the latter is more "foolproof" in that it is almost impossible to arrive at faulty data due to incorrect use. Not so with a reflected light meter which can be misleading if used to measure objects of more or less than average brightness. In landscape photography, for example, a reflected light meter will yield inflated data that lead to underexposure if pointed too high off the ground because, in that case, an excessive amount of bright skylight is admitted to the light-sensitive cell and adversely influences the reading. Conversely, if the subject is abnormally dark all over or the light is very dim, readings established with a reflected light meter can lead to overexposed negatives or slides because this type of meter "thinks average," that is, "assumes" that the subject in front of its light-sensitive cell is of "average" brightness. If this is not the case, the photographer must make appropriate corrections: if the subject is abnormally bright all over (snow scenes, pictures taken on a sandy beach, or on a bright but hazy day), exposures as indicated by a reflected light meter (even one built into the camera!) must be increased by one-half to one-and-a-half f-stops if underexposure is to be avoided. Conversely, if

the subject is abnormally dark all over, exposures must be shortened by one-half to one full *f*-stop to avoid overexposure.

Such problems can be circumvented if the brightness reading is not taken directly by pointing the meter at the subject itself, but indirectly with the aid of an 18-percent gray test card. The one made by Kodak is an 8 x 10-inch piece of cardboard that is gray on one side and white on the other. The gray side reflects approximately 18 percent of the incident light and represents a "subject of average brightness," while the white side reflects approximately 90 percent. By holding this card immediately in front of the subject, with its gray side facing the camera, and measuring its brightness with a reflected light meter (either a hand-held instrument or the one built into your camera), you can arrive at data that are directly applicable and correct, no matter how bright or dark the subject or how bright or dim the light. If the illumination level is so low that you cannot get a reading from the gray side, turn the card around so that the white side faces the camera, then measure its brightness. In that case, however, you must multiply the resulting exposure by a factor of five to be certain of correctly exposed negatives or slides.

Two other types of light meter are available to photographers requiring more sophisticated equipment: a special type of reflected light meter (called a "spot meter") which, depending on the model, has an angle of acceptance of only one to three degrees, making it possible to take individual brightness readings of the light reflected by very small subject areas regardless of their distance from the camera; and a second type called a "flash meter," which establishes the correct *f*-stop for electronic flash (speedlight) exposures. These types do have drawbacks: spot meters require a fairly high degree of experience to correctly evaluate the data, and flash meters are very expensive.

Bracketing. Photography is not a "science" because it doesn't obey specific "laws." Therefore, it should come as no surprise to hear that it is sometimes impossible to unequivocally establish exposure data which are "correct." There are several reasons for this: shutter speeds are not always precisely what they are supposed to

be; exposure meters vary slightly in their readings; brightness measurements are not always taken correctly; film speeds may vary somewhat due to unavoidable manufacturing tolerances; development procedures may vary, resulting in variations in effective (as opposed to "listed") film speeds; what one photographer calls "a subject of average brightness" may be "abnormally bright" or "abnormally dim" in the opinion of another; some photographers prefer their negatives more fully exposed or their slides more saturated in color than others. And so on.

To make sure that they get correctly exposed negatives or slides despite such unavoidable uncertainties, experienced photographers therefore "bracket" their exposures whenever circumstances permit. Instead of only one, they take several shots of the same subject or setup using slightly different *f*-stops or, if time exposures requiring more than one second are involved, different shutter speeds.

The basis for each "bracket" is an exposure established with the aid of a light meter. In addition to this supposedly "correctly exposed" shot, two, three, or more exposures are then made with slightly larger as well as smaller diaphragm stops. (With automatic cameras, use the manual override or plus-and-minus settings when bracketing.) If black-and-white or negative color film is used, the difference between exposures should be one full *f*-stop; if reversal or positive color film is used, one-half *f*-stop. Smaller exposure variations are a waste of film; larger ones may result in missing the best exposure. In most cases, a total of three different exposures should be sufficient—one "normal" (according to the light meter), one at a smaller *f*-stop (or one slightly shorter), and one at a larger *f*-stop (or slightly longer). But if shooting conditions are no longer average, the "bracket" may have to be extended in order to include the one "perfect" exposure. This is particularly advisable if subject contrast is abnormally high, or the light abnormally bright or dim. Note, however, that when you work with positive color film, if more than three shots seem advisable, the number of shorter-than-normal exposures should exceed the number of longer-than-normal exposures since an underexposed transparency is still preferable to an overexposed one whose color is too "washed out" to be

usable. Working with negative color film or in black-and-white, the opposite is true: the number of longer-than-normal exposures should exceed the number of shorter-than-normal ones since, in this case, it is the underexposed negatives which are useless. And if you believe that "bracketing" is "amateurish," or a sign of insecurity on the part of the photographer, think again. Whenever possible, almost all experienced photographers bracket their exposures because they know the hazards involved and realize that the cost of a few frames of film is nothing in comparison to a botched opportunity for making a fine picture. If you feel you have to conserve film, be more discriminating in what you photograph; but don't spoil your chances for success by curtailing your "bracket."

Color. If you work in black-and-white, the color of the incident light is normally of no interest to you; to the color photographer, however, it can make the difference between success and failure. Why? Because all positive color (reversal) films will yield natural-appearing color renditions only if used in the type of light they are intended for or, as the experts say, for which they are "balanced." *p. 107-108* Otherwise, the transparency will have a more or less pronounced "color cast"—an overall tone in the color of the incident light. In this respect, you must distinguish between the following types and colors of light:

> white light: natural daylight, electronic flash
> yellow light: photoflood lamps, professional tungsten lamps, household bulbs, early morning or late afternoon light
> blue light: open shade, at dusk, on heavily overcast days
> red light: shortly before and after sunset
> mixed daylight and artificial light
> fluorescent light.

White light. The only type of daylight considered "white" by the color photographer and therefore suited for use in conjunction with daylight color films without the need for filtration is

standard daylight—a combination of direct sunlight and light reflected from a clear blue sky with a few white clouds when the sun is more than 20 degrees above the horizon.

Virtually the same "white" light is also encountered on misty and foggy days, during a snowfall, or in rain, and on days when the sky is covered by a high, thin haze. All other variations of daylight, however, are more or less colored toward yellow, red, or blue and photographs made under such conditions on daylight color film must be expected to have a more or less pronounced overall tone in the respective color unless an appropriate correction filter is used. "White" light is also emitted by electronic flash tubes (speedlights, "strobes"), and photographs taken with this kind of light usually show excellent color rendition.

Yellow light is emitted by all incandescent lamps, although to different degrees ranging from pale yellow to orange. When working in color, you must distinguish between photoflood lamps, professional tungsten lamps, and ordinary household bulbs.

pp. 107-108

Photoflood lamps with a color temperature of 3400 K (the rather complex meaning of "K" is unimportant at this time—if you are interested, look up "Kelvin" in a good encyclopedia) must be used in conjunction with Type A color film, as it is specifically balanced to give natural-appearing color rendition in this kind of light.

pp. 107-108

Professional tungsten lamps with a color temperature of 3200 K must be used in conjunction with tungsten (Type B) color film, which is specifically balanced to give natural-appearing color rendition when using these lamps.

pp. 199-201

Ordinary all-purpose or "household" lightbulbs with color temperatures around 2800 K used with either Type A or tungsten (Type B) color film yield transparencies with a more or less pronounced yellow color cast which, however, can be avoided by appropriate filtration.

Outdoors, early morning or late afternoon sunlight is always more or less yellow, and unfiltered color photographs taken under such conditions with daylight color film will have a corresponding yellow tone overall. Unlike many other forms of color casts, however, this one is usually not objectionable but, on the contrary, tends to give such pictures a rather attractive warm, sunny tone. If desired, this yellow cast can be avoided by using the appropriate light-balancing filter (Wratten No. 82 in the correct density).

Blue light. Outdoors, on a sunny day, light in the open shade is always blue since it is reflected skylight. Consequently, color photographs taken under such conditions always have a more or less pronounced bluish color cast.

A blue or purplish cast can also be expected in color photographs taken on heavily overcast days and at dusk.

Red light is frequently encountered shortly before and after sunset.

Mixed daylight and artificial-light illumination is a blend of two or more colors and presents a problem insofar as no color film exists which is capable of handling this form of light satisfactorily, and filtration doesn't do much good. In such cases as night photography in a city or when taking indoor pictures illuminated partly by daylight streaming through windows and partly by photo lamps used as shadow fill-in lights, the photographer only has the choice between daylight color film on the one hand, and Type A or tung- *pp. 107-108* sten (Type B) color film on the other. Daylight film gives "warmer" renditions with overtones of yellow and red, while Type A and Type B yield transparencies with cold, bluish overtones.

Fluorescent light. Although an excellent form of light for black-and-white photography, fluorescent light is basically unsuited to color photography because of its unusual spectral composition (a pronounced deficiency in red), and because fluorescent tubes are made in a variety of different colors, each of which would require its own special combination of correction filters to assure at least reasonably natural-appearing colors. Since color photographs taken in unfiltered fluorescent light usually have an unpleasant muddy-greenish color cast, and since satisfactory filtration is always difficult and often impossible, I suggest you avoid taking color photographs by fluorescent light.

Direction. While the most important quality of light to the color photographer is color, to the black-and-white photographer it is direction. Why? Because it is the direction from which light strikes the subject that determines the presence or absence, location, form, and extent of the shadows in a picture.

In color photography, shadows are basically undesirable because they may increase the contrast range of a scene beyond the capability of the film and thereby cause unnatural-appearing colors. On the other hand, in black-and-white photography, shadows are the most effective means for creating illusions of three-dimensionality and depth. Furthermore, they are indispensable for the characterization of surface texture and essential for the creation of graphic contrast which here takes the place of color. I cannot impress upon you strongly enough the importance of analyzing the incident light in regard to its direction as well as its strength, and the location and extent of the shadows it casts. Learn to distinguish between the following forms of light:

> frontlight
> sidelight
> backlight
> toplight
> light from below
> multi-directional light.

Frontlight. The light source is more or less behind the photographer as he faces the subject. Frontlight typically casts fewer shadows than light from any other direction. As a result, it is the least contrasty form of illumination and tends to make the subject look flat—as if it had no depth. While occasionally a paucity of shadows may be desirable, as in cases where they would interfere with the subject's structure or design and thereby make the picture confusing, it normally is an undesirable quality in black-and-white photography but a desirable one in color work, where it facilitates accurate color rendition.

Sidelight. The light source is more or less to the right or left of the subject and illuminates it from only one side. Sidelight produces an average amount of generally well-positioned shadows, creates convincing illusions of depth and effectively emphasizes surface texture. It is never really "wrong" and is, therefore, the most popular form of light. Such popularity, however, makes it a not very "original" type of light and unlikely to produce very exciting effects. Exceptions, of course, are possible; for example, light very

early or late in the day when a low-riding sun casts enormously elongated shadows is a potentially extremely effective form of light.

Backlight. Backlight is the form of light which occurs when the light source is more or less behind the subject, facing the photographer. As a result, the light appears to "flow around" the subject toward the camera, sometimes outlining it with luminous edges while always leaving the side facing the photographer more or less in its own shade.

Backlight is the most contrasty type of illumination. Potentially, it also is the most beautiful and exciting. Graphically it can be enormously effective, but it is always difficult to handle successfully because of the high contrast it generates, which often exceeds the contrast range of film—even black-and-white. Furthermore, direct light striking the lens may cause halation and flare effects in the negative or slide. On the other hand, skillfully utilized by an imaginative photographer, these effects, which normally are rightfully considered faults, can enhance a picture to the point of greatness.

If lens flare and halation are to be avoided, all direct light must be prevented from reaching the lens, no matter how "multicoated" (treated with a chemical anti-reflection deposit) the lens may be. This can be done with the aid of a sufficiently long lens shade (most ordinary lens shades are too short to be really effective), or by interposing special or improvised "shields" between the light source and the lens.

The key to successful backlight photographs is to expose for the lightest subject areas (to prevent detail and color from being "burned out" or "washed out") and let the darkest areas go black. If shadow fill-in illumination is desired, use it sparingly; heavy-handedness could be disastrous because backlight and frontlight (from fill-in illumination) neutralize one another and combine to produce flat and insipid pictures.

Toplight. Toplight is "overhead light" which strikes the subject more or less from above, a usually harsh and unphotogenic form of

illumination. This is the typical midday light in summer, beloved by amateurs—because it is "so nice and bright"—but shunned by experts because it casts harsh and unphotogenic shadows while insufficiently illuminating vertical surfaces. In portraiture, toplight is the worst possible kind of light because it leaves the eyes in deepest shade while casting a long and ugly nose shadow. In my opinion, toplight has no redeeming qualities and should be avoided.

Light from below. Light from below the plane of the subject is a form of illumination normally not found in nature (exceptions: campfire light and sun glare on water). It always creates "unnatural" or artificial, theatrical, weird, often outright grotesque, and usually unpleasant, impressions. It is easily produced with the aid of photo lamps and particularly beloved by beginners because it is "different." Unless you know precisely what you are doing and need its specific effects, my advice is to avoid light from below.

Multi-directional light. This is an illumination employing several light sources simultaneously and it always means artificial light. I have already discussed its characteristics and pitfalls, in the section in Chapter I on Unphotogenic Lighting Techniques.

p. 38-39

Contrast

As photographers, we must distinguish between more or less "contrasty" forms of light. The difference is this: contrasty (or "high contrast") light is harsh and casts sharply defined, deep black shadows; contrastless (or low contrast) light is diffused, casts shadows with softer, more indistinct outlines that are grayish rather than black. Each form of light, as well as any form between these extremes, has its uses, creates a different kind of mood, and may be needed to achieve specific effects.

Contrast has nothing to do with brightness—bright light can be diffused, dim light can be contrasty—because the factor that normally determines whether an illumination is high or low in contrast is the *effective* diameter of the light-source: the smaller its effective diameter, the more contrasty the light; the larger, the more diffused (lower in contrast).

Note that I specifically said "effective" diameter, not "actual." The difference is this: sunlight on a clear and cloudless day, for example, is harsh and contrasty, even though its source, the sun, is "actually" enormous; but, because this light source is some 93 million miles away, its "effective" diameter is very small, which, for practical photographic purposes, makes the sun a small-diameter light source, and therefore, a high-contrast illuminator.

In artificial light photography, regular photoflood lamps in reflectors are light sources with medium diameters, producing light that is neither particularly contrasty nor diffused. To make such a lamp yield light of lower contrast, its effective diameter must be increased. This can be done in two ways: (1) by using the bulb in a larger reflector, or (2) with the aid of a diffusion screen. To have the desired effect, however, this screen must enlarge the effective diameter of the light source which, in this case, is not the lightbulb, but the reflector. In other words, merely placing a diffusion screen in the size of the reflector in front of the lamp accomplishes nothing except reduction of its brightness; the degree of contrast remains virtually the same. What is needed is a diffusion screen substantially *larger* in diameter than the reflector, placed well in front of the reflector in such a way that it is fully illuminated by the bulb. A photo lamp so equipped would yield light that is considerably less contrasty (more diffused and softer) than that emitted by the unscreened lamp.

On the other hand, illumination contrast can be *increased* by combining an incandescent bulb and a light-gathering lens-mirror system. Such an illuminator is called a spotlight. Spotlights come in many different sizes from 150 watts to 5,000 watts and, despite their relatively *large* effective diameters, produce a harsh and contrasty light.

If the shadows cast by a spotlight appear too black and obscure desirable subject detail, they can be made lighter and more transparent to any desired degree with the aid of a second, well-diffused photo lamp called a *"fill-in light."* In this way, a photographer can "have his cake and eat it too": a sharply defined shadow (typical of contrasty light) which nevertheless is not too black but pleasantly detailed (typical of diffused light).

Arranged in descending order from most contrasty at the top to most diffused at the bottom, here is a list of commonly used photo illuminators:

zirconium-arc lamps
end-on ribbon filament lamps
the sun on a clear, bright day
spotlights
small flashbulbs
speedlights (electronic flash)
photoflood lamp without reflector
photoflood lamp in small reflector
photoflood lamp in large reflector
photoflood lamp in large reflector with a still larger, spun-glass diffuser 6 to 10 inches in front of the reflector
banks of nine or more photoflood lamps, or three or more fluorescent tubes, mounted together on a frame
daylight from an evenly overcast sky or in the open shade
bounce light (a photo lamp or a speedlight directed against a wall, ceiling, or a reflective umbrella, illuminating the subject with light "bounced off" the reflecting surface)
light inside a light tent (an enclosure, the walls of which consist of translucent material evenly illuminated from the outside with a number of photo lamps directed toward the center of the "tent," inside of which the subject is placed, surrounded on all sides by totally diffused, completely shadowless light)

Contrasty light is harsh and brilliant, sharp, matter-of-fact; it is best suited to fact-oriented, documentary, and scientific photography. Diffused light is soft, even, gentle, soothing, and romantic; it is best suited in cases in which mood is more important than fact. Between these extremes lies the realm of light of more or less average contrast which is best suited to the average kind of photography. Making these distinctions may seem a matter of small concern to most photographers, and perhaps it is. But for those ambitious men and women who strive for the top and are satisfied with nothing but the best, the sensitive ones who can see and appreciate the difference, light contrast is an additional device in the arsenal of

tools which enables them to realize their visions with more precision.

Shadow

From the creative photographer's point of view, as far as the effect of the picture is concerned, shadow is just as important as light. Unfortunately, many photographers make the mistake of seeing the relationship between light and shadow as analogous to that between subject and background, with shadow and background in both cases playing subordinate roles. This erroneous attitude can have undesirable consequences: a "bad" shadow (most obvious in portraiture) can spoil the effect of an othewise excellent picture just as thoroughly as a "bad" background.

As far as the effect on the picture is concerned, shadow, like light, has three important functions:

it is the most effective means for creating **illusions of depth**
it is graphically important because of its **darkness**
it can, in the form of cast shadows, play the role of an **independent picture element.**

Shadow creates illusions of depth. A shadow—any kind of shadow—is graphic evidence of "depth"; this is the How of photography. But unless justified by the WHY and WHEN, the mere fact that a photograph contains shadows and thereby proves that the subject is three-dimensional does not necessarily make it an effective picture. To prove this to your own satisfaction, I suggest that you perform the following experiment:

Get yourself a model and shoot a portrait; nothing fancy, just an ordinary frontal pose against a white or light-colored wall. Mount your camera on a tripod to insure that all the pictures you are going to take are identical (for fair comparison) except for the position and extend of the shadows. Then go to work with a single photo lamp mounted on a lightstand. Move this lamp in small steps all around your subject, from one side to the front and on to the other side, first with the lamp at the level of your model's head, then somewhat higher, then higher still until it becomes toplight; then lower the lamp below the level of the model's face. In addition,

take a similar series of shots with the lamp in different positions more or less behind your subject to study the effects of backlight. Don't worry that the illumination will be harsh and the shadows too black to show much detail because this is exactly what I want you to see: black, uncompromising shadows which clearly show you the effect of specific lamp positions on the rendition of your model's face. Remember, these are only test shots to learn from, not "finished" pictures. Later, when you know more about the art of portrait lighting, it is the easiest thing in the world to make the shadows more transparent. All you have to do is place a second photo lamp as close to the subject-camera axis as possible and ever so slightly higher than the level of the lens, and use it to "fill in the shadows" with auxiliary illumination. Right now, your task is to expose an entire role of thirty-six pictures with thirty-six different "main light" positions in a completely mechanical, uncritical way.

The critique part comes when you place your developed slides side by side on a viewer or your black-and-white proof prints side by side on your desk, and study their effects. As I cautioned earlier, pay particular attention to the positions and extent of the shadow cast by the nose (which looks terrible if it comes too close to the lips, and worse if it crosses them); the shadows around the eyes (which, if too deep, can completely obscure the eyes); the shadow beneath the chin; and the shadow of the model on the background. If the latter is ruining the picture because it appears as an area of darkness which contributes nothing and only blends with the head, remember the next time to increase the distance between model and background until the shadow falls short of the wall. If this is impossible, use a separate "background lamp" to "burn out" the offensive shadow. But the lamp must be placed low enough to be hidden as seen from the camera position by the model's body.

Properly executed and evaluated, an experiment like this ought to convince you that, as far as the effect of the picture is concerned, shadows are often more consequential than light. A second experiment should confirm this. This time, I want you to study "texture lighting," that is, learn how to place your lamp to achieve the most effective rendition of surface texture. In this case, your test object can be any kind of material that possesses a distinctive surface tex-

ture and is flat—a piece of uniformly colored carpeting, a door mat, rough-textured fabric, a brick, a slice of bread. You will find that a low-raking, high-contrast, semi-backlight illumination in conjunction with a weak and diffused frontal shadow fill-in lamp normally gives the best results. But I'll leave precisely how these lamps should be placed for you to find out.

A series of six to eight shots should be enough. Later, when you are ready to make "finished" pictures, you will remember these lessons and pay proper attention to shadows.

Shadow is pictorially important because of its "weight." Graphically speaking, darkness carries more "weight" than light— extensive shadows areas make a picture "heavy," powerful, somber. In its various manifestations, shadow, therefore, is an effective symbol for indicating specific moods.

Black is the darkest tone in any photograph. As such, it is a catalyst which can enhance other picture elements merely by its presence. White, for example, never seems brighter than when adjacent to black—and a deep shadow can provide the necessary "blackness." And in color photography, the brightness of any color is automatically raised to its highest potential by juxtaposition with black.

These are facts well known to artists, and open-minded photographers willing to learn should likewise realize that, contrary to traditional concepts, detailless shadows of solid black are not necessarily "mistakes" but, creatively used in the appropriate places, they can become powerful means of graphic expression.

Shadow can become the subject of the picture. A photograph I shall never forget is a low-level aerial shot by Margaret Bourke-White taken over Germany during World War II. It showed rows of bombed and burned-out houses photographed from directly above in such a way that the thin, still standing walls seen on edge were all but invisible. What "made" the picture were the shadows of these shattered, empty-windowed walls cast by the low-riding late afternoon sun. By forming endless patterns of hollow squares, they evoked the feeling of a terrifying "city of shadows" which in

an unforgettable manner summed up and symbolized the monstrous brutality of war.

p. 47

In this case the tangible subject of the picture, shadow, was masterfully used to express an "intangible"—the concept of war.

Although shadows expressive enough to serve as the subject proper of a picture are rare, it pays to be aware of this possibility because the photographer may be rewarded with a significant image.

The only kind of shadow which, unless specifically wanted, should never appear in the picture is that of the photographer himself—an amateurish mistake which sometimes occurs when taking pictures in frontlight.

The forms of light

As a photographer, I have found it advantageous to distinguish between three often confused forms of light: radiant, direct, and reflected. Since this is not a scientifically justifiable breakdown, I shall explain. Scientifically speaking what we call "visible light" is sunlight or artificial light reflected by the layer of molecules that form the surface of objects. Light as such is invisible—we can only see its effects. The proof is that if you projected your slides in a totally dark room with perfectly clean air, free from particles of dust and smoke, all you would see would be (1) the filament of the projection lamp heated to incandescence by electricity which, in this state, emits light, and (2) the light reflected from the screen, the image. But the actual beam of "direct light" itself between projector and screen would be invisible.

We see *radiant light* when we look directly into a light source. The resulting sensation is one of radiance, that is, extreme luminosity.

We see the effect of *direct light* when we look at objects of our surroundings, most of which owe their visibility to this form of light.

We see *reflected light* when we "fill-in" (that is, lighten) shadows in a portrait or close-up with the aid of "indirect light" by means of a reflecting panel.

At the beginning of this chapter I emphasized the importance of the "qualitative approach" to light. Here is a list of thirteen different forms of light. *pp. 71-72*

 radiant light
 direct light
 reflected light
 diffused light
 shadowless light
 filtered light
 polarized light
 natural light
 artificial light
 continuous light
 discontinuous light
 point-source light
 area-source light

Radiant light. The outstanding characteristic of radiant light is its *radiance,* or its "blinding" quality. In other words, we "see stars" and experience other sensations because of the extreme luminosity of the light. But if we were to photograph a light source—radiant light!—all we would get in the picture would be a blob of white, precisely the same white we would get if we were to photograph a white object giving off reflected light. In other words, radiant and reflected light would be graphically expressed in identical form—as white—notwithstanding the fact that we experience one as potentially blinding light and the other as harmless white, a "color." Radiance, therefore, is one of those qualities which cannot be rendered directly in a photograph but must be indicated in symbolic form. *p. 189*

Direct light. This is the most common type of light. It is more or less directional light, of average or high contrast, which strikes the subject directly without first having been modified by a diffuser, a reflecting surface, or a filter. It has qualities like brightness, color, and contrast, and manifests itself as frontlight, sidelight, backlight, and so on.

Reflected light. As photographers, we must distinguish between three forms of reflected light:

reflected by objects
reflected by a ceiling, umbrella, or reflecting panel
light we perceive as reflections and glare.

Light *reflected by objects* is the form of light listed above as "direct light" which is a misnomer but serves as a practical concept from the photographic point of view.

The second form of reflected light is light which we use for general illumination in the form of *indirect light*, such as: electronic flash directed against the ceiling ("bounce light"), light reflected from the aluminized inside of a photo umbrella, and light reflected from a large variety of matte or shiny reflecting panels serving as auxiliary illumination ("shadow fill-in") to make excessively deep shadows more transparent.

Light reflected from *matte* surfaces is always more diffused, and less bright, than the light emitted by the primary source. (Light reflected from a *shiny* surface, such as a mirror, is virtually as direct and bright as the primary source.) Therefore, diffused-reflected light is useful in cases where a diffused form of light is required to create a specific mood or achieve a specific effect, for example, when you want to lighten deep shadows (cast by the main light) without incurring the danger of secondary shadows (cast by the fill-in light) or "killing' through overlighting the light-and-shadow distribution created by the main light. A large white Bristol board or a thin plywood panel painted white or covered with finely crinkled aluminum foil reflecting light emitted by the primary source of illumination (the sun or a photo lamp) into the shadow areas to make them more transparent is most commonly used for this purpose.

Reflected light is direct light, the spectral composition of which may have been altered by the reflecting surface. This fact can have photographically important consequences.

For example in color photography, light reflected from a colored surface can have the unwelcome effect of giving the transparency

or slide a *color cast.* This possibility must be considered by photographers who work with bounce light. If the ceiling is not pure white, the picture is bound to have an overall tint in the color of the ceiling. And any object adjacent to a strongly colored surface is bound to pick up some of this color through light reflected by it.

p. 88

The third form of reflected light is light which we perceive in the form of *mirror images, reflections* in shiny surfaces, and ordinary *glare.* Note, however, that light reflected by any shiny, non-metallic surface in the form of a mirror image (reflection) or glare is more or less *polarized*, the degree of polarization depending on the angle of the incident light relative to the reflecting surface. The photographic consequences of this phenomenon will be discussed later.

p. 98, 193

Diffused light. In the case of diffused light, it is important to distinguish between three types:

> direct light which has passed through a diffusing medium
> direct light which has been reflected by a nonspecular (matte), usually white, surface
> light emitted by an area-type light source

Examples of direct light passed through a diffusing medium are light emitted by a photo lamp equipped with a spun glass or other suitable diffuser, and sunlight on a hazy or completely overcast day. Examples of direct light reflected by a matte and usually white surface are bounce light and light from a photo umbrella (electronic flash directed against the aluminized inside of a photo umbrella which in turn reflects light onto the subject). A typical example of light emitted by an area-type light source is outdoor light on an evenly overcast day, and light from banks of fluorescent tubes.

In contrast to direct light, which is more or less directional, diffused light is always scattered, and therefore has low contrast and casts only weak and softly defined shadows. It is primarily used for lightening the shadows in portraiture, fashion photography, and commercial product photography. Photographers working in color, however, must be sure that diffusers and reflecting surfaces

are neutral in tone. Otherwise transparencies or slides would acquire the color cast in the color of the respective diffuser or reflecting screen.

Shadowless light is light which evenly and more or less completely envelopes the subject from all sides, or at least the areas that are visible from the camera position. Completely shadow-free illumination is found inside a light tent. Since light tents are not available commercially, photographers must construct their own from translucent material like tracing paper or white polyethylene sheeting over wooden frames. Sizes vary from approximately one cubic foot for small objects like jewelry, to structures that occupy a large part of the studio floor and are big enough to accommodate live models. Access for the lens is provided by cutting a horseshoe-shaped flap into the side facing the camera.

p. 88

Cast shadows from small objects can be avoided by placing them on a lightbox, light table, or slide viewer, and illuminating them with one or several photo lamps.

Shadowless light is rarely used and difficult to handle successfully. But for a certain kind of subject (one inherently contrasty with a wealth of fine detail or consisting of subtly rounded forms), it is capable of producing outstanding results that captivate the viewer with the delicate modulation of color and tone of shadowless light.

Filtered light. The spectral composition of light emitted by the usual photographic light sources (the sun, photo lamps, electronic flash) is constant. This, however, is no guarantee that the composition of the light which illuminates the subject is necessarily the same as that of the light source because in the process of transmission it may have been altered by filtration while passing through a filtering medium like a photographic color filter, the greenish lens of a spotlight, a layer of clouds, tinted window glass, or the tracing paper or polyethylene sheeting that constitutes the walls of a light tent.

The fact that light passing through a filtering medium loses some of its spectral components affects photographers who work in color

as well as those who work in black-and-white, although in different ways. Learn to distinguish between two possibilities:

light altered by influences beyond the photographer's control
filtration deliberately used to get a better picture.

One example of filtration beyond the photographer's control is sunlight that is no longer direct (as on a cloudless day) but modified by passage through layers of clouds, smoke, or accumulations of airborne particles of dust, as is the case early and late in the day when the sun is low in the sky. Such light no longer conforms to the specifications set for standard daylight—the type of light for which *p. 81* daylight color film is balanced. As a result, color pictures taken under those conditions are bound to have a more or less pronounced color cast (blue-purple, yellow, or red, as the case may be) unless the photographer brings the light back to "standard" with the aid of an appropriate color-balancing filter. *p. 199*

Another frequently encountered, undesirable filtering agent over which a photographer has no control is window glass. Ordinary window glass is greenish, most noticeable when the pane is thick or double. Also, windows in many modern office buildings and airplanes consist of heat- and glare-absorbing tinted glass. Shooting color pictures on daylight color film through such windows or shooting color pictures inside enclosures equipped with tinted glass invariably results in transparencies or slides which are more or less tinted in the color of the glass—unless you neutralized the tint by using an appropriate filter.

The effects of filtration can be harmful as well as beneficial. Uncontrolled, they can result in disappointing pictures. But they can be beneficial when consciously and creatively used to improve the effect of your pictures. The means for doing this are color filters, which will be explained in more detail later when we discuss the *p. 199, 205* means of photographic control. What I want you to realize at this point is that light can be controlled, that unexpected and uncontrolled light filtration can adversely affect the outcome of your pictures, and that deliberate filtration is an important means of creative control.

p. 95
Polarized light. As I mentioned before, light reflected from shiny, non-metallic surfaces in the form of reflections and glare is more or less "polarized" (vibrating in only a single plane). If such reflections or glare are undesirable in the picture, they can be toned down and, under certain conditions, even eliminated com-
p. 193
pletely with the aid of a polarizing filter ("polarizer").

Natural light differs from artificial light in the following important respects:

it is highly variable in brightness, contrast and color (spectral composition)
only a single light source exists—the sun
only a single set of shadows is cast
natural light generally strikes from above.

Since natural light varies in brightness, contrast, and spectral composition, it is relatively unpredictable. Photographers must pay attention to possible changes in these qualities when working with natural light.

Since only one light source exists for natural light—the sun—there is never more than a single set of shadows, the components all parallel and pointing in the same direction. Natural light (with the exception of sunlight reflected from water) always strikes from above, never below.

A subject photographed by natural light always look "natural." However, if that same subject is photographed by artificial light, it might make a surprisingly "unnatural" impression.

Artificial light differs from natural light in the following respects:

artificial illumination is constant
multiple light sources may be used
multiple shadows are possible
an infinite number of types of illumination can be created.

Unlike natural light, the brightness, contrast and color of artificial light sources are constant and, hence, predictable. This is a special

boon to those working in color, as they can forget about filtration—
provided they use the right kind of light with the right kind of film. *p. 107*

Any number of individual artificial light sources can be employed simultaneously to illuminate a subject or scene. In the hands of an experienced photographer, the opportunity to use a number of light sources is a potential advantage; in the hands of a neophyte, it is an invitation to pictorial disaster.

Working with artificial light involves the problems of multiple sets of shadows cast by several lamps pointing in different directions, shadows crisscrossing, and secondary shadows within primary shadows.

These are effects which make an ugly, amateurish impression. A good artificial illumination set-up creates the impression that only a single light source was used, no matter how many lamps were actually involved.

Since photo lamps are movable, any kind of illumination, including light from below, can easily be arranged. In contrast to the inherent simplicity of natural light, the virtually unlimited number of options available to any photographer, whether equipped to handle them successfully or not, makes working with artificial light a relatively difficult affair.

Later on, in the chapter on photographic control, I'll tell you more *pp. 177-178*
specifically how to work with artificial light.

Continuous light, like daylight or the light of photoflood lamps, has a great advantage over discontinuous light (flash) in that it enables you to see precisely where the light hits and where the shadows fall. Furthermore, you can easily establish the degree of brightness of the illumination with the aid of ordinary light meters and determine, if necessary, the contrast range of the subject by taking close-up brightness readings of its lightest and darkest parts. You can see and therefore control or eliminate undesirable reflections (like, for example, the reflection of a photo lamp in a window pane or in a picture under glass hanging on a wall) when taking indoor photographs. You can avoid overlighting certain areas as well as underlighting other areas. Finally, photo lamps complete

with reflector and stand are usually less expensive than speedlights or "flash."

The disadvantages of working with continuous light are that photo lamps get very hot, consume large quantities of electric power, yet are normally not bright enough to enable you to make instantaneous exposures with shutter speeds high enough to "freeze" a moving subect. Furthermore, unlike battery-powered speedlights, they are tied to an electric outlet and their mobility and placement are limited by the length of the cord.

Discontinuous light from electronic flash or ordinary flashbulbs has the following advantages over continuous light: the light source, at least as far as amateur flash units are concerned, is small, lightweight, portable, and ready for use anywhere since it carries its own power supply in the form of batteries. Furthermore, many modern speedlights are fully automatic in use, thereby eliminating the need for time-consuming and often inaccurate exposure calculations on the basis of guide numbers; their light is cold, delightfully "soft" and easy on the eyes of models; and they deliver a wallop of light short and bright enough to "freeze" the fastest moving subjects.

The disadvantages of amateur speedlights are that you can never be quite sure where the light will hit your subject and where the shadows will fall (larger professional units have built-in modeling lights); that the most popular way of using speedlights is mounted on top of the camera where they deliver pure frontlight with all its undesirable effects (professional units can also be used off-camera and fired with the aid of "slaves"); and that they don't permit you to take spot readings with a light meter with the purpose of balancing the light in an effort to avoid overlighting some areas while inadvertently letting others go too dark. Furthermore, in comparison to photo lamps, speedlights are quite expensive and many depend on batteries which might go "dead" when you least can afford it.

p. 86

Point-source light, as mentioned, is always relatively contrasty, casting deep and sharply defined shadows. The smaller the effective diameter of the light source, the more pronounced these ef-

fects. A photoflood bulb used "bare," for example, delivers a more contrasty illumination than the same bulb used in a reflector. "True" point-like light sources, such as zirconium-arc lamps, yield light that is so contrasty that it can be used in enlargers without the need for a lens, and the shadows which it casts are razor sharp.

Area-source light is always of relatively low contrast and softly diffused, casting grayish, indistinct shadows. The larger the effective diameter of its source, the more pronounced these effects. The ultimate in area source illumination is the light tent, which provides virtually shadowless light.

p. 88

Conclusions

A good photograph is more than merely the sum of its parts. The extra element is the attitude and creativity of its originator. It is he who, from an unlimited number of picture possibilities chooses the one that seems most suitable to represent his personal view. And this realized option—the finished photograph—in turn is the sum of an almost infinite number of choices which the photographer had to make—choices regarding the distance and angle of view from which the subject is shown, the background against which it is presented, the kind of light in which it is seen—each again the result of careful deliberation, rejection of unsatisfactory possibilities, and selection of more promising ones, all held together by an idea: the purpose of the picture, the WHY. The How—the implementation of the photograph by means of camera, lens, filter, film, developer, and so on—is merely a mechanical process which almost automatically evolves from, and is subordinated to, the WHY.

During this process of choosing, selecting, and rejecting options, the good photographer realizes that all the factors which, in combination, "make" the picture, are intimately and inseparably interrelated. Invariably, a change in one will have an effect (often adverse) on one or several of the others. It is then up to the photographer to coordinate the various and often contradictory elements involved in the making of a photograph—creative as well as technical—in such a way that the result, the finished picture, becomes a harmonious entity. The only way this can be accom-

plished is by considering all these elements right from the start in their proper relationships to one another, weighing option against option, balancing, adjusting, compromising, jiggling all the pieces of the puzzle that comprise the photograph until they mesh properly and gel.

In short, the good photographer must adopt a TOTAL view.

III. The Nuts-and-Bolts Foundation of Photography

Today, in the age of electronically controlled cameras and custom photo labs, photography is as simple or as complex as you want to make it. Nothing is easier than taking technically perfect snaps—any bright six-year-old who can read can do it. And he doesn't even need a book to teach him "technique" because everything he needs to know in this respect can be found in the camera and film manufacturers' instructions that accompany their products—information that is both authoritative and free.

On the other hand, nothing is more involved and takes more artistry, effort, and time than making the kind of image that commands attention—the pictures that we remember. Why? Because the means of modern photography are so sophisticated and refined that only a thoroughly competent, not to say inspired, photographer can fully exploit their potential. This kind of craftsman-artist is, of course, relatively rare, but it is his photographs as seen in magazines and exhibitions that set the standard by which we judge all photographic work.

For reasons which will be clear in a moment, I'd like to begin with an analogy between photography and music.

What is the most important aspect of music, the thing we enjoy and criticize? Obviously, the score, the melody, the music itself, the work of the composer. However, before we can experience music, several things must happen: An artist—the composer—must have had an inspiration, a specific idea for a musical work. Before this idea can be shared with anyone, it must be given tangible form—the composer must put it down on paper in the form of a score. And before this score can be enjoyed by an audience, it must be

played by skilled performers who, with the aid of instruments, convert the written notes into sound.

Now, let's analyze the relative importance of each step and relate it to photography. Most important, obviously, is the idea, the music, the creative achievement of the artist (in this case, the composer). The same is true in photography: the most important factor in the making of any photograph is the conceptual image of the subject in the photographer's mind.

Next step: fixation of the concept, the idea. Before it can be of use to anyone, an idea must be given tangible form. In music, this form is the written score; in photography, it is the exposed film. Both are intermediate stages required for practical-technical reasons—you cannot store or communicate ideas unless they are first converted into tangible symbols—notes or words on paper, chemical changes on film.

Third and final step: reconversion of the symbols by trained performers. A score must be transformed into sound by skilled musicians; an exposed film must be developed and printed by a skilled technician, unless it is a positive color transparency.

To be able to perform, both musicians and lab technicians need special tools—musical instruments, darkroom equipment—which they use with greater or lesser skill to produce a more or less satisfactory result: the symphony; the transparency or print. And it stands to reason that the more skillful the "performers" and the better their "tools," the closer the result—the music or the photograph—will approach the concept of its creator—the composer or photographer.

Now for the lesson: If the concept of the artist (composer, photographer) is valid, the work, at least potentially, is valid, too. An exciting score my be badly played—perhaps because the musicians are amateurs or use badly tuned instruments—but everything is not lost. In another performance by more competent musicians using more carefully tuned instruments, the full beauty and power of the music may be revealed.

Similarly, in photography, poor technique can never completely destroy a valid concept—a skilled printer can do wonders with a

technically poor negative. By using paper of a more suitable grade, a corrected exposure, a little bit of dodging here and there, the concept of the photograph will come through, and the picture will "speak" its message. But if the original concept of the work is poor, not even the most skillful "performers" can transform an uninspired score into a memorable musical event, or coax a memorable print out of a film containing in latent form a dull or poorly conceived subject.

This analogy should give you an idea of what's involved, and where emphasis must be put: on the concept of your picture. This is the starting point: if valid, you have a chance; if not, every added effort will be in vain.

Ideas and concepts—the starting points of both music and photographs—are the outcome of creativity, imagination, and fantasy, and constitute the province of the artist. These are qualities which a person either does, or does not, possess. They cannot be learned, although, if present in latent form, they can be developed.

Ideas have to be implemented before they can be transmitted to other people. And implementation with the aid of "tools" is a technical process. And technique can be learned.

"Technique" in the photographic sense is a means to an end—the implementation of the photographer's ideas. Although subservient in character to creativity, it nevertheless is a vitally important element in the creation of any picture; for the better the "technique," the more closely will the photograph conform to its originator's ideas.

Technique is the How of photography, which must always be guided by the WHY. The WHY, together with the WHEN and WHAT, define the photographer's goal; the How defines the process which turns intangibles into realities—finished slides or prints. And the more you know about the How—the technical aspects of photography—the better equipped you will be to transform concepts into photographs and the better, clearer, and more eloquent, your pictures will be.

So, let's start by getting down to brass tacks—the nuts-and-bolts of photography.

pp. 22-28

You have your camera—a camera suitable to your work and comfortable to use, as discussed in Chapter I, and you are impatient to go and take pictures. How should you begin?

Begin by making it a habit to read or review the instructions for use that came with each item of your photographic paraphernalia, no matter whether the instructions are for a complex piece of equipment like an automated camera, or an apparently simple item like a roll of film. These instructions are there for a purpose: to enable you to derive the greatest possible benefit from your purchase. In my opinion, people who disregard instructions cheat themselves out of something they paid for—information and knowledge.

Next on the agenda is the question of film. What should you buy? While the film size is obviously determined by the format of the camera, there are other decisions to be made—using the wrong kind of film can spell pictorial disaster. As in the case of the camera, you must choose your film in accordance with the kind of work you want to do.

The film

Color film or black-and-white? Don't make the common mistake of believing that color is superior to black-and-white because it yields more "natural" pictures. This is not necessarily true: a portrait that has a blue, green, or purple color cast makes a less "natural" impression than a good rendition in black-and-white. And a picture postcard-type color slide is, at least in my opinion, inferior to any well-conceived and powerfully executed image of the same scene in black-and-white. Artistically speaking, neither of these two forms of photographic rendition is "better" than the other; they are merely different. Each fulfills specific needs.

Normally, color film will yield more satisfactory results than black-and-white if color is the subject's most important characteristic. Subjects of this kind are colorful flowers, fruit, and fall foliage; insects, birds, and tropical fish; food arrangements; masses of green vegetation; rainbows and flaming sunset skies; colorful wearing apparel; paintings and other colorful works of art; landscapes and outdoor scenes photographed in an unusual light (for example,

around sunset or during a thunderstorm). Also, for subjects in which the highest possible degree of likeness is desirable, as in medical, scientific, and identification photography, good color photographs are superior to pictures in black-and-white, although color photographs in which color is distorted are worse.

As long as color is not the subject's most important quality, black-and-white film often yields better results. Indeed, it may be preferable because it offers the photographer the following advantages over color film: a much higher degree of control (control is a very important aspect of *good* photography which will be discussed later in detail); a chance for powerful and typically "graphic" semi-abstract effects; it is less expensive all along the line, from the price of the film to the cost of printing material and processing; and finally, the techniques involved are much simpler and less critical, allowing greater latitude in exposure and development.

pp. 169, 171-228

Color slides or paper prints? If you wish to work in color you must decide whether you want to see your pictures in the form of transparencies ("slides") suitable for viewing and projection, or in the form of paper prints. For slides you must load your camera with positive ("reversal") color film, and for color prints, use negative ("non-reversal") color film, which yields color negatives suitable for printing.

As far as Kodak color films are concerned, you can distinguish between the two types by their codelike suffix: the suffix *"chrome"* indicates a *positive* (transparency) color film (Koda*chrome,* Ekta*chrome*); the suffix *"color"* indicates a *negative* (print) color film (Koda*color,* Ekta*color*). Although paper prints can be made from positive transparencies and slides, the process involved is more complicated and costly, and the results are often inferior to prints made directly from color negatives. Incidentally, although "transparency" and "slide" mean basically the same—a positive color image on film—the first term is usually reserved for color images 2¼x2¼-inch and larger, the second one for color pictures on 35mm film.

Daylight color film or Type A or tungsten (Type B)? Most positive color films are made in two main types: Daylight type

which is intended ("balanced") for use in daylight (sunlight), and a second type intended for use in artificial (incandescent or tungsten) light. Those balanced for use in artificial light are of two different sub-types: Type A intended for use with amateur photoflood lamps (3400 K), tungsten (Type B) for use with professional tungsten lamps (3200 K).

p. 199

Why this apparent confusion? Because different types of light differ in regard to their spectral composition, and unless a color film is "balanced" for the kind of light in which it will be used, it cannot give natural-appearing colors unless the appropriate color correction or light-balancing filter is used. Daylight-type color film, for example, if used in conjunction with incandescent light, would yield slides that appear too yellow; they would have a yellow "color cast." Conversely, used in conjunction with daylight, a color film balanced for use in incandescent light would yield slides that would have a bluish color cast. To avoid such "unnatural" appearing color renditions it therefore is vitally important that, at the time of purchase, you specify which type of color film you want: Daylight Type, Type A, or tungsten (Type B).

Black-and-white films. If you intend to make photographs in black-and-white, matters are somewhat simpler since almost any type of black-and-white film can be used in any type of light (the few exceptions don't concern us here). Nevertheless, here, too, you have a choice between films with different characteristics which, for best results, must be considered at the time of purchase.

General-purpose films. These films are unsurpassed for average needs and shooting conditions because they combine a wide exposure latitude with relatively high speed and relatively fine grain. (I'll tell you in a moment what all this means to the final picture.) My preference is Kodak Tri-X Pan Film®. If rated conservatively at a speed slightly lower than that recommended by the manufacturer and developed in Kodak Developer D-76 for a slightly shorter-than-normal time, Tri-X will give you 35mm negatives which, enlarged to 11x14-inch size, yield beautiful prints which for

p. 109

all practical purposes are "grainless," almost free of granular pattern.

Fine grain or thin-emulsion films (for example, Kodak Pana-tomic-X®) are almost unbelievably sharp and "grainless" but require considerable experience on the part of the photographer for best results. Their low ISO/ASA numbers indicate they are very "slow," their exposure latitude is minimal, they require special "compensating" developers and, if underexposed even slightly, yield negatives that are useless. I recommend them only in cases where 35mm negatives must be enlarged to mural size, and even then only if the photographer knows what he is doing.

p. 110

High-speed films (for example, Kodak Royal-X Pan Film®) are extremely "fast" but very "grainy" and sensitive to overexposure, which results in negatives so lacking in contrast as to be virtually useless. These, too, are highly specialized films which should be used only in cases in which general-purpose films are too "slow."

Now, what does all this talk about exposure latitude, slow and fast films, speed, grain (granularity) mean? Actually, it is quite simple:

Grain refers to clumps of microscopic silver particles in the film's emulsion (the light-sensitive layer where the image is formed). The size of these clumps varies in accordance with the film's speed (the higher the speed, the coarser the granularity) and mode of processing. Fine-grain films yield virtually grainless prints, and coarse-grain films produce obvious granularity. Film grain is always most noticeable in the medium gray tones or colors of a print, increasingly so the more contrasty the paper. Although normally an undesirable quality, under certain conditions granularity can become a means for creative expression and thus desirable.

Exposure latitude designates a film's tolerance to accidental over- and underexposure. The wider the exposure latitude, the less critical the exposure and simultaneously the greater the film's ability to cope with subjects of more than average contrast. Plenty of exposure latitude, therefore, is a very desirable quality, especially in color film. Depending on the brand, the exposure latitude of color film varies between plus-or-minus ½ to 1½ *f*-stops, that of black-and-white film between ½ and 4 *f*-stops. Generally speaking (although there are a few exceptions), the exposure latitude is

widest in films of average speed and contrast and narrower in slow and contrasty films, as well as in high-speed, low-contrast films.

Film speed, when used in reference to film, is photographic jargon for "sensitivity to light." It is measured in ISO and/or ASA numbers: the higher the number, the more light-sensitive the film, and consequently, the shorter the exposure under otherwise identical conditions. Films with speeds from ISO/ASA 25 to 64 are "slow"; ratings from ISO/ASA 125 to 400 designate films with moderate to average speeds; and anything from ASA 500 and up is "fast." These speed numbers are calculated in such a way that a film with a number twice as high as another film has twice its speed and, other factors being equal, requires only half as much exposure. It is the ISO number of your film which you must feed into your light meter or the film speed dial of your automated camera in order to make sure they will function properly.

Now, following the manufacturer's instructions, load your camera with the right kind of film for your subject and the light. Make sure to shield both camera and film cartridge from strong light during this operation to avoid accidental "fogging" (partial exposure) of the film. Outdoors, if there is no shade, turn away from the sun and load the camera in the shadow cast by your body. While operating the film transport lever to get the first frame into position, make sure that the rewind knob also turns; otherwise, the film is not advancing properly.

Set the film speed dial of your "automatic" camera in accordance with the ISO or ASA speed of the film you are going to use. If you work with a nonautomatic camera, set the film speed dial of your exposure meter in accordance with the instructions that accompany it before you take a brightness reading.

In reality, film speeds (ISO/ASA numbers) are the manufacturer's guidelines to indicate how you can obtain optimum results. And a good photographer uses these numbers as guides only. Having said this, now is perhaps as good a moment as any to squash a popular misconception: the assumption that photography is a "science." This is simply not true. Photography might rightly be called a mixture of art and craft and imagination with a dash of intuition and

luck thrown in, but it is definitely not a science because it is not subject to specific "laws." All the "rules" of photography are riddled with exceptions, and every statement or piece of advice is to be taken with a grain of salt. This is also true in regard to film speed (ISO/ASA) numbers, which are merely intended as guides. If your film as a whole turns out more or less underexposed or overexposed, you can avoid such disappointment in the future by changing the setting of the film speed dial accordingly. If your film as a whole was underexposed (color film generally too dark, black-and-white film too thin and transparent), set the dial to a somewhat lower number than the "official" (manufacturer's) ISO or ASA rating of the film. Conversely, if your film as a whole was overexposed (color: too light and "washed-out"; black-and-white: too dense and dark), set the dial to a somewhat higher ISO or ASA number than the rated speed of your film. The degree of the difference between "rated" and "actual" film speed is proportional to the degree of under- or overexposure, respectively, and has to be established by test. If the discrepancy is slight, change the number by one click of the film speed dial; if the discrepancy is considerable, by two or even three clicks. Be sure to keep notes for that particular camera. Another may vary in another way.

Variations in "actual" (in contrast to "rated") film speed of this kind can be caused by several factors: The "true" film speed may vary slightly due to unavoidable manufacturing differences (tolerances), and the shutter speeds of your camera may not be exactly what they are marked. Furthermore, variations in film development can also cause changes in "speed" equivalent to one or two f-stops; and finally, some photographers like their slides or negatives more (or less) fully exposed than others.

With this rather technical but important subject out of the way, you are now ready to take the next step on the road to good photography, which is concerned with the principles of film exposure.

Film exposure

Exposing correctly means admitting precisely the right amount of light to the film, neither too little (which would cause under-

exposure) nor too much (which would cause overexposure). An underexposed color transparency is too dense and all its colors appear unnaturally dark; an overexposed one appears too light and its colors washed out. In black-and-white, an underexposed negative is too transparent and often also too contrasty (too "hard"); an overexposed one is too dense and dark and often also lacking in contrast (too "soft"). Either extreme would yield an unsatisfactory picture or, in more severe cases, and particularly in color, a useless one.

Diaphragm and shutter

Exposure regulation is necessary because, unlike the human eye, the film does not change its sensitivity in accordance with the intensity of the prevailing light. Therefore, the photographer must see to it that the film receives relatively more light when the illumination is dim than when it is bright. He accomplishes this by means of two devices, each of which has a double function;

the diaphragm
the shutter.

The diaphragm is a variable aperture built into the lens which controls the amount of light permitted to reach the film per unit of time much like the pupil does in the eye. Wide open, it obviously admits more light to the film in a given amount of time than when reduced to a tiny hole.

Simultaneously, the diaphragm determines the degree to which a three-dimensional subject will be rendered sharply in depth: with the diaphragm wide open, the near-to-far extent of sharpness in depth—the "depth of field" (or zone of sharp focus)—will be relatively limited. Decreasing the diaphragm aperture (an operation called "stopping down the lens") increases the extent or depth of the zone of sharp focus until it reaches a maximum when the diaphragm is reduced to its smallest opening.

The concept of f-*stops.* To make precise and repeatable settings possible, the diaphragm is calibrated in *f*-numbers called *f*-stops or

simply "stops." A fact which tends to confuse the beginner is that the largest diaphragm aperture on any given lens has the smallest *f*-number, and the smallest aperture the largest. The necessity for this is technical and need not concern us here; one simply has to get used to it.

F-stops are computed in such a way that "stopping down" the diaphragm by one full stop (*increasing* the *f*-number accordingly) cuts in half the amount of light admitted to the film. Stopping down by two full stops cuts the light to one-quarter; stopping down by three full stops to one-eighth the amount of light, and so on.

Conversely, opening the diaphragm by one full stop (decreasing the *f*-number accordingly) doubles the light that reaches the film; opening it two full stops lets in four times the amount of light, and so on.

A typical sequence of *f*-stops (or aperture numbers) is:

f/1.4 2 2.8 4 5.6 8 11 16 22.

The shutter controls the time during which light is admitted to the film: the longer the shutter is open, the more light reaches the film at any *f*-stop, and vice versa. A typical sequence of shutter speeds in fractions of a second is

1/1000 1/500 1/250 1/125 1/60 1/30 1/15 1/8 1/4 1/2 1 second

The shutter also determines whether a subject in motion will appear "frozen" in the picture—that is, rendered in sharp detail or more or less blurred. The higher (more rapid) the shutter speed, the sharper the image of an object in motion; the lower the shutter speed, the more pronounced the blur.

In combination, appropriate adjustment of diaphragm aperture and shutter speed enables the photographer to admit to the film precisely the quantity of light required for a perfect exposure. This can be accomplished in a number of different ways. As far as the exposure is concerned, it makes no difference whether we admit to the film a large amount of light for a short period of time or a smaller amount for a correspondingly longer duration. (There are

exceptions to this "law" which would result in *reciprocity failure*, but this is somewhat beyond the scope of this guide.)

Applying the knowledge. Now, you might say, this is all very interesting and clear, but precisely how do I know when I should do what? This is how you should proceed:

The basis for any perfect exposure is a brightness reading taken with the aid of an exposure meter. Many modern cameras have a built-in exposure meter that automatically measures the brightness of the incident light; many will set the exposure automatically. If your camera doesn't have a built-in meter—or you want to take an independent, confirmatory reading—use a separate, hand-held instrument.

Used in accordance with the instructions provided by its manufacturer, an exposure meter will provide you with a set of data in the form of *f*-stops and corresponding shutter speeds. Under certain light conditions in conjunction with a film of a specific "speed," such a series might take this form:

f/stops: 1.4 2 2.8 4 5.6 8 11 16 22

seconds: 1/1000 1/500 1/250 1/125 1/60 1/30 1/15 1/8 1/4

Now, each pair of *f*-stops (top row) and corresponding shutter speeds (bottom row) would, in our assumed case, result in a perfect exposure. But which of these combinations should you use?

This is another example of the importance of the WHY relative to the How. Although each combination would produce a perfect *exposure*, the resulting images would be very different in two other important respects:

depth of field
rendition of motion.

Depth of field. Most photographic subjects are not two-dimensional, but three-dimensional—they have depth. This raises two questions:

(1) At which distance should you focus your camera?

(2) How can you make sure that, after focusing, the extent of the sharply rendered zone will be sufficient in depth to cover your subject all the way from front to back?

You can accomplish this by making use of the following facts: Normally, a camera can be focused on only one specific plane at a time perpendicular to the optical axis located at a specific distance from the lens. But the lens's ability to capture detail or its "sharpness" is not confined to a plane, but extends also somewhat in front of and behind the plane on which the lens is focused. The extent of this zone of sharpness in depth—the depth of field—depends on three factors: *the distance* between the camera and the plane on which the lens is focused, *the focal length* of the lens, and its *relative aperture* or "speed" (which is different from film "speed"). The greater the distance between subject and camera, the shorter the focal length of the lens, and the slower its "speed," the more extensive the depth of field; and vice versa. This is not a "rule" but a fact, so there are no exceptions. And since it involves lenses, the time has come for a brief discussion of what is—from the point of view of the *good* photographer—a most important subject.

The lens

Any lens has three basic qualities:

> **focal length**
> **covering power**
> **relative aperture** or **"speed."**

Any photographer should understand these qualities because they tell him what a lens—any kind of lens—can and cannot do.

The focal length is the shortest distance from the film at which a lens can still produce a sharp image. It determines the size in which the subject will be rendered on the film. From the same camera position, a lens with a longer focal length than another will render the subject in larger scale than the lens with the shorter focal length. Focal length and image size are directly proportional: a

lens with twice the focal length of another will depict the subject twice as large on the film as the "shorter" lens.

The focal length of a lens, normally engraved on the lens mount, is measured in millimeters, centimeters, or inches. It is the distance from approximately the center of the lens (more precisely: from the "node of emission," which in telephoto and retrofocus wide-angle lenses lies outside the lens) to the film when the lens is focused at infinity (a very distant object like, for example, the moon).

Focal length and film size are related insofar as the focal length of a standard lens is roughly the same as the length of the diagonal of the negative size it must cover. The diagonals of the three most popular film sizes and the focal lengths of the corresponding standard lenses are:

Film size	Negative diagonal	Standard focal length
35mm	1-11/16″ (44mm)	50mm or 55mm
2¼″ × 2¼″	3⅜″ (85mm)	75mm or 80mm
4″ × 5″	6⅜″ (162mm)	150mm

By itself, however, focal length does not tell you whether a specific lens can be used in conjunction with a specific film size, nor do the constantly used terms "long-focus" or "short-focus" lens provide much information in this respect.

Let me explain. A wide-angle lens designed for use in conjunction with, say, 8x10-inch film with a diagonal of 12¾ inches may have a focal length of six inches which, relative to the huge negative format, is very short, making this a short-focus lens. If used on a 4x5-inch camera, however, this lens would perform like a standard lens because the focal length of a standard lens for this format is six inches. But if used on a 35mm camera, this same six-inch lens would act like a long-focus lens (telephoto lens) since the standard lens for 35mm film has a focal length of about two inches. In other words, what is a short-focus or "wide-angle lens" in respect to one film size or camera format can be a standard lens or even a long-focus or "telephoto" lens if used in conjunction with a smaller negative size.

But this is still not the full story. A short-focus or wide-angle lens designed for use with a specific film format can always be used with a smaller negative size; but a long-focus or telephoto lens specifically designed for use with a small film format can never be used with a larger negative size, even if its focal length is longer than that of a lens which is "standard" for this format. The reason: insufficient covering power.

The covering power of a lens—not its focal length!—determines the largest film format it can be used with. To understand why this is so, you must know that any lens transmits light in the form of a cone, the basis of which coincides with the film plane inside the camera. However, the base of this cone (which contains the image produced by the lens) is not rectangular (as the negative on which it falls), but circular, and the quality of this image is not uniform: it is most detailed and brightest near the center, with detail and brightness gradually decreasing toward the edge. For this reason, only the central part of this circular image is suitable for photographic purposes. Consequently, the diameter of the usable area of the circle must be at least as long as the diagonal of the negative format. Otherwise, the corners and edges of the picture would appear blurred, perhaps even black.

Now, to go back to our example, a wide-angle lens with a focal length of six inches designed for use in conjunction with 8x10-inch film is, of course, so computed that it will sharply "cover" its entire size; therefore, it obviously could cover any smaller film size, too. A telephoto lens with a focal length of, say, six inches designed for use with 35mm film, however, is so computed that it will cover sharply only this relatively small negative size. Even though its focal length is longer than that of the wide-angle lens we talked about above, it will not cover the 8x10-inch film size, nor a 4x5-inch negative, and not even a 2¼x2¼-inch negative, because the cone of light which it transmits is so narrow, and its base so small, that only a 35mm negative will fit the usable area. If used in conjunction with any larger film size, such a lens would simply produce a circular image with a diameter of approximately two inches, while the rest of the film would be blank.

The relative aperture of a lens, popularly known as its "speed," determines the maximum light transmission of the respective lens. It is expressed in the form of a ratio (usually engraved on the lens mount): focal length (*f*) divided by the effective lens diameter (which usually differs slightly from the actual diameter). This explains why the term includes the word "relative"; neither focal length nor effective lens diameter alone can give an indication of how much light a lens can effectively transmit—its "speed." Only if one is evaluated relative to the other does the result become meaningful.

To give an example: If a lens with a focal length of two inches has an effective diameter of one inch, its relative aperture would be 2:1 = 2 and would be expressed in the familiar form of *f*/2. However, if a lens with a focal length of two inches has an effective diameter of 1.65 inches (a larger diameter which transmits more light), its relatively aperture would be 2:1.65 = 1.2 and expressed as *f*/1.2 This designates a considerably "faster" lens than one with a "speed" of only *f*/2.

Please notice that here we have the same apparent paradox we encountered already when discussing *f*-stops: the fact that the greater the amount of light transmitted by a lens (which means, the higher its speed), the lower its relative aperture number. These *f*-numbers which, incidentally, are simply the maximum *f*-stops of the respective lenses, are computed and progress in the same way as *f*-stops: an *f*/1.2 lens is twice as "fast" as an *f*/1.8 lens, which in turn is twice as fast as an *f*/2.5 lens, and so on. For practical purposes, lenses with relative apertures of *f*/1.2 to *f*/2 are considered "fast" or high-speed lenses; relative apertures of *f*/2.5 to *f*/4.5 designate lenses of moderate speeds, and lenses with relative aperture numbers larger than *f*/4.5 must be considered "slow."

Fast lenses have two advantages over slower lenses:

1) When light conditions are marginal, fast lenses offer the photographer a reserve in terms of *f*-stops or greater "speed," thereby enabling him to take satisfactory pictures which he could not have done, had he been forced to use a "slower" lens. Lacking the fast lens's higher speed, he would have been forced to make a choice

between underexposure, blurring a moving subject, or using a shutter speed too slow to safely hand-hold the camera to avoid accidental camera movement during the exposure, which would have resulted in a blurred picture.

2) Sometimes it is desirable to keep the sharply rendered zone in depth (depth of field) as shallow as possible in order to emphasize this zone by keeping it sharp while everything in front of and behind it appears more or less blurred—a technique called "selective focus." In these cases, fast lenses, because of their larger maximum diaphragm apertures, enable a photographer to achieve this effect to a more pronounced degree than would be possible with slower lenses.

The disadvantages of fast lenses relative to slower ones are their sometimes inferior sharpness and the fact that they are always larger, heavier, and much more expensive.

Transform knowledge into performance

After this brief excursion into lens lore, which was necessary in order to make you fully understand the story behind the concept of depth of field, let's go back to where we left off and continue our p. 115 discussion of the consequences of different combinations of *f*-stops and shutter speeds in regard to the appearance and weaving of the picture by examining them in terms of the second factor, rendition of motion.

Rendition of motion. To render motion directly in a "still" pho- p. 222 tograph is obviously impossible. It can, however, be indicated symbolically. Any photographer faced with the problem of photographing a subject which involves motion has to make a decision: should he pictorially annihilate motion and "freeze" his moving subject on the film, or should he indicate its motion in symbolic form? The first alternative requires either a shutter speed high enough to "stop" the subject's motion or electronic flash. The second possibility requires using a shutter speed slow enough to render the moving subject slightly blurred—enough to indicate motion, but not too much or the subject could become unrecognizable in the picture.

p. 224 A third possibility is: "panning." This means using the camera on a moving subject as a hunter uses a shotgun on a flying duck: he centers his target in the viewfinder, keeps it there by following it as it moves, and releases the shutter while swinging. In this way, the moving subject will be rendered sharply and the stationary background blurred—a reversal of the second of the two alternatives above, where stationary objects would appear sharp and moving subjects blurred. The psychological effect, however, is the same: the contrast between sharpness and blur evolves the feeling of motion.

There is yet another option to consider: blur involving the entire picture due to accidental camera movement during the exposure. The cause of this very common fault is use of a shutter speed that was too slow to enable the photographer to hold the camera steady during the exposure. In this respect, the slowest shutter speed that normally can be safely hand-held is 1/125 second. Slower shutter speeds down to approximately 1/30 second can usually be hand-held safely if the photographer is properly braced. Still slower shutter speeds require that the camera be firmly supported, if not by a tripod, then perhaps by pressing it against a solid object, if sharpness due to accidental camera movement is to be avoided.

And now, with all the preliminaries taken care of and out of the way, we come to the payoff of this chapter, where the WHEN and WHY triumph over the How; where all the factors discussed separately come together, mesh, form a pattern and, like a successfully completed puzzle, enable you to see the final design.

You are now ready to make an intelligent choice in regard not only to exposure but also to depth of field and rendition of motion: which one of all the possible combinations of *f*-stop and shutter speed should you select for the one and only exposure that will present your subject most tellingly in picture form? That depends on the following aspects and their ramifications:

Should the exposure be made with the camera hand-held or firmly supported? In the first case, set your shutter at a speed not slower than 1/125 second and choose your *f*-stop accordingly. In

the second case, you have no problem and can proceed to the next question.

Is your subject static (stationary, holding still), or is it dynamic, involving motion? If your subject is not in motion there is no problem; your subject holds still and you can use any *f*-stop needed to give sufficient sharpness in depth without having to worry about shutter speed. If the light is dim and the corresponding shutter speed is too slow for a hand-held exposure, mount your camera on a tripod.

If you have chosen a dynamic subject, the shutter speed selected should either "freeze" the subject in the picture or "symbolize" its motion through controlled blur which dictates the exposure. The *f*-stop must then be chosen accordingly.

If your subject is dynamic (involving motion), ask yourself which aspect is more important for most effective characterization: its motion, or its depth?

If depth is more important than motion, start by determining the extent of the zone which must appear sharp and the distance from the camera at which this zone should begin. If time is of the essence, guess; if there is plenty of time, focus your lens first on the nearest, then on the farthest part of the subject which must be rendered in sharp detail and read the respective distances in feet (or meters) off the distance scale of your lens. Next, refocus the lens (disregarding the viewfinder image) until identical *f*-stop numbers appear on the depth-of-field-indicator scale of your lens opposite the foot-numbers (or meter numbers) which correspond to the beginning and end of the depth zone that must be rendered sharply. Leave the lens in this focusing position. Next, stop down the diaphragm to the *f*-number that appears opposite the foot-numbers (meter numbers) that correspond to the distances indicating the beginning and the end, respectively, of the subject's depth. In this way, a maximum of sharpness in depth is created with a minimum of stopping down.

For cameras without a depth-of-field indicator scale, proceed as follows: Determine the distances of the near and far ends of the

zone you want to cover sharply by focusing your lens first on one, then on the other, and read the respective values off the distance scale engraved on the lens. From these figures, calculate the number of feet that must be covered sharply in depth, divide the result by three, and add this figure to the number of feet from the camera at which your depth zone should start. The result gives you the distance in feet at which to focus your lens.

For example, imagine that you want to photograph a garden. According to the figures read off the distance scale of your lens after focusing, the first row of flowers that must be rendered in sharp detail is six feet from the camera, and the last row is thirty feet away. By subtracting six from thirty you establish the depth of the zone you want to render sharply and arrive at twenty-four feet. Dividing twenty-four by three you get eight. Add to this result the distance in feet between the camera and the beginning of the sharply rendered zone—six—and you get fourteen as the number of feet at which you must focus your lens. Subsequently, stop down your diaphragm until the entire depth zone appears sharp.

All this may sound complicated but is actually very simple, particularly if you practice with your camera while you read this. Here is how and why it works:

As I pointed out before, a certain amount of sharpness in depth is inherent in any lens. Normally, this "inherent depth" is insufficent to cover sharply a three-dimensional subject in its entire depth. It then becomes necessary to increase the extent of the sharply covered zone in depth. The means for this is the diaphragm. Stopping down the diaphragm increases the "inherent depth zone" in two directions from the plane of focus: toward, and away from, the camera. The gain in "depth" is the greater, the more the lens is stopped down.

p. 112

Since stopping down the lens increases sharpness in depth in two directions relative to the plane of focus—toward and away from the camera—it would be foolish to focus on either the beginning or the end of the depth zone that has to be rendered sharply and then stop down the lens accordingly. Focusing the lens on infinity and stopping down the diaphragm, for example, would be wasteful

since depth beyond infinity is useless and unnecessarily small *f*-stops would be required to cover the zone of interest.

Stopping down the lens creates sharpness in depth at about twice the rate beyond the plane of focus (away from the camera) than in front of the plane of focus (toward the camera). Therefore, fullest use of any increase in sharpness in depth is made by focusing the lens on a plane located approximately one-third within the depth zone that must be covered sharply and then stopping it down accordingly.

If motion is more important than depth, start by choosing the most suitable shutter speed, then adjust the *f*-stop accordingly. Consider whether it is more advisable to "freeze" or "symbolize" your subject's motion. In the first case, choose your shutter speed in accordance with the table on page 124, then set the diaphragm aperture accordingly.

Should motion be indicated in the picture through blur, the degree of this form of *directional* unsharpness must be just right, neither too little (in which case the effect would appear accidental), nor too much (in which case the moving subject would appear unrecognizable in the picture). Choosing the right shutter speed requires experience based on tests and evaluation of previous failures. In this respect, any mistake a photographer makes can be a blessing in disguise. A smart photographer learns more from his mistakes than from his successes because, once he has determined its cause, he never has to make the same mistake again.

And now, I suggest that you pick up your camera and practice what you just read without film—make a few dry-runs. What we just discussed is part of the basic "vocabulary" of any pictorially "literate" photographer. It must be absorbed until it becomes second nature—part of your subconscious memory—because it represents another indispensable step on the road to success.

What's next?

That depends . . . if you work with color film, you can give your exposed roll to your photo store for processing or mail it to one of

Recommended shutter speeds for stopping subject motion

		Direction of subject motion		
Speed of subject	Subject distance	toward or away from camera	at 45-degree angle to optical axis	at 90-degree angle to optical axis
5-10 mph (people, children, sailboards, pets, etc.)	25 ft	1/125 sec.	1/250 sec.	1/500 sec.
	50 ft	1/60 sec.	1/125 sec.	1/250 sec.
	100 ft	1/30 sec.	1/60 sec.	1/125 sec.
20-30 mph (athletes, motorboats, city traffic, etc.)	25 ft	1/250 sec.	1/500 sec.	1/1000 sec.
	50 ft	1/125 sec.	1/250 sec.	1/500 sec.
	100 ft	1/60 sec.	1/125 sec.	1/250 sec.
Over 50 mph (racing cars, trains, air-planes, etc.)	25 ft	1/500 sec.	1/1000 sec.	pan*
	50 ft	1/250 sec.	1/500 sec.	1/1000 sec.
	100 ft	1/125 sec.	1/250 sec.	1/500 sec.
	200 ft	1/60 sec.	1/125 sec.	1/250 sec.

*"Pan" means: use of the technique known as "panning," which we discussed before. Generally, panning at the here-indicated shutter speeds will produce still sharper pictures of the moving subject (although the stationary background will appear blurred) than holding the camera motionless while making the shot. If a camera doesn't have the here-recommended shutter speeds, the one that is closest to it should be used; any difference in sharpness will be negligible.

From the book, *The Complete Photographer*, Revised Edition, by Andreas Feininger, © 1978, 1969, 1965 by Andreas Feininger. Published by Prentice-Hall, Inc., Englewood Cliffs, New Jersey 07632.

the numerous custom color labs that regularly advertise in photo magazines.

If you work in black-and-white, you can let a photo-finisher develop and print your film or you can do it yourself.

Using a commercial lab. While color film-processing labs are proliferating like mushrooms, commercial labs that still process black-and-white film are getting rarer all the time and finding one may be a problem unless you live in a big city. Nevertheless, letting somebody else do the lab work for you has the advantage that you

don't need a darkroom, don't have to invest in expensive dark-
room equipment, and you don't have to learn darkroom tech-
niques. Instead, you get professionally developed, spotlessly clean
negatives plus a set of proof prints or contact sheets (which you
should always request) as they serve a double purpose: as a basis
for selecting those negatives worth enlarging, and as a record of
your work, telling you at a glance what you have photographed
and where to find each negative.

Developing your films and printing your negatives yourself
has the advantage that you don't have to wait before you see re-
sults, and that you can learn through experimentation. A negative
can be printed in literally dozens of different ways—lighter or
darker, more or less contrasty, cropped in an endless variety of dif-
ferent compositions and degrees of enlargement—and only the
photographer himself can decide which one of all these different
versions conforms most closely to what he had in mind, the way he
wanted to see his subject in picture form. This is the approach of
the confirmed photographer, the perfectionist, the creative artist
who doesn't trust anybody but himself. It requires darkroom facil-
ities (in larger cities, darkroom space can often be rented on an
hourly basis or shared with another photographer), a great deal of
time, and plenty of hard work. But, at least in my opinion, the re-
wards are well worth the effort.

I suggest that you start by letting a commercial photo lab do your
darkroom work and concentrate instead on picture-taking. Then,
should you find that you really want to go all out in photography,
investigate the possibility of doing your own darkroom work. You
will find everything you need to know in this respect in my book
Darkroom Techniques (*Vol. I: Darkroom and Film Development*
and *Vol. II: Printing and Enlarging*; Amphoto, New York). Only
by attending to every step in the process of picture-making your-
self can you achieve the ultimate control over your work, which
signifies the master.

Conclusions
Today, in the age of electronically controlled cameras and custom
photolabs, photography is as simple or as complex as you want to

make it. Nothing is easier than taking technically perfect snap-shots.

On the other hand, nothing is more involved and takes more artistry, effort, and time than making the kind of images that command attention—the pictures that we remember. But we have two things going for us: automated cameras which free us from wasting precious shooting time on technicalities when every second counts, and insight into the photographic process which enables us to turn drawbacks into advantages. In other words, instead of having to divide our attention between the technical and the pictorial requirements necessary to make good photographs, we now can more efficiently solve the mechanical problems of photography and focus our entire attention on the creative aspects—the ones which decide whether or not the picture will be *good.*

And as far as turning a drawback into an advanatage is concerned, let me cite Ansel Adams' work as an example. By creatively exploiting the semi-abstract potential of graphic black-and-white, he turned an apparent drawback of black-and-white photography—lack of "natural" color—into an advantage, thereby creating masterpieces.

However, before you can compete successfully with the masters, you still have much to learn. So far, you have only completed the first part of this course, which dealt with fundamentals. Now you must refine your aim and learn how to transform knowledge into performance. This involves learning how to bridge the difference in "seeing" between eye and lens—the subject of the next chapter.

IV. Learning to See like a Camera

Having followed me so far you should by now have absorbed the fundamentals of photography, acquired a camera that precisely suits your purpose, and know the basics of subject approach and rendition. You are already aware of the fact that considerable differences exist between human and camera vision. Now you must learn precisely what these differences are, how to reconcile them and, once again, turn drawbacks into advantages.

pp. 22-28

It has been my experience that photographs are unsatisfactory for two main reasons: (1) because the subject lacks viewer interest, is hackneyed, boring, or "has been done to death" before (the cure for such shortcomings is obvious), and (2) because the photographer presented a valid subject in a photographically ineffective form because he was unable to "see in terms of photography." This chapter concerns itself with finding solutions to the second problem.

Differences in "seeing" between eye and camera

It is beside the point whether human vision is superior or inferior to the "vision" of the camera. What matters is the fact that the eye and the lens have different characteristics. As a result, they often "see" the same subject differently and, unless such differences are taken into account by the photographer and reconciled before he releases the shutter, the effect of the picture may be seriously impaired. In this respect, you should consider the following:

Camera vision is objective, uncompromising, matter-of-fact. Human vision is subjective, selective, and, more often than not, unreliable. The cause of this difference lies in the fact that a cam-

era is a machine, whereas the eye is part of a living, thinking, feeling being controlled by a brain.

As far as the photographer is concerned, the consequences of this dissimilarity can, and frequently do, result in images that seem "unnatural" despite the fact that the respective photographs are actually "true." Common examples of this are pictures of people that appear distorted because their noses, hands, or feet seem unproportionally big—the result of working with a lens of relatively short focal length (wide-angle lens) at a relatively short distance between subject and camera. Also in this category of seemingly "distorted" pictures belong all those shots of street scenes and buildings in which walls converge toward the top of the picture instead of being rendered parallel. This "distortion," of course, is nothing but the natural manifestations of perspective in the vertical plane, here brought about by tilting the camera during the exposure. Optically speaking, all these pictures—these "exaggerated" forms of perspective—are perfectly correct; emotionally evaluated, they seem "wrong."

Now, photographers who haven't learned yet to "see in terms of photography" don't notice these phenomena in reality (although they are clearly visible to the trained eye; obviously, the camera can record only what is actually in front of the lens). As a result, they cannot take proper action before they release the shutter and end up with "distorted" images. In contrast, experienced photographers not only are familiar with these effects of perspective and watch out for them, they also know how to avoid them: by not going too close to the subject with a wide-angle lens (unless, of course, perspective distortion is used deliberately to achieve a desired effect); and by holding the camera level when shooting architectural subjects or working with a view camera, the front and back adjustments of which enable them to exert perspective control and render verticals parallel in the picture.

Other examples illustrating the differences between human and camera "seeing" are pictures in which objects overlooked by the photographer at the moment of exposure spoil the effect of the photograph. Examples are: an unsuitable background, ugly shad-

p. 66

ows, the proverbial tree that appears to grow right out of the beautiful maiden's head, and so on. In such cases, the photographer saw only what he wanted to see—the subject that caught his interest—and didn't pay attention to anything else, because the eye and brain react subjectively. The camera, on the other hand, in its objective, mindlessly efficient way, "saw" everything and rendered unimportant or distracting detail with the same precision as the subject itself.

Pay equal attention to the important and the unimportant picture elements. No matter how effectively you may record the important subject aspects, apparently unimportant picture elements may still spoil the image. The lesson:

Human vision is untrustworthy, subjective, and selective. Camera vision is total and non-objective.

Nonvisual sensory stimuli. You, the photographer, are a human being and are thus susceptible to a multitude of sensory stimuli. The camera, a light-sensitive machine, is susceptible to only one—optical impressions.

The consequences of this limitation can be serious if you let yourself get carried away by a subject whose main attraction is not visual. I mentioned already the case of the disappointing beach photographs which I had taken in my youth, where the main attractions of the experience were the *warmth* of the sun, the *sound* of the waves, the *smell* of the kelp, and the *taste* of the salty spray—all *non-visual* sense impressions. No wonder my pictures failed. They comprised only a fraction of the totality—the visual aspects which, especially in black-and-white, embodied the least important part of the experience which had motivated me to reach for the camera. The lesson: *p. 53*

Before you shoot an irresistible subject, mute all your senses except sight to find out how much is left for the camera to record.

If the visual part of the total experience still makes sense, shoot; otherwise, save your film for a more rewarding occasion unless, of

course, all you want is a snapshot as a souvenir. But don't show such pictures to other people—their reactions might be painfully cool.

The total subject experience. The totality of a subject worth photographing is the sum of many different aspects. Take, for example, the experience of a walk in a metropolis you have never visited before. Everywhere there is action and life, in front of and behind you, to your right and left ... bustling people, shops and bazaars, traffic jams, shouts and noise and vibration, an airplane flying overhead ... you want to record this unforgettable experience on film. But in which direction should you point the camera?

This example—a very common one known to every photographer—points out one of the shortcomings of still photography. A subject like the excitement of a strange city is "made to order" for the movie camera, where motion is king and a number of shots, none lasting more than a few seconds, combine to create an exciting, convincing record of the scene, even though each individual frame, if enlarged and presented as a "still," would mean very little. But what should a still photographer do to capture the feeling of such an intangible subject on film?

What he should not do is split it up into a multitude of single pictures, each meaning little by itself, each dull and conventional. Instead, he should *see the scene in terms of photography* and gather all its different components in one tremendous view—for me, the kind of view only an extreme telephoto lens can deliver. This, of course, requires a suitable place for the camera, high and far away from the scene, to give the telephoto lens a chance to pull everything together, stack car upon car in monumentally compressed perspective, annihilating space yet capturing its essence. It was this I did in 1949, when I took my 4x5-inch super-telephoto camera equipped with a lens having a focal length of forty inches to New York's Fifth Avenue, set it up on a building scaffold, and made a series of shots from fifteen city blocks away which compressed what seemed like thousands of cars and double-decker buses into one comprehensive view which subsequently appeared as a double spread in *Life* Magazine (December 18, 1950).

In other words, don't photograph the way a human being "sees"—by gathering a dozen different impressions in a dozen different pictures which, hopefully, convey to the brain the essence of the experience. Why not? Because it wouldn't work—a dozen different close-ups don't combine to give you an overall impression of the whole. Instead, think "big," as big as your subject. Take your longest telephoto lens, step back, and compress the whole experience into one single shot.

Most photographers, when confronted with a very extensive subject, reach for a wide-angle lens to encompass it all in one view. It will be there, all right, caught in a single picture; but how will this picture look? Nearby objects looming much too large will dominate the scene, with the rest relegated to the background appearing in minuscule, totally ineffective scale.

"Photographic seeing" tells you not to "go close," but to "step back" until you are far enough away to bring your biggest gun into action. A monumental subject can only be rendered effectively in a monumental perspective which, again, can only be created with a super-telephoto lens. The lesson:

Learn to see the whole scene photographically, and gather all its components in one tremendous and effective view.

The subject as part of its surroundings. When contemplating a specific subject, we see it in the context of its surrounding, as part of a much larger scene. "Seen" by the camera, in picture form, this same subject is divorced from its surroundings, isolated, and becomes a self-contained entity.

The consequence of this difference between human and camera "seeing" is that a subject which appeared attractive in reality may yet make a poor impression when converted to an image—a slide or a print. Why? Because many factors outside the boundaries of the future picture might have contributed to the effect the subject had on us, peripheral vision providing a gradual transition between the thing which caught our interest, objects adjacent to it, and still others outside our immediate field of view of which we are nevertheless dimly aware.

In contrast, a photograph is the image of a subject or event seen and experienced cut off from its normal environment, out of contact with reality. It also is usually relatively small and flat, which makes it easy to take in at a glance and evaluate as a unit, with no "peripheral impressions" handy to detract and satisfy the eye. In addition, it holds still, giving us all the time we want to discover whatever "faults" it may have. As a result, we can be more critical and apply tougher standards to a photograph than we would have applied to the original in reality—one of the reasons why so many pictures disappoint us.

When evaluating a potential subject, don't judge it by looking at it directly; instead, assess its image in the viewfinder or on the groundglass where you can see the subject as it will appear in picture form—isolated and "framed," self-contained, a composition, a design in shades of color or black-and-white, and two-dimensional. This way, you automatically avoid being influenced by aspects which may be valid in reality but don't apply to the picture—influences which may warp your judgment and make the subject look "better" (in the photographic sense) than it really is.

Another good way of evaluating a subject is by observing it through a viewing frame. This is a piece of cardboard about 8 x 10 inches in size with a rectangular 4x5-inch hole cut in its center through which a prospective subject is studied. Specifically, it serves the following purposes:

 isolating your subject
 eliminating parallax
 determining cropping
 aiding in composition
 showing effects of different lenses
 selecting horizontal versus vertical
 helping to avoid unwanted perspective distortion.

Isolating your subject. By holding the viewing frame at a convenient distance and looking through its aperture with one eye (keeping the other shut), you can isolate your subject from its surroundings and study it, divorced from outside influences, precisely as it would later appear in the picture.

Eliminating parallax. When studying the subject with only *one* eye, you can convert your normally stereoscopic vision into monocular vision—the "vision" of the camera. This way, by eliminating the parallax effect of stereoscopic vision, you can see your subject as "flat" as it later would appear in picture form and decide whether other depth indicators such as shadows, overlapping, diminution, perspective convergence of actually parallel lines, and so on, can or should be used to give the image "depth" and restore a sense of the third dimension.

Determining cropping. If you vary the position of the viewing frame slightly relative to the subject—now a little bit more to the right, now to the left, now higher or lower—you can precisely determine the most effective boundaries of your future picture. You can see how the subject would look "cropped" this way or that way; which parts, in the interest of a tighter composition, can be eliminated without hurting the rest, those which must be included as essential, and others which should be eliminated as distracting or merely superfluous.

Aiding in composition. In the same way, you can find the best location for one particular picture element within your chosen boundaries, such as the most effective placement for a solitary figure which you wish to use to give your picture scale—whether it should be placed higher or lower, more to one side, near one corner, and so on. Similarly, you can determine the best position for the *horizon*—if higher or lower would produce the best effect. In this respect, you should know that a high horizon symbolizes nearness, intimacy, detail, and earthy qualities, whereas a low horizon, emphasizing the sky, suggests distance, freedom, space, and spiritual qualities.

Showing effects of different lenses. By varying the distance between viewing frame and eye—holding it close, farther away and at arm's length—you can study the effects which lenses of different focal lengths would have on the appearance of your subject seen from this particular camera position. The frame held close to the eye would correspond to a rendition by a wide-angle lens; held at a medium distance, to a rendition by a lens of standard focal length;

and held at arm's length, to a telephoto view. The only (mental) adjustment you have to make would be one of image size: the greater the distance between frame and eye, the smaller the aperture appears although, of course, in the future picture, the image size of all the different, contemplated versions would be the same. This method is particularly effective when it comes to evaluating the pictorial qualities of distant subjects, scenery, and wide-open views.

Selecting horizontal versus vertical. By turning the viewing frame's position from horizontal to vertical you can determine whether the subject would look better if composed as a horizontal or a vertical picture.

Helping to avoid unwanted perspective distortion. Using the viewing frame as a frame of reference, you can avoid the danger of unwanted perspective distortion. To consciously see converging verticals, for example, look up at a building through the viewing frame, which must be held at right angles to the axis of vision. When you now compare the direction of the vertical lines of the building with the parallel edges of the frame aperture, you will see that they diverge—the verticals of the building appear to tilt inward. Similarly, the effect of the typical wide-angle ("exaggerated") perspective can be clearly seen if the viewing frame is held relatively close to the subject and the eye close to the viewing frame aperture. The lesson:

> **When evaluating a potential subject, don't be content to judge it merely by looking at it directly. You will be able to see it more clearly as it will appear in picture form if you also assess the image in the viewfinder, on the groundglass, or through a viewing frame.**

Stereoscopic vs. monoscopic vision. One of the most consequential differences between human and camera "seeing" is that we see with two eyes, the camera with only one. As a result, our vision is stereoscopic, and we see depth directly as parallax, while the camera "sees" three-dimensional objects in the form of central projections, that is, "flat." Consequently, depth—the third dimen-

sion—is a subject quality which cannot be rendered directly in a photograph, but may only be indicated in symbolic form.

A number of symbols exist by means of which depth can be expressed in graphic form. An important aspect of "seeing like a camera" is to look for these depth indicators when studying your subject. Proving the presence of depth may be accomplished by showing significant shadows, overlapping forms, foreshortening, diminution, the apparent converging of parallel lines toward distance or height, the effects of aerial perspective—all factors which, properly used, give your pictures a feeling of depth. The lesson:

Don't look for "depth," but instead, search for subject aspects which prove the presence of depth.

Scale of rendition. The focal length of the lenses of our eyes is virtually constant. As a result, from the same standpoint we always see everything in the same scale—nearby objects relatively large, objects farther away proportionally smaller as distance increases. The camera, however, can be equipped with lenses of almost any focal length. And since focal length and scale of rendition are directly proportional, a photographer can render almost any subject, regardless of distance, in almost any size on the film, with the aid of the appropriate lens.

Needless to say, this characteristic of photography is particularly valuable because it enables us to widen our visual horizons, letting us see in picture form, and show to other people, things we otherwise could not have seen, or seen as clearly, because of limitations inherent in our vision. This is one instance (as we'll see soon, there are others) in which the camera is clearly superior to the eye. Smart photographers make use of this potential whenever possible—it is the reason they acquire lenses with different focal lengths. The lesson:

The focal length of the eye is constant. But the camera may be equipped with "eyes" of any focal length, thereby increasing the scope of our visual horizons enormously.

Angle of view. The angle of view of our eye is constant. As a result, we always encompass the same sector of view. This consists of

three parts: a very narrow central sector where we see sharply; adjacent regions where we see more or less clearly although never really sharply; and a large peripheral zone where we sense rather than see things. The camera, on the other hand, can be equipped with lenses encompassing sharply almost any angle of view, from extreme telephoto lenses with angles of view of only two or three degrees to "fish-eye" lenses which can literally "look backward" because they have angles of view of more than 180 degrees.

To visualize what this means, imagine such a fish-eye lens-equipped camera placed flat on the ground with its lens pointing straight up. A picture taken in this position would include everything you could see in every direction, everything from the horizon to the zenith. everything you would see if you completely turned around, all this plus a ring-shaped area of ground around the camera. This is "total vision"—another instance where the camera beats the eye. The lesson:

The angle of view of our eyes is fixed. But equipped with an appropriate lens, the camera's angle of view may range from a few to more than 180 degrees, enabling us to show aspects of our surroundings which otherwise we could only have seen less clearly, if at all.

Limits of human vision. The shortest distance at which the normal human eye can see anything sharply is approximately eight inches (twenty centimeters); shorter only if you are nearsighted and take off your glasses. A lens, however, can be focused at distances down to fractions of an inch, if necessary, in conjunction with a microscope.

As a result, photography enables us to extend the limits of our vision beyond our natural range not only toward the distance (with the aid of telephoto lenses and telescopes), but also in the opposite direction, enabling us to see, study, and show to other people, objects and aspects of our surroundings too small to be seen clearly by the unaided eye, or so minute that we cannot see them at all. This is still another potential of photography where the camera is superior to the eye—the realm of close-ups and photomicrographs,

a field offering alert photographers infinite opportunities for exploration and discoveries. The lesson:

The camera can extend our limits of vision beyond our natural range in two ways: by bringing close what is too far away, as well as enabling us to show through close-ups what is too small for the eye to see.

Variations of focus. The human eye "automatically" focuses itself almost instantaneously on subjects located at different distances. As a result, we feel as if we could see sharply, regardless of distance, everything at once. The camera, on the other hand, offers us a choice: either sharpness all the way from near to far, or sharpness limited in depth.

Sharpness all the way from near to far (by means of very small diaphragm apertures) has the advantage of creating images that closely duplicate normal visual impressions. On the other hand, sharpness of rendition limited in depth to almost any desired degree (by means of large diaphragm apertures in conjunction with lenses of long focal lengths) has the advantage of enabling the photographer to graphically single out and emphasize one specific subject plane in depth.

p. 112

Awareness of this particular difference between human and camera vision gives the creative photographer an opportunity to refine his images and, by means of a technique called "selective focus," to further increase the illusion of depth in his pictures, for example, by showing a face rendered in razor-sharp detail against a totally blurred background. The lesson:

The camera allows us to choose and limit the zone of sharpest focus in a picture, whereas the eye adjusts itself so rapidly that everything seems to be sharp at once.

Color versus black-and-white. The human eye is sensitive to color, whereas black-and-white film "sees" reality in shades or tones of gray. This photographic "shortcoming" of bygone days has, of course, long since been "corrected" through the introduction of color film. But don't make the mistake of writing off black-

and-white films as "old-fashioned" or obsolete. Some of the best photographic work is done in black-and-white, which not only gives the photographer a choice between an essentially naturalistic medium (color) and a basically graphic-abstract medium (black-and-white), but also has the advantages over color in that it is technically simpler, it is easier to control, and it is less expensive to utilize commercially.

Photographers working in black-and-white must learn to "see color in terms of gray." Even though subject color is transformed automatically into gray tones of corresponding brightness every time we take a picture on black-and-white film, the form which this transformation takes can, and frequently must, be controlled if the resulting picture is to effectively represent the subject. The reason for this is that colors differing in hue (for example, red and blue) but equal in brightness, which we perceive as very different and perhaps even complementary visual stimulants, would be rendered as two very similar, if not identical, shades of gray. As a result, the contrast effect (and graphic-tonal separation), which might have played a very important role in reality (for example, an arrangement of flowers in contrasting colors) would be more or less lost during translation from reality to photograph, and what appeared joyful and exciting to the eye in reality would end up as a drab and meaningless picture.

To avoid such disappointments, the black-and-white photographer must train himself to see color not as "color," but as brightness; and learn how to transform colors of different hues of more or less equal brightness into different shades of gray to indicate color differences in the subject through contrast between lighter and darker shades of gray in the picture. The means by which this is accomplished are colored filters; their use will be explained in Chapter VI. What is important here is that anybody working in black-and-white become aware of this difference in "seeing" and that he realize the necessity for evaluating color in terms of brightness which subsequently must be "translated" into specific shades of gray. The lesson:

p. 205

The black-and-white photographer must train himself to see color as brightness, and learn to control the transformation of

colors of equal brightness into different shades of gray, should this seem desirable in the interest of a better picture.

Cumulative exposure effects. The eye cannot add up light impressions, whereas the film accomplishes this with ease. If the level of illumination is too low, the eye ceases to function—we can no longer see. Not so the camera. As long as there is even the faintest trace of light—much too weak to be perceived by the eye—an image can still be formed on film through sufficiently long exposure.

This peculiarity of the photographic process is invaluable in many situations, from astronomy (where it enables scientists to get clear pictures of stars and galaxies much too faint to be seen directly even through the largest telescopes), to photography at night (where we can get pictures almost as detailed as if they had been taken in daylight if only we expose the film long enough)—another example of the superiority of the camera over the eye, and another opportunity to widen our visual horizons through creative exploitation of this unique photographic characteristic. The lesson:

Given a long enough exposure, the camera can render on film what the eye cannot see due to insufficient illumination.

Reaction to brightness changes. The eye adjusts itself automatically and almost instantaneously to differences in brightness by means of the iris—its "diaphragm"—which expands and contracts to control the amount of light reaching the retina. Not so the lens, whose diaphragm must be adjusted in accordance with the brightness of the incident light each time we want to take a picture, either automatically (if the camera features a built-in diaphragm- or shutter-coupled light meter), or manually.

This difference between human and camera "seeing" would be of little consequence were it not for the fact that brightness levels within one and the same subject can vary so much that the overall contrast span exceeds the capability of the film to record it. In reality, our eyes adjust themselves to differences in brightness almost as fast as we switch our gaze from brightly lit to deeply shaded areas of the subject. The camera, on the other hand, can be set to

yield satisfactory pictures only if subject contrast is "average." If subject contrast is too high, underexposure (of the darkest areas) and overexposure (of the brightest areas) can occur within the same negative or slide unless the photographer takes appropriate countermeasures. (How contrast can be controlled will be explained in Chapter VI.) At this point I only want you to become aware of the fact that, as far as ability to deal with contrast is concerned, the eye is superior to the camera; that you must evaluate your subject in regard to its contrast range; and that, if contrast is excessive, you must learn how to deal with this problem successfully. The lesson:

p. 194

> **The eye automatically adjusts to differences in brightness, and therefore, contrast. Camera and film, because they are much more limited in their ability to handle contrast, require expert control.**

Sensitivity to the spectral composition of light. The eye is rather insensitive to minor changes in the color of light; color film, however, reacts immediately and drastically with slides that have a "color cast."

p. 107

To convince yourself of the fallibility of your eyes in this respect, I suggest you perform the following revealing experiment: Take two light-balancing filters (for example, Wratten Filters 81 and 82 or pieces of cellophane or gelatin, one pale pink and the other pale blue). Look out the window, preferably on a gray, overcast day when the phenomena described in the following are most pronounced—the sky will appear gray. Then contemplate the same view for a minute or so through the pink filter—naturally, everything will now look pink. However, within a relatively short time, the eye will adjust to this pink shade and you will no longer be aware of it—the view outside the window will appear as it was before, as seen in ordinary daylight. Then, put the filter down and presto, the "unfiltered" view will all of a sudden appear decidedly blue. But again, within a short time, the blue impression will fade and the sky look normal again.

p. 200

Then make the same test with the pale blue filter. Seen through it, the view will obviously appear pale blue. But within less than a

minute of intensive contemplation, the sky will appear normal again. Now put the filter down and watch the "unfiltered" sky suddenly turn pink. But again, it doesn't take long before the eye adjusts itself once more and the sky looks normal again.

This dissimilarity in reaction to color between eye and color film is the cause of many an unexpected color cast. What the photographer had assumed to be "white" or colorless light actually was subtly tinted. His eyes, used to seeing familiar objects in certain colors, didn't notice this tint, but his color film did and reacted accordingly. What to do in such cases will be explained later. Here, I only want to draw your attention to the fact that, when it comes to assessing the quality of light, a photographer working in color cannot be content with simply "seeing," he also must ask himself: (1) Is the light filtered or reflected light? (2) Has the light's spectral composition undergone a change since emission from its source? (3) Has the light acquired a tint? Evaluating all this properly and employing accurate corrective measures will result in pictures that have no color cast. The lesson:

p. 199

Your eyes are fallible in judging the color of light. Learning to properly evaluate the tint of light can avoid pictures with a color cast your eyes were unable to anticipate.

Speed of visual recording. The eye requires a certain amount of time to form an image and have it processed by the brain; the camera can record a subject instantaneously.

This difference in human and camera "seeing" is significant because it enables a photographer to "freeze" on film even the most rapidly moving subject, either with the aid of high shutter speeds or by means of electronic flash. This is another instance of superiority of the camera over the eye. Properly utilized, it can help us to see and understand phenomena which otherwise might pass unnoticed or be forever unknown in detail. The lesson:

p. 123

The eye requires time to process an image, and cannot subdivide motion. The camera can record instantaneously, and freeze a moment which the eye could not single out.

Duration of image retention. The eye cannot retain an image for any length of time; the camera-recorded image is held forever. This difference between human and camera vision makes photographs priceless and indispensable aids to memory, their uniqueness in this respect threatened only recently by electronically recorded images on tape.

The fact that, at least in principle, a photograph is "forever" should be food for thought to all photographers, reminding them that anything which is potentially photographable should also be worth preserving. Unfortunately, very few photographs measure up to this requirement. Self-restraint, discrimination, and taste are qualities which, as far as the making of good photographs are concerned, rate even higher than technical skill. The lesson:

The eye cannot retain an image, but the camera-recorded image is held forever. Think before you shoot, and make sure your subject is worth preserving.

p. 226

Multiple images and image superimposition. The eye cannot handle more than a single image at one time; the camera, on the other hand, through multiple exposure or printing, can show us any number simultaneously.

This difference between human and camera seeing has made it possible to see and enjoy not only creative superimpositions like Jerry Uelsmann's sensitive, surrealistic photographs, but also Harold Edgerton's and Gjon Mili's breathtakingly beautiful motion studies by means of repetitive electronic flash—another priceless plus of the camera over the eye. The lesson:

The eye can handle only one image at a time. Photographic techniques can show us any number simultaneously.

Positive versus negative images. The eye sees everything "positive"; the camera, on the other hand, in addition to presenting us with positive images, is also capable of showing us the world as it would look if light and dark values were reversed—in the negative form. This is true not only in black-and-white, where light becomes dark and dark becomes light, but also in color, in the form

of transparencies and slides in which each subject color is represented by its complement—yellow as blue, blue as yellow, green as red, red as green, and so on.

This difference between eye and camera vision opens a new and unique field of creative activity to the artistically gifted photographer in search of new forms of graphic expression. This is the domain of the artist, the abstractionist, the surrealist—the man or woman who scorns all presently accepted standards of photography, and is concerned only with graphically acting out fantasies and exploring unknown worlds. The lesson:

The eye sees only positive images, but the camera can present positive as well as negative images, in black-and-white or color, thereby opening up a completely new world.

Other uniquely photographic effects. The eye is insensitive to all forms of electromagnetic radiation except light, whereas film is also sensitive to infrared, ultraviolet, and X-rays thereby enabling us to "see" otherwise invisible things and phenomena.

Another seldom-utilized aspect of the photographic process permits artistically gifted photographers to create strange and haunting images with the aid of solarization (more precisely, utilization of the Sabattier-effect, also known as "pseudo-solarization"). Or a negative and a diapositive can be combined, printed slightly out of register, and turned into a "bas-relief print" which, in abstract black-and-white, converts natural subjects into highly stylized, graphically fascinating designs. Not to forget the effects—solely produced by photographic means since non-existing in reality—of halation and flare, or star patterns created by exposing tiny, bright, light sources for relatively long times with very small diaphragm apertures—phenomena symbolizing brilliant light, which in graphically most effective form create impressions of radiance. The lesson:

The eye is unable to react to any form of electromagnetic radiation except light, whereas film can also "see" infrared, ultraviolet, and X-ray, and through appropriate manipulation, permit the creation of semi-abstract images, thereby giving the

imaginative photographer an opportunity to extend his imagery into new fields.

Conclusions

You now doubtlessly realize the importance of paying attention to the differences between human and camera vision and learning to "see like a camera."

Why is this so important? For two reasons: to avoid disillusionment in cases where the camera is *inferior* to the eye, and to take advantage of the possibilities for making better photographs in cases where the camera is *superior* to the eye. For it is a fact that a picture which shows the viewer something new, or shows him more than he could or would have seen in reality, is a better picture—more interesting, informative, stimulating, and hence enjoyable—than one that merely repeats impressions previously received by the eye.

Now you may perhaps be thinking: all this is very well, but too much for me, and much too complicated to recapitulate each time I take a picture. Relax—it only seems that way to you because it is new.

Permit me to cite an analogy: Does a writer, each time he starts work on a new book, read through a dictionary or consult a textbook on syntax before he puts pen to paper or hands to typewriter keys? Obviously not. Why? Because he already knows the meaning of the words, the synonyms from which to choose, the spelling, the grammar, the language. And the same is true in photography. To become a good photographer, you must learn certain basic facts about photography—neither more nor less than I tell you in this book. The rest must come from you—interest in the subject, concern, feeling for what's essential, taste, and creativity.

Obviously, anyone can take pictures without knowing anything about photography except which button to push to take "a snap." But, in that case, that's all he ever gets—a snap!

Is that what you want? I thought not. . . . Carry on!

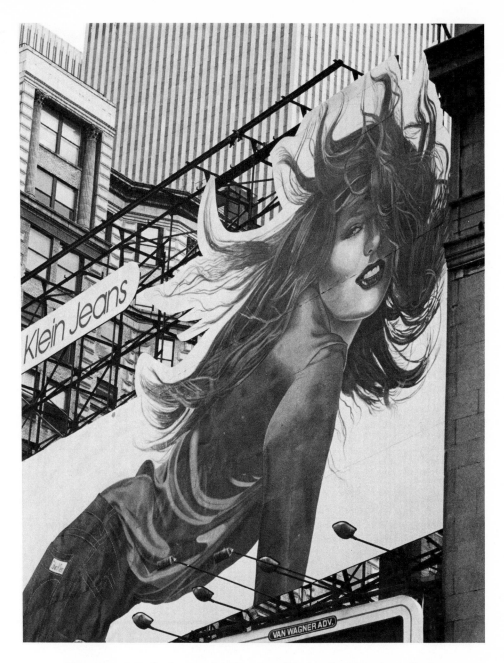

Use your eyes, look around, train yourself to "see" and render ordinary subjects in new and interesting ways. Like the Calvin Klein blue-jean girl high above Times Square in New York, a creature wild and beautiful, calmly watching the antics of the milling crowd below from her lofty billboard perch. The office buildings in the background spell "metropolis."

You always have a choice. Having found a subject that caught your interest (like, for example, these broken down windmills on Öland, Sweden), don't be content with only a single shot. As I said before, anything can be photographed in dozens of different ways, some, of course, more effective than others. Rarely will the first view make the best picture. So before you shoot, study the subject of your interest from as many different angles as possible, literally as well as figuratively. Make use of your privilege of choice in regard to different directions and angles of view, subject-to-camera distances and scale, focal lengths of the lens and perspective, direction and quality of the light, backgrounds (the sky is never wrong as a background and is often the best), and so on. And if you cannot decide immediately which one of all the available possibilities you like best, take many pictures. Film is the cheapest ingredient in making pictures—and you may never get a second chance at this particular subject again.

Capture the essence of your subject. The first time I saw Stonehenge I was completely overwhelmed by its monumentality—this ancient observatory on Salisbury Plain in England is truly the work of giants. To express this feeling in graphic form I had to give my pictures scale. Only by showing these hulking monoliths together with people could I hope, through juxtaposition of big and small, to indicate in my photographs the monstrous size of these stones. Consequently, I mounted a 100mm telephoto lens on my half-frame Olympus Pen FT SLR in order to minimize as much as possible perspective distortion and preserve the true proportions between the people and the stones, backed off accordingly, and waited for the right kind of tourist to appear in the right place. And to further strengthen the feeling of massiveness and weight I minimized the extent of the sky in many of my shots, filling most of the picture area with stone.

Timing can make or break your picture. The effect of the photographs on this spread depends not so much on subject matter as on split-second timing. The silent dialog between the supercilious mannequin in the window of a fashionable shop in Copenhagen and the admiring little girl lasted only a moment, as did the burst of exuberance by the two lady tourists having their picture taken in front of a topless bar by a friend. These are examples of what Henri Cartier-Bresson so aptly called "the decisive moment." To be able to recognize it when it occurs so that you can capture it on film is an essential aspect of "seeing."

Learn to recognize abstract beauty and design. A subject may attract a photographer for two reasons: either because he finds it intrinsically interesting or because it forms a graphically pleasing design. As far as I'm concerned, the latter was the case in regard to the pictures on this spread. In both instances, the proportions and distribution of light and dark——the abstract black-and-white effect—is such that I derived considerable aesthetic enjoyment from contemplating these "abstractions." This has nothing to do with the nature of the depicted objects. As a matter of fact, I could turn the picture of the tenement roofs (above) into a vertical position and the shot of the office buildings in New York (opposite page) into a horizontal position without diminishing their effectiveness. The implication is clear: Photographers with an eye for abstract beauty and graphic design can considerably increase the scope of their work relative to those who lack this special gift.

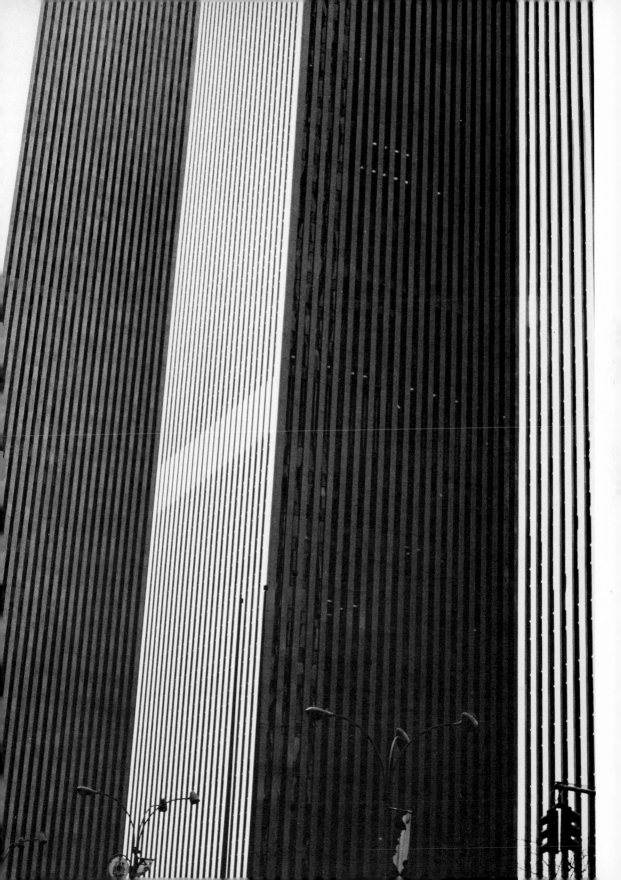

Approach the world with an open mind. To me, the city—any city—is a place of endless fascination. Roaming the streets with my camera, I never know what will happen next. I rarely look for specific subject matter or situations; instead, I keep an open mind. The pictures on this spread show some of my rewards: I found the relationship between the billboard message and the street scene shown on the opposite page significant, and I was touched by the tragedy inherent in the vandalized call for help depicted above. As far as I'm concerned, both pictures are documents—valid comments on modern life.

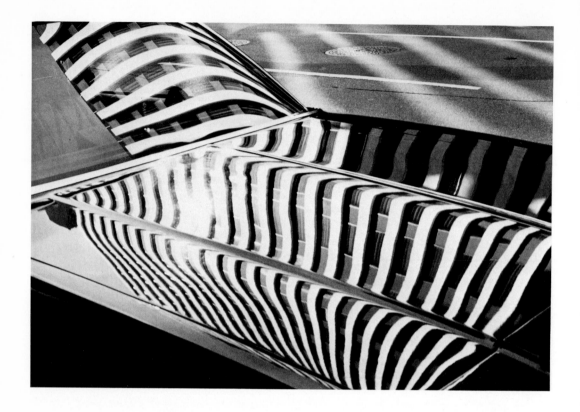

Look for the strange among the common. Photographs of familiar objects or events, unless done in an unconventional manner, are by their very nature less interesting and satisfying than the more informative kind of picture which makes us aware of something we hadn't noticed before. Examples of such sights are the images on this spread, reflections of buildings in an automobile (above) and in the glass curtain wall of a skyscraper (opposite page), grotesquely distorted by the poor quality of the glass. Phenomena of this kind—anything that is different from the run-of-the-mill subject matter, anything graphically exciting, strangely beautiful, fantastic or bizarre—can be found almost anywhere by eyes that know how to "see." They provide the basis for prize-winning photographs.

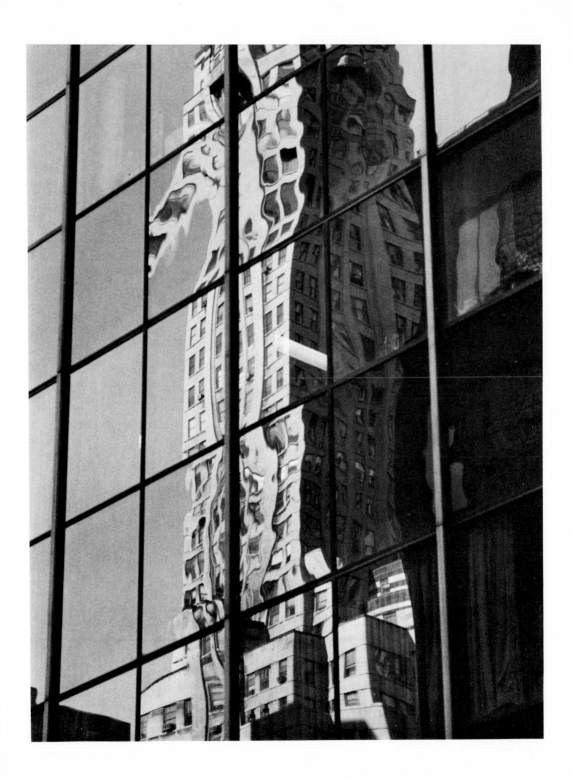

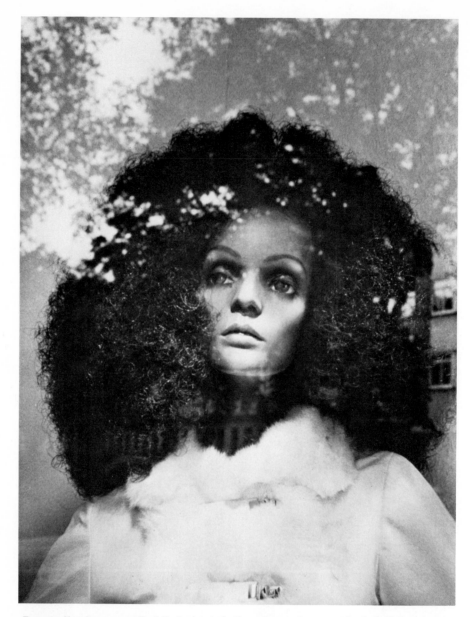

Beauty is where you find it; it also is in the observer's eye and mind. Things some people find beautiful and worth recording may be passed up by others who considered them ugly, commonplace, or dull. To me, the two store-window displays shown here are beautiful. I find the wistful expression of the mannequin appealing and the interpenetration of inner and outer space due to reflections in the windowpane a satisfactory symbolization of space. And the arrangement of the shop window display paraphernalia (opposite page), with its strange, semi-covered shapes, fulfills all the conditions for successful creation of an aesthetically pleasing abstract composition.

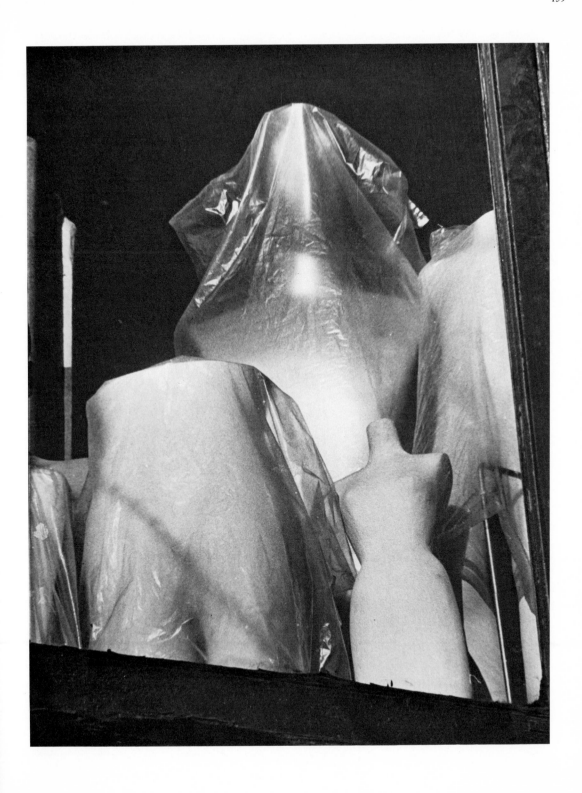

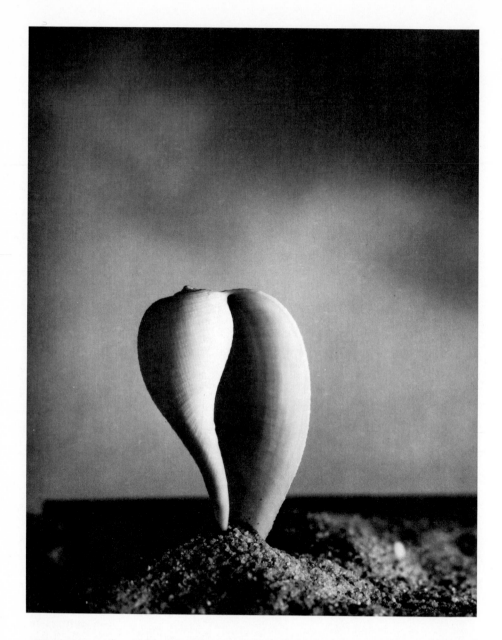

Create your own world of fantasy. I found this fig shell on the beach, stuck it in the sand, and photographed it against a background of sea and sky. The resulting image, I'm happy to say, reflects the essence of my experience on that particular day: the aesthetic pleasure evoked by contemplation of the exquisitely curving forms of the shell, the feeling of freedom, the sense of space and eternity. Through photography, I was able to express a personal fantasy and preserve forever a treasured memory. I see no reason why you, in your own individual way, shouldn't be able to do the same.

V. You Always Have a Choice

Any subject can be photographed in an infinite number of ways, some of them, of course, more effective than others.

Photography is picture language. It can be mastered only by those who are familiar with its particular symbols and forms of expression. Getting to know these graphic elements is less difficult than learning how to read and write, but just as indispensable if you want to express yourself effectively in picture form. Why? Because both literary and visual statements can be formulated either elegantly or clumsily; and yet, in both cases, the "spelling" may have been correct.

Let me give you an example: The picture editor of a magazine wants to hire a new photographer. He is considering several names—how should he go about finding the "best"? He might ask each of them to shoot the same subject or picture story. All, of course, would be accomplished technicians (otherwise, they wouldn't have been considered), so the technical quality of all the resulting pictures should be unassailable; no difference in this respect.

What would be different, what would distinguish the work of one photographer from that of another, would be the attitude with which each of the contestants approached the job—the way of conceiving the subject in terms of pictures and the specific means chosen to implement this view. This is where the picture editor would put the emphasis, *on the creative aspects* of photography, the seeing, the feeling, the mood . . . the way light strikes the subject, and the particular character and quality of this light. . . . Space rendition in terms of perspective, scale, relative proportions of the dif-

ferent picture elements, degree of foreshortening and diminution. ... Sharpness throughout, sharpness limited to a specific zone in depth (selective focus), or motion-indicating blur. ... Color selection, color relationships and harmonies, colors subtle or bold, warm or cold. ... Contrast higher or lower to symbolize specific subject qualities ... and so on. Because, provided the subject is valid, it is on the basis of such subtleties of presentation that we judge whether a photograph is outstanding, average, or dull.

Today, a good photographer is a man or woman who is no longer satisfied to produce pictures that are merely correctly focused, exposed, developed and printed. Such technicalities are nowadays taken for granted. No matter how sharp a photograph and how natural its colors, it still can be the world's most boring picture.

Why? Because, as I keep pointing out, the How—the "technique"—is *not* the end, the criterion by which to judge a photograph, but only the servant of the WHY, the WHAT, the WHEN. It is the concept of the subject that decides the means that must be used. And as a good writer knows grammar and spelling, synonyms and different literary forms of expression, so a *good* photographer must know the devices and techniques that will fit his expressive intentions precisely. To be able to do this he must know them all.

In the following I am going to tell you how *you* can control your pictures and get everything "just right." I'll show you how to modify basic aspects and means to make them do exactly what you need to implement your views. You will find that this will make the difference between pictures that merely *represent* the subject they depict and photographs that are interesting, stimulating, and thought-provoking *interpretations*. The first type shows the viewer nothing new, nothing that he hadn't seen or thought before. They are only record shots (there is nothing wrong with record shots, of course, in their proper place). But the latter can make the viewer aware of something he hadn't experienced before and thereby enrich his mind.

To produce interpretations instead of representations, a photographer must possess two qualities: *vision* and *craftsmanship*. Vision—

the power to recognize the essence of a subject and translate it into graphic form—is a mixture of perceptiveness, sensitivity, imagination, interest in the subject, and that intangible quality called "talent." It is a gift a person either does or does not possess. It cannot be taught. Craftsmanship, however, can be acquired by anyone willing to make the effort. And the basis of this effort, in addition to dedication and plain hard work, is experimentation. Here is a list of the more important options with which you must experiment— the options from which a photographer must choose.

Subject approach and rendition

Distance between subject and camera—long or overall shot, medium-long shot, close-up. *p. 62*

Direction of view—subject seen from the front, more or less from one side, from the back, from above, from below. *p. 63*

Angle of view—from very wide to very narrow. *p. 62*

Background and foreground—the choice is unlimited. *pp. 64, 69*

Light *p. 71*
Brightness—from very bright to very dim. *p. 77*

Color—"white" (colorless) light, more or less tinted light, strongly colored light. *p. 81*

Direction—frontlight, sidelight, backlight, light from above, light from below. *p. 83*

Contrast—high, medium (average), low. *p. 86*

Type of light—radiant light, direct light, reflected light, diffused light, shadowless light, filtered light, polarized light; natural light, artificial light; continuous light, discontinuous (flash) light. *p. 92*

Space rendition and perspective
Wide-angle, normal, telephoto perspective.

Academic rectilinear, true rectilinear, cylindrical, spherical perspective.

Presence or absence of perspective distortion, degree of perspective distortion, type of perspective distortion.

Indicator of scale present or absent (scaleless rendition).

Motion rendition
Motion "frozen," motion symbolized by blur of various degrees, motion symbolized by panning.

Multiple exposure (superimposition in the negative or print), multiple exposure by means of repetitive electronic flash (stroboscopic light).

Picture sequences.

Equipment
Cameras—for dynamic and static subjects; instant-picture cameras, wide-angle cameras, panoramic cameras; aerial cameras.

Lenses—standard, wide-angle, telephoto, zoom, high-speed, macro (close-up), fisheye lenses; teleconverters (focal length extenders).

Filters for color photography—light-balancing, color compensating.

Filters for black-and-white photography—correction, contrast, infrared.

Filters for both black-and-white and color photography—ultraviolet (haze), polarizing, neutral density.

Photo lamps—photoflood lamps from small to large, spotlights from small to large, fluorescent tubes, flashbulbs, electronic flash.

Film

p. 106

Choose between color and black-and-white film:

Color pictures—choose between large (2¼x2¼-inch and larger) transparencies suitable for viewing, slides (35mm) suitable for projection, and color prints on paper in any desired size.

Color film—choose between positive (reversal) film for transparencies and slides, and negative (non-reversal) film for paper prints; choose between Daylight Type color film for use in daylight and with electronic flash, and Type A or tungsten (Type B) color film for use with 3400K photoflood lamps or 3200K professional tungsten lamps, respectively.

p. 107

Black-and-white film—choose between general-purpose films, thin-emulsion films, high-speed films, and infrared films.

p. 108

Technique-related controls

You have the following options:

Lighting—natural light (low degree of control) or artificial light (high degree of control); direct light or indirect light (bounce-light, reflected light, shadowless light); single light-source or multiple-lamp lighting schemes; floodlight or flash; auxiliary illumination for shadow fill-in and contrast control.

p. 92

Diaphragm apertures—from small to large for greater or lesser extent of the zone of sharpness in depth.

p. 112

Shutter speeds—from high to low for "freezing" or "symbolizing" subject motion, respectively.

p. 113

Print control in black-and-white—lighter or darker prints; more or less contrasty prints; local contrast control through dodging and burning in; different scales of enlargement; print proportions—horizontal, vertical, or square; unlimited possibilities for cropping the image during enlarging (printing only specific areas of the negative in various sizes and proportions).

As you can see, the list of options at your disposal is quite impressive. As a matter of fact, it is infinite, because almost any one of the options listed above can be used in conjunction with several or many of the others in an endless variety of combinations, and quite a few contain within themselves an infinite number of different degrees. That is why I opened this chapter with the statement that any subject can be photographed in an infinite number of different ways.

Tests and experiments—the wellsprings of technical proficiency

The way I see it, tests and experiments are indispensable for acquiring photo-technical skills. Learning from books is important as a shortcut to success through theoretical knowledge; tests and experiments are essential to transform knowledge into performance through the acquisition of practical skills.

Let me explain: testing comes first, experimenting afterward. We *test* our photographic equipment and materials to make sure they are up to standard and perform the way they should. Then, we *experiment* with them to find out what they can and cannot do.

Testing is basically a *selective process*. In a rigidly controlled way, we try to learn how good something is, or which one of a number of allegedly similar or identical items is the best for a specific purpose.

Experimenting is a *process where "everything goes."* It is guided by curiosity, inspiration, and a spirit of adventure in accordance with the motto "let's see what happens, if. . . . "

For example: You want to buy an additional lens for your 35mm single-lens reflex camera. There are several brands on the market which fit both your camera and your specifications, each claimed by its manufacturer as outstanding in its field. Which one should you buy? You ask your friends and colleagues, but their opinions are divided. Looks and price don't tell you anything about actual performance. So the only way to find out which one is "the best," as far as you are concerned, is to make a test.

Here is how you should proceed: Borrow from your friendly photo-dealer one sample of each of the lenses you are interested in and test them in accordance with the following principles:

Standardize. Make it a practice always to use the same testing equipment for a specific kind of test, set up in the same way and operated under the same conditions. Use a standard lens testing chart. Otherwise, a fair and valid comparison of the results of different tests would be impossible; the whole effort would be a waste.

Eliminate falsifying factors. Be careful to exclude all factors which accidentally might falsify the test results. When testing lenses for sharpness, for example, should the negative or slide turn out unsatisfactory in regard to sharpness, make sure that this is actually caused by the lens and not by external influences. Specifically, when testing lenses, always mount the camera on a tripod instead of making hand-held shots to exclude the possibility of unsharpness due to accidental camera movement during the exposure. Should the floor of the test room be weak, a person walking on it during the exposure might conceivably cause enough vibration to invalidate the test, causing unsharpness in the test film as the result of vibration rather than an inferior lens. For the same reason, always trip the shutter with a cable release instead of pressing the release button directly. And if the lens is relatively long (like certain zoom and telephoto lenses), it is advisable to support the front end of the lens separately to exclude any possibility of vibration; for the longer the focal length of a lens, the more sensitive it is to vibration which is magnified in direct proportion to its focal length.

Prepare set-ups correctly. Other potential causes of unsharpness in test negatives which are not the fault of the lens are misalignment of camera and test chart and sloppy focusing. To avoid the first, ask a friend to hold a small mirror flat against the wall in the center of the test chart, then place your tripod-mounted camera in such a way that, after focusing, you see in the center of the

viewfinder the image of the front of the lens being reflected in the mirror. And to avoid the second possibility, make several exposures under identical conditions but refocus the lens prior to each shot, using a focusing magnifier whenever possible.

Keep accurate and complete records. When testing a lens, for example, write its brand name, focal length, relative aperture, and serial number on a small card, and attach this card to your test chart. Before making an exposure, write the *f*-stop that will be used on another little card and include it in your test set-up. This way, by photographically recording all important data directly on the film, they become a permanent part of the test picture and can never be mixed up afterward or lost. Be careful, of course, to remember to change the *f*-stop number on your chart if the next shot is to be made with a different diaphragm aperture.

Experimenting. Whereas the purpose of testing is to learn how good something is or how well it performs, the reason for experimenting is to find out what something can do—its range and limitations. Testing, therefore, is a prerequisite for sound photographic technique and experimentation indispensable for exerting pictorial control.

For example: you want to photograph a landscape in black-and-white on a beautiful spring morning. There are distant vistas framed by stately trees and a pale blue sky enlivened by fleecy clouds. Actually, it was the springlike quality of the sky which inspired you to make the picture, and your problem is now how to get the sky "just right," neither too "heavy," nor too pale. Which *p. 205* filter should you use?

This is a typical case where prior experimentation with different filters would pay off handsomely in the form of a "perfect picture." It is entirely up to you how this sky will appear in your photograph: Shot through a blue filter, the entire sky would be rendered uniformly white and the clouds would disappear; an unfiltered shot would show white clouds on a very light-gray sky—contrast between sky and clouds would be extremely low. A yellow filter would render the blue sky somewhat darker, and a red filter would

make it darker still and rather on the heavy side. Finally, a combination of red filter and polarizer would render the blue sky in a very dark shade of gray, and if such a negative were to be printed on contrasty paper, the sky could be made to appear black. So, you see, merely by using the appropriate color filter, you could render the clouds and sky all the way from white-on-white through white-on-different-shades-of-gray to white-on-black. Figuratively speaking, your options range from a gentle, almost imperceptible caress to a brutal, smashing blow. This is control.

Control in photography is necessary because, as I explained before, the eye and the camera "see" things differently, and often the uncontrolled image does not reflect the impression which the eye received in reality. Fortunately, you always have a choice between many different forms of rendition and, provided you did your "homework" and know your options, you can choose the one most likely to produce the best result. This means exerting control. *p. 127*

In photography, control begins with what musicians would call "finger exercises" or "playing scales." Translated into terms of photography, it means that you must explore the full range of every photographic aspect capable of modification. To give a few examples: Film exposure can be varied from disastrous underexposure to catastrophic overexposure; in black-and-white photography, any color, through appropriate filtration in conjunction with printing on a paper of suitable gradation, can be rendered in almost any shade of gray; a three-dimensional subject can be photographed either distortion-free or more or less distorted, and it can be rendered in any one of four different forms of perspective: academic rectilinear, true rectilinear, cylindrical, and spherical. And so on. *p. 205**p. 214*

Normally, of course, nobody would photograph one and the same subject through, say, the whole range of color filters from red to blue; nobody—except the person who wants to learn which filter has which effect. Normally, manifestations of graininess in the negative, lens flare and halation, are considered faults if they show up in a print; occasionally, however, these same "faults" can become graphic symbols of some intangible subject quality which *p. 191*

cannot be expressed in any other form. Hence, an ambitious and creatively motivated photographer must study such apparent "mistakes," too.

All this may sound tedious and time-consuming, and, believe me, it is. But such is the price of learning, of developing craftsmanship, of acquiring mastery over your medium. It is the only way to perfect your "technique" and eventually enable you to produce any desired graphic effect at will.

In the following section are do-it-yourself assignments—finger exercises—which I hope you will execute in careful accordance with my instructions. Each will be accompanied by whatever technical information may be required. Some must be shot in black-and-white, others in color. The results—proof prints or slides—should always be saved, whether or not successful, and each set should be mounted in a suitable way for future reference. (It is a fact that we learn more from our mistakes than from our successes.) The order of these assignments roughly follows the order in which I discussed the respective topics in this book. They range from the apparently obvious to the most unlikely which, in that "one-in-a-million case," might provide the only acceptable solution to a knotty graphic problem—and give you a smashing picture. So let's proceed.

VI. Twenty Assignments

Assignment 1
Focusing and depth of field

By now you have learned that a lens can be focused on only one specific plane at a time at a specific distance from the camera; that the zone of sharpness in depth can be increased by stopping down the diaphragm, and that focusing the lens on a plane approximately one-third within the depth-zone that must be covered sharply enables the photographer to create a maximum of sharpness in depth with a minimum of stopping down.

p. 112

pp. 122-123

However, reading about an operation, a process, or a graphic effect is one thing; doing it yourself and experiencing it in actuality is another. The difference between theory and practice, and between knowledge and performance, is that in photography, as anywhere else, it is performance that counts. Therefore, I suggest you perform the following experiment, regardless of how obvious it may appear; it will help you become a better photographer, more aware of the subtleties and nuances of your craft.

Prepare a tabletop set-up consisting of three objects arranged in depth: a grille in the foreground (through which you shoot your pictures), a wall poster with large type in the background, and a small plaster or china figurine placed about one-third of the distance from the grille to the poster. Distance between foreground and background should be approximately four feet. Shoot two series of pictures using a lens of standard focal length:

1-1. Take three photographs with the diaphragm wide open, focused on the grille (foreground), the figurine (middle

ground), and the poster (background), respectively. Analyze distribution and degree of sharpness and unsharpness in these three pictures. In the first, the grille will appear sharp, the figurine blurred, and the poster all but unrecognizable. In the second shot, the figurine will be sharp while the grill appears transparent, the poster blurred. And in the third, the poster will be sharp, the figurine blurred, and the grille will all but disappear.

Evaluation. From this you should learn that *focusing selectively* with the diaphragm more or less open enables you to single out one specific zone in depth, thereby achieving a double result: (1) Objects situated within this zone (or close to it) will be graphically emphasized through sharpness while those in front of or behind it appear increasingly blurred. (2) Contrast between sharp and unsharp creates the illusion of depth, a fact which will become even more apparent if you compare this set of pictures with those resulting from the following experiment.

1-2. Photograph the same set-up three times, with widely differing f-stops, focusing first on the grille, then on the figurine, and finally on the poster. This time, don't limit yourself to a single shot of each of the three targets, but take a series of three or four exposures with different diaphragm stops, including the largest and the smallest. Compare the results.

Evaluation. This time you will learn the degree to which stopping down the diaphragm increases the zone of sharpness in depth, and will be able to convince yourself that the illusion of depth and space decreases proportionally as sharpness in depth increases.

Assignment 2
Sharp-unsharp-blurred
First, a clarification: photographers must distinguish between unsharpness and blur. *Unsharpness* is caused by inaccurate focusing or by using a diaphragm aperture that is not small enough to create sufficient sharpness in depth; it has nothing to do with motion of either the subject or the camera. *Blur* is caused by movement during the exposure, either of the subject or the camera; it has nothing to do with focusing or stopping down the lens.

To learn how to distinguish between the different forms of "non-sharpness," perform the following experiments. As a test subject, find a place in the street that combines the following features: on the opposite side of the street, a storefront with writing in large letters (perhaps the firm's name on the shop window); traffic (automobiles or pedestrians or both) passing in front of it; and in the foreground, on your side of the street, a prominent poster or traffic sign. With the camera mounted on a tripod, shoot at right angles across the street, making sure to include both the store on the other side and the poster or traffic sign in the foreground somewhere in the picture. Take four shots in accordance with the following instructions:

2-1. Faulty focusing. Placing your camera six to eight feet from the poster or traffic sign in the foreground and using a moderate wide-angle lens, focus at a distance of only three feet and shoot with the diaphragm wide open. The entire picture will be out-of-focus—nothing is sharp.

You can diagnose faulty focusing by the fact that *everything important is unsharp* in the picture, and that this unsharpness is *non-directional,* that is, evenly spread out in all directions. To avoid this fault, focus accurately on the subject.

2-2. Faulty f-*stop.* From the identical camera position, focus sharply on the poster or traffic sign in the foreground, then take the picture with the lens wide open. The sign will appear sharp; the rest of the picture unsharp.

You can diagnose this fault by the fact that *only certain picture elements are not sharp while others are sharp,* and that unsharpness is *non-directional.* To avoid this fault, use a smaller diaphragm aperture to extend the zone of sharpness in depth until it covers the entire depth of your subject. To assure maximum depth with a minimum amount of stopping-down, focus on a plane one-third within the depth of your scene as recommended and explained before.

pp. 122-123

2-3. Wrong shutter speed. From the identical camera position, shoot the same scene at a shutter speed of 1/5 or 1/2 second and a correspondingly small diaphragm stop.

You can diagnose this fault by the fact that *all stationary picture elements are rendered sharply while everything that was in motion is blurred.* This time, "unsharpness" (blur) is *directional* in the direction of the motion. To avoid this fault, use a higher shutter speed.

2-4. Camera moved during the exposure. Take the camera off the tripod and shoot the same scene at 1/2 second, holding the camera loosely in your hand and moving it slightly during the exposure.

pp. 40-41

You can diagnose this fault by the fact that *everything is blurred,* the stationary picture elements as well as those that were in motion, and that unsharpness is *directional,* this time in the direction in which the camera was accidentally moved during the exposure. If you photograph with the camera hand-held, to avoid this fault, shoot at a shutter speed not slower than 1/125 second; otherwise, use a tripod.

Evaluation. Learning to distinguish between these four forms of "non-sharpness" is important for two reasons: (1) to properly evaluate an unexpectedly unsharp or blurred slide or negative so that the respective fault can be avoided in the future; and (2) to assess the graphic effects of these normally undesirable manifestations. Occasionally, however, non-sharpness can become a valid means of expression—for example, deliberate limitation of the zone of sharpness in depth (selective focus) as a means of symbolizing depth and space through use of a "faulty *f*-stop," or directional

p. 225

blur due to subject movement as a highly effective photographic symbol of motion.

Assignment 3
Variations in exposure
According to traditional photographic practices, an exposure is either correct or incorrect; a slide or negative is either correctly exposed, overexposed, or underexposed. This is no longer true in holistic photography, where variations in exposure are recognized as valid means for achieving specific effects. To familiarize yourself with this technique, perform the following experiments.

3-1. In softly diffused light (this is important), take a series of color photographs of a person, bracketing your exposures so that they range from pronounced underexposure to pronounced overexposure. Mount the slides side by side and assess their effects.

Evaluation. The shorter the exposure, the darker the colors and the heavier the overall effect of the slide. Conversely, the longer the exposure, the lighter the colors and the more delicate the overall effect of the slide. Now, while usually a normal-appearing color rendition will be most appropriate, occasionally it may be desirable to deviate from the standard in order to create a specific impression—a *high-key* or a *low-key* effect. The first would give the picture a more airy and joyous appearance; the second would evoke a more serious and somber mood. Either might be just what is required to bring out specific intangible subject qualities and thereby produce a better picture than the standard approach.

3-2. Using black-and-white film (this is important), take a series of six to eight exposures of a dimly illuminated street or alley at night. Again, bracket your exposures to range all the way from total underexposure to total overexposure, from, say, one second to ten minutes at $f/5.6$ on Tri-X Pan film. Have your film developed and compare the proof prints.

Evaluation. You will find that the first picture of your series shows *less* detail than you could see in reality at the moment of exposure, while the last one shows *ever so much more,* giving almost the impression of a daylight shot. The reason: Unlike the eye, film has the ability to add up weak light impressions and thereby yield pictures that show increasingly more detail, the longer the exposure, even under circumstances where the eye saw nothing but barely differentiated darkness. Although rarely required, this is a priceless quality, a creative tool which lets you extend the scope of human vision far beyond its inherent limitations for such uses as night and astronomical photography.

However, there are restrictions. Completely satisfactory results can only be achieved if subject contrast is relatively low. If subject contrast is high, the lighter areas (for example, bright street lights at night) will be catastrophically overexposed before the darker areas have had time to accumulate sufficient density within the film emulsion. And not only will bright areas be overexposed, they will also be surrounded by halos which expand with the length of the exposure and spill over into adjacent areas, obliterating detail.

Assignment 4
Exposure equivalents

pp. 59, 113
As mentioned before, a perfect exposure can be accomplished in many ways through appropriate combinations of different *f*-stops and shutter speeds although the effects in regard to depth of field and rendition of subject motion would be very different. To actually see how these differences manifest themselves in your slides or prints, I suggest you perform the following exercise:

From the same camera position and using daylight color film, photograph a street scene with different combinations of f-*stops and shutter speeds,* ranging from very short exposures intended to "freeze" subject motion (pedestrians and cars) to very long exposures designed to create a maximum of sharpness in depth. Make the first exposure with the diaphragm fully open (using a correspondingly high shutter speed), the last one with the diaphragm stopped down to its smallest aperture (using a correspondingly slow shutter speed). To avoid unwanted blur due to accidental camera movement during the exposure, mount the camera on a tripod.

Evaluation. Compare and evaluate the results. Which is more
p. 222
p. 121
important: "freezing" subject motion or maximum extent of sharpness in depth? Or, perhaps, a compromise—the result of some intermediate *f*-stops and shutter speeds? Learn what the different combinations of *f*-stops and shutter speeds will do so you will be able to use the right one at the right time.

Basically, "freezing" of subject motion and creation of maximum extention of sharpness in depth are mutually exclusive. However,

the higher the speed of the film, the higher the degree to which these two picture qualities can be achieved within the same shot. This is the most important of the few advantages which high-speed films have over films of average speeds.

p. 109

Learn to work with light

In my opinion, light is the most important non-technical factor which decides whether you are going to make it as a photographer or fail. Therefore, it is vitally important that you learn to assess available light correctly, to choose the right kind of artificial light, and to control your illumination—that is, to work with light. And since artificial light is easier to control than natural light, I suggest you start your experiments with it.

p. 72

When I speak in the following of artificial light, I have primarily incandescent light in mind—photoflood illumination. Light emitted by electronic flash ("speedlight") or fluorescent lamps, although basically, as far as its effect on the picture is concerned, subject to the same considerations as incandescent light, is here of less interest because the correct use of speedlight illumination from the camera position is adequately covered by the instructions that accompany the flash unit; fluorescent light is already outside the scope of this guide.

p. 98

To work successfully with photoflood illumination—that is, electricity—requires adherence to certain rules. Here is what you should know:

Be careful not to overload your house circuits by using too many photo lamps simultaneously. To determine how many lamps can safely be connected to one circuit, multiply the voltage of the powerline by the number of amperes of the respective fuse. To find the correct fuse, connect a lamp to the outlet you intend to use, turn it on, then go to the fuse-box (or circuit breaker panel) and disconnect one fuse after another until your lamp goes out—this is the fuse you want. Read off the number of amperes which it is designed to handle and multiply this figure by the voltage of the powerline, which normally is 120. If the fuse is designed to accommodate 15 amps (most household fuses are), the result would be

1800—the number of watts you can safely draw from the respective outlet. Now, all you have to do is to divide 1800 by the wattage of your photo lamps—500 or 250 as the case may be—and you know how many lamps you can use: either 3 lamps of 500 watt each for a total of 1500 watts plus 300 watts for general room illumination and a radio; or 3 lamps of 500 watts each plus one 250-watt lamp for a total of 1750 watts; or 7 lamps of 250 watts each for a total of 1750 watts, and so on. As long as you don't draw more than 1800 watts you are safe; if you draw more, you will blow the fuse.

A fuse is the safety valve of the powerline; it is designed to melt and thereby protect the line in case of overload. Therefore, replacing the proper fuse with a stronger one, a wad of aluminum foil, or a coin is stupid (and illegal) because, in the case of overload, it now would be the powerline which melts instead of the fuse—a costly and dangerous event which can start a fire that might burn down the house. If you blow a fuse, find and eliminate the cause of its demise before your replace it with a new one; it may be a simple case of overload (in that case, use fewer lamps simultaneously or disconnect other appliances temporarily from this particular circuit) or it may be due to a short circuit somewhere in your equipment, a lamp fitting, a connecting wire, an outlet, or a plug.

The chances of blowing a fuse can be substantially reduced by heeding the following advice:

Do not use electric wires that have cracks in the insulation or broken plugs; replace them with new ones.

Make sure that your wires are of suffciently heavy gauge. After your lamps have been burning for a while, get a tight grip on the cord and "take its temperature." It may feel warm but should never get uncomfortably hot—a sign of an overloaded wire.

When disconnecting a plug, don't just grab the cord and yank—you may tear the wire from one of its contact points. Instead, take a firm hold on the plug itself and pull it out straight.

Place temporarily strung cords so that people cannot trip over them. Lay them along walls, behind furniture, cover them with rugs.

The best way to join two extension cords is by making a plug connection. If you prefer a splice, solder both connections first, then insolate each of the two strands separately with electric tape before you tape the entire splice.

When buying electrical equipment or wiring, give preference to items that carry the UL (Underwriters Laboratories) label. It is a guarantee that they conform to certain minimum safety standards which products lacking this label may not meet.

Assignment 5
Principles of illumination with one lamp
Your subject for this assignment is a white cube. If necessary, make one yourself out of stiff white paper or cardboard and adhesive tape. Place this cube in front of the camera in such a way that three of its sides will be visible simultaneously in the picture and photograph it four times from the same camera position illuminated in accordance with the following instructions:

5-1. With only a single photoflood lamp, illuminate the cube in such a way that its three visible sides reflect the same amount of light. You do this by placing the lamp slightly higher than the camera and more or less in line with the lens. The cube, illuminated by pure front light, will look "flat" instead of three-dimensional.

p. 84

5-2. Slightly shift the lamp horizontally to one side and illuminate the cube in such a way that its top and one vertical side reflect the same amounts of light while the third side gets less light and appears darker. The cube will no longer look "flat" but will begin to suggest a form in space.

5-3. Move the lamp to a position which will result in a space-suggesting illumination—an illumination in which each of the three visible sides of the cube appear in a different degree of brightness: the top pure white, the "front" a medium gray, and the "side" virtually black. The image of the cube will now appear three-dimensional.

5-4. Without changing anything, take a piece of white cardboard or paper and, using it as a reflecting panel, throw some light on the "black" side of the cube, illuminating it with reflected light (that is, your photoflood lamp illuminates the panel, which in turn illuminates the cube). Notice that by changing the distance between subject (the cube) and reflector (the panel) you can give the shadow side of the cube almost any desired degree of lightness. If instead of the cardboard reflector, you use a mirror, you can make the shadowed side of the cube appear as light as the brightest side.

p. 72

Evaluation. Merely by manipulating a single light source in conjunction with a reflecting panel, you can render any three-dimensional subject in any desired form from "flat" to "three-dimensional." What is important is this: As already discussed, light and shadow are the most effective means for creating illusions of depth and space. If a subject has three extensions in space—front, side, and top—and all are visible in the picture at the same time, light and shadow can be used to separate these elements graphically by rendering them in different degrees of brightness. This is the principle of any good lighting scheme regardless of subject matter and number of lamps involved. Once understood, it can be varied in innumerable ways—light can be made to dominate over shadow or shadow over light, contrast can vary from low to high, shadows can be soft or bold, detailed or pitch black.

Just for fun, get yourself one of the little plaster-of-paris copies of the Venus de Milo and, using only a single lamp in conjunction with a reflecting panel, try to get as many different graphic versions of it as you can think of, all identical in regard to angle of view, scale, and background, but each illuminated differently with only a single lamp. I once did this exercise myself and exposed an entire roll of film, 36 different versions, from light to dark, soft to harsh, in frontlight, sidelight, and backlight, with light and shadow subtly emphasizing the form in countless different ways, some of them, of course, more effective than others. Go to it, have fun—and learn!

Assignment 6
Principles of illumination using several lamps

Your subject is a live model; your illumination, three identical photoflood lamps, one small spotlight, and four light stands.

6-1. Preparation. Seat your model facing the camera in a relaxed, natural pose far enough in front of a neutral background so that the model's shadow cannot fall on it. Extinguish the room lights but turn on a small table lamp somewhere in a corner. Its light, while not strong enough to interfere with your portrait lighting scheme, will help you to see until you have lit your photo lamps. If possible, get someone to assist you—a person who can shift your lamps around while you stand behind the camera (which should be tripod-mounted) and assess the lighting effects.

6-2. Place the main light. Use an undiffused 500-watt photoflood lamp in a reflector. This is your most important light. Its placement, through distribution of light and shadow and establishing the ratio of light to dark, determines the character of the illumination and thereby sets the picture's mood.

The purpose of the main light is to bring out the characteristic features of the head in terms of the underlying bone structure, its hollows and elevations, curves and planes. Don't worry if shadows appear too harsh and black as long as they appear in the right places, graphically modelling the face; in a moment I'll show you how to lighten them to any desired degree.

To start, place the main light six feet from the model and slightly to one side; the center of the lamp should be about six inches higher than the level of the model's eyes. Take all the time you need, work carefully, and try different positions because, with shadows falling on curved surfaces like cheeks, shifting the lamp a few inches one way or another can make the difference between a successful and a disappointing picture. As long as the main light is well placed, the basic design of the portrait will be good and what's left is mainly a matter of contrast control with the aid of the fill-in light.

p. 87

p. 38

pp. 195-196

6-3. *Place the shadow fill-in light.* Use the same kind of photoflood lamp as for the main light. Later, when you have more experience, you may want to soften its light with the aid of a diffuser. The fill-in lamp should be placed in line with and immediately above the lens axis since, in this position, the shadows it casts are virtually invisible from the camera position, thereby avoiding the possibility of shadows within shadows or two sets of shadows—faults which would spoil the clarity of the rendition.

Distance between model and fill-in light should be more or less the same as that between model and main light. If this is the case, provided both lamps are identical, subject areas illuminated by both main light and fill-in light would receive two units of light, while those that lie in the shadow cast by the main light would receive only one light unit (from the fill-in lamp). As a result, the lighting contrast ratio would be 2:1, which is ideal for the average color portrait.

The purpose of the fill-in light is to balance illumination in regard to contrast in accordance with the intentions of the photographer. Normally, this means that subject contrast must not exceed the contrast capability of the film (which is considerably more limited in color than in black-and-white). Occasionally, of course, high contrast can be precisely what the photographer wants, in which case the shadow fill-in lamp may not be needed at all. Examples of this kind of work are Richard Avedon's memorable portraits, which often consist entirely of pure, unadulterated black and white. However, if a fill-in lamp is used, its light must not in any way alter the distribution of light and dark established by the main light. Its only purpose is to decrease contrast.

6-4. *Place the accent light.* Use a small spotlight for this purpose. Its function is to enliven the picture by adding sparkle to the model's hair and, perhaps, edge-lighten the outline of a cheek.

To be effective, the accent light must be placed somewhat behind and to one side of the model, furnishing a beam of sharply directional backlight. In this position, it cannot cast objectionable shadows visible from the camera position but it could hit the lens and

cause flare and halation on the film. This possibility can be avoided if a cardboard shield (called a "gobo") is placed between spotlight and lens outside the picture area.

Placing the accent light correctly is a rather critical operation. If no assistant is available to shift the lamp around while the photographer observes its effect from behind the camera, working alone can involve numerous trips back and forth between camera and lamp.

To avoid this, proceed as follows: Get a piece of string about eight feet long with a small weight at one end. Next, place the spotlight immediately in front of the lens and train it on the model while all the other lamps are turned off. Now, by slowly circling and observing the model from all angles and sides, from eye-level on up, you can easily pick out attractive highlights in the model's hair. At the moment of observation, your eye will occupy the exact spot at which the spotlight must be placed if these highlights are to be visible to the lens. By using your weighted string like a mason's plumb bob, you can now find the exact spot on the floor above which you must place the stand that supports your spotlight, while the distance between the floor and your eye (measured along the string) gives you the height to which you must raise the lamp.

6-5. Place the background lamp. Depending on the photographer's intentions, this can be either a photoflood lamp or a medium-sized spotlight. It serves a double purpose.

(1) To assure that the background receives a sufficient amount of light for satisfactory color or black-and-white rendition. Normally, the background should receive the same amount of light as the subject. Whether or not this is the case can easily be checked by taking brightness readings with a light meter in conjunction with a Kodak Neutral Test Card. Usually, it will be found that the background received less light than the subject and therefore needs additional illumination.

p. 79

(2) To graphically separate subject and background in black-and-white photography (in color photography, separation is usually based on differences in color). If the subject is dark, the background should normally be light; if the subject is light, the back-

ground should be dark. Occasionally, of course, one side of the subject may be light and the other dark (this is quite common in portraiture). If this is the case, the background can be illuminated either in such a way that it will appear in the picture as a consistent intermediate shade of gray, or the background lamp can be placed so that its light strikes the background at an angle, illuminating it unevenly in such a way that, in the picture, it appears light where the subject is dark, and dark where the subject is light. A third possibility is to place the background lamp directly behind the subject (which hides it from the camera) with its beam directed toward the background where it will create a "hot spot" with gradually darkening edges against which the subject stands out vividly, as if surrounded by a halo.

Evaluation. Please note that in the lighting scheme described above, each of the four lamps fulfills a specific purpose. There is neither duplication nor overlapping of function. This particular assignment simply could not have been executed satisfactorily with fewer than four lamps, although, perhaps, a large reflecting panel might have been used instead of the shadow fill-in lamp. But such a substitution would already have involved mechanical complications in regard to the placement of the screen. In the previous assignment, a reflecting panel could be used for shadow fill-in illumination because the set-up was small. In portraiture, where conditions are different, a shadow fill-in lamp is normally more practical.

p. 180

Together, assignments 5 and 6 should teach you the following basic principles of good lighting: The simpler the lighting scheme in regard to technical requirements, the better. Analyze your contemplated lighting scheme, then choose your lamps accordingly. Each lamp involved must have its own specific function. Don't duplicate them; don't use two lamps if one can do the job. Fewer lamps mean fewer sets of shadows. A main light in conjunction with a reflecting panel is basically preferable to a combination of main light and shadow fill-in lamp because it eliminates the danger of shadows within shadows.

Assignment 7
Experiment with different types of illumination

Now that you know the principles of good lighting, I want you to experiment with them. The portrait lighting scheme described in assignment 6, for example, produces what might be called a "standard" illumination. It will always give good results regardless of the nature of the subject but will never be particularly exciting or original. Fortunately, it can be varied in innumerable ways simply by varying the position of the main light (and thereby the distribution of light and shadow), the distance and wattage of the shadow fill-in lamp (and thereby the contrast range of the subject), and the print exposure (and thereby the overall lightness or darkness of the picture). To study these possibilities and their combinations, I suggest you perform the following experiments.

7-1. Explore the effects of light from different directions.
Under otherwise identical conditions, take a series of frontal portraits of your model using only the main light and the background light. Vary the main light position (with the lamp always at eye level of the model) from sidelight to quarter sidelight to frontlight; vary the frontlight illumination from light from above to light from below. Make the lamp position changes in relatively small increments to get a comprehensive series of all possible effects. Mount the finished pictures side by side and study them with particular attention given to the shadows, filing your findings in your mind under two categories: "effects to be used" and "effects to be avoided."

7-2. Explore the effects of different degrees of shadow fill-in light. Under otherwise identical conditions, take a series of frontal portraits of your model illuminated by quarter sidelight. Leave the main light unchanged but vary the degree of shadow fill-in illumination from zero (no fill-in lamp) to the maximum that is still practicable. Study the different effects of a series of portraits that range from harsh but graphically powerful to soft and graphically "flat."

7-3. Take a series of portraits of the model used in your previous exercises, applying everything you have learned so far. This series, however, should no longer be considered a "finger exercise," the purpose of which is to explore one specific factor in depth—from one extreme to the other—but a collection of unrelated, individually posed, "finished" portraits. This time, you are on your own. You can do anything you want, anything you can think of to create graphically exciting images—from the "Avedontype" of portrait in purest black and white (highest possible contrast) to the most sophisticated shadowless rendition by means of light tent or photo umbrella and electronic flash (totally diffused or reflected light).

Assignment 8
Study the effects which the overall degree of lightness or darkness has on the mood of the picture

Select a few negatives of average or below-average contrast and print each several times, varying the exposure of each print to get a series which ranges from very light to very dark. Suitable subjects are "moody" landscapes, leafless trees against a cloudy sky, and portraits. Notice how overall lightness makes a picture appear joyous, light, and elegant; average brightness makes for average impressions; and overall darkness creates more serious and somber moods. However, although these effects are typical and independent of the nature of the subject, it is often difficult, and sometimes impossible, to decide which is most suitable in conjunction with a specific case. Merely by varying the print exposure time, the same landscape, beach scene, portrait, etc., can be presented in a light and airy or a dark and serious mood—each version having its own merits, neither one being necessarily "better" than the others, but merely different. This is another aspect of photography which enables a photographer to express himself precisely with a minimum of effort.

The principles of good lighting

You have now discovered by experimentation that the principles of good lighting are as follows:

Keep it simple. In capable hands, a single photo lamp in conjunction with a large reflecting panel for shadow fill-in light is unsurpassed when it comes to illuminating subjects not exceeding about two feet in width.

Basically, if applicable at all, one lamp is preferable to two lamps; two lamps are better than three; three are better than four, five, or six lamps, and so on. As a matter of fact, normally, the quality of an artificial illumination is inversely proportional to the number of photo lamps involved. Using too many lamps and too much light is a sure way to ruin any lighting scheme.

Work from darkness toward light. Before you turn on your photo lamps, reduce the overall room illumination to a level just bright enough to enable you to see what you are doing but not so light that it would make it difficult to assess the effect of your lamps.

Build your illumination step by step. Start by placing the main light. Never add another lamp to your lighting scheme until the previous one has been placed to your satisfaction. Assess the effect of each lamp by itself while all the other lamps are turned off. Then, switch all the other lamps on again and leave them on while turning the newly added lamp repeatedly on and off to evaluate its effect relative to the other lamps and the lighting scheme as a whole.

If you use a shadow fill-in lamp (instead of a reflecting panel), place it slightly above the level of the lens and as close to the optical axis as possible but on the opposite side from the main light. In this position, whatever shadows it casts will be minimal and least likely to be offensive.

To avoid shadows cast by the fill-in light within or crossing shadows cast by the main light—a particularly unsightly fault of many photographs taken by artificial light—use only well-diffused lamps as shadow fill-in lights.

As far as shadow fill-in illumination is concerned, too little is usually better than too much. Underlighting the shadows can lead to powerful graphic effects, particularly in black-and-white photography. But shadows that are overly filled-in with auxiliary illumination easily give a picture a flat and insipid character, in color somewhat less than in black-and-white. It is one thing to deliberately use flat frontal illumination to emphasize color or subject design; it is another thing to destroy a carefully balanced lighting scheme by overlighting and thereby negating the shadows.

The impression of a photograph should normally be as if the subject, no matter how extensive, were illuminated by only a single light source, regardless of the number of photo lamps actually deployed. To achieve this, all shadows must point in the same direction, and the occurrence of secondary shadows within primary shadows as well as shadows that cross each other must be avoided.

Don't place your subject so close to the background that its shadow falls on it unless there is a reason. Such a shadow usually interferes with the clarity of the presentation by obscuring the outline of the subject and even blending with it.

In portraiture, the most important shadow is that cast by the nose. It should never touch or come even close to the lips. Placing the main light at or only very slightly above the level of the subject's eyes will normally produce the desired shadow effect. Other shadows to be watched and, if necessary, filled-in with auxiliary illumination, are those around the eyes, in the corners between nose and cheek, and underneath the chin.

Don't be afraid of pitch-black, undetailed shadows as long as such shadows help to characterize the subject's forms and strengthen the graphic design. A master in the use of inky unrelieved shadows is Richard Avedon, whose portraits I recommend that you study.

Make sure that the background receives sufficient light, particularly if you work in color. An underlighted background will

be rendered off-color and makes a drab impression. Check its brightness by taking a separate meter reading with the aid of a Kodak Neutral Test Card as described before; if necessary, provide for additional illumination. Basically, a picture in which the background is lighter than the foreground, especially if foreground matter acts like some kind of frame, evokes a stronger impression of depth than one in which the positions of light and dark are reversed. Illumination provided solely by flash at the camera, for example, by overlighting nearby subject matter and underlighting the background, gives any picture a cavernous impression and proves that flash at the camera (unless used for shadow fill-in) is the pictorially least attractive kind of light.

p. 79

Backlight is potentially the pictorially most effective type of light, particularly in black-and-white photography.

p. 85

Low-skimming sidelight and backlight that just graze a surface are best for effective rendition of texture.

pp. 84, 85

Flat frontal illumination is best for natural-appearing rendition of color and for photographing subjects characterized by a wealth of fine detail which might be obscured by shadows.

How to symbolize the radiance of direct light

p. 93

Photography is picture language. As language can be prosaic or poetic, so photography, too, offers you different forms of expression. Normally, of course, a documentary or "prosaic" subject approach would probably be most likely to give you the desired result. On special occasions, however, only a "poetic" form of presentation can express what you felt in the presence of your subject. In that case, one of the following methods of rendering light not simply as white, but in pictorially symbolic form as "radiance" might provide you with a means of transforming reality into fantasy.

Assignment 9
The graphic symbols of radiant light

p. 93

As I pointed out before, the lightest tone we can produce in a picture is white—a "color." As a result, in picture form, as far as

brightness is concerned, there would be no difference between, say, a white gown or house, and the sun or a lit incandescent light-bulb. In reality, these objects make very different impressions on us, but pictorially we treat them as if they were the same—areas of white. While run-of-the-mill photographers accept this as one of the inherent limitations of the photographic medium, creative workers once more turn weakness into strength by expressing radiance symbolically with the aid of certain techniques. If you are a photographer to whom such things matter, you have the following options with the aid of which you can distinguish pictorially between "white" and "light."

9-1. Wire screens. Many times, I'm sure, on TV, you have seen light sources rendered as brilliant, four-pointed stars. This was done deliberately to give the scene a sparkling and festive mood, and you can do the same. By placing a piece of shiny bronze or copper fly screen in front of the lens during the exposure, you can render bright, pointlike light sources (for example, the sun or distant street lights at night) in the form of four-pointed stars. And if you want to produce eight-pointed stars, use two pieces of fly-screen in close contact, one rotated 45 degrees against the other. The resulting star images will be the sharper and larger, the smaller and more brilliant the light source and the longer the exposure. A potential disadvantage of this technique is a slight degree of overall unsharpness in the picture caused by diffraction which, however, in night photographs where this technique is most often used, may actually enhance the mysterious mood.

9-2. Diaphragm stars. Take a series of photographs of a row of street lamps at night with different *f*-stops and corresponding shutter speeds. You will find that bright, pointlike light sources will be rendered in the form of many-pointed stars whose rays will be the longer, the smaller the diaphragm aperture and the longer the exposure time. This technique has an advantage over the previous one in that, except for small bright sources of light, the rest of the image remains unaffected, that is, will be rendered in sharp detail. On the other hand, results are not precisely predictable and the

star patterns are less regular and symmetrical than those produced by wire screens. Subjects most suitable for this technique are sun glittering on water, street scenes at night, and landscape photographs that include the image of the sun.

9-3. Flare and halation. According to the tenets of traditional photography, direct light must never be permitted to enter the lens because this might have undesirable consequences which can manifest themselves in two forms: (1) as *halation*—a veil of light overlaying parts or all of the film causing loss of contrast or color saturation in the image; and (2) as *flare*—more or less sharply defined circular, pie-shaped or crescent-shaped and occasionally polygonal light spots which didn't exist in reality but are superimposed upon the image.

Halation and flare are caused by light reflected from the internal surfaces of the lens and are normally—and rightfully—considered faults which should be avoided. Deliberately used in the right places, however, they become valid tools of creation, because they symbolize the blinding radiance of light better than any other graphic means. Unfortunately, the forms in which they manifest themselves are rather unpredictable and so are the effects upon the picture, ranging from powerful and exciting to disastrous. This, however, should never deter you from trying to make use of these potentially fantastically effective symbols of radiance whenever an opportunity presents itself; for what can you lose except a piece of film? And film, as any creative photographer knows, is our most expendable commodity. . . .

p. 93

Therefore, to familiarize yourself with the different forms which these symbols of brilliant luminosity can take, I suggest that you shoot pictures which feature sources of direct light—the sun, street lamps at night, shots in the studio which include lit photo lamps, and so on. You will find that lenses of different constructions act very differently under the same conditions (make tests to find out which of your lenses are "flare-prone" and which are not), and that small changes in the degree of brilliance or the angle of incidence of the light can make surprisingly great differences in regard to the form in which flare manifests itself on the film. This is an aspect of

photography where rules are meaningless, anything goes, waste is great, and daring can pay off in the form of spectacular pictures.

9-4. Diffusion screens and out-of-focus rendition. One of the oldest symbols of brilliant light—of radiance—is the halo, a circular area of luminosity surrounding a source of light. In photography, a similar effect can be achieved with the aid of diffusion disks which, like filters, are placed in front of the lens during the exposure. If interested in this technique, I suggest that you experiment with diffusion disks, which come in two strengths for more or less pronounced halation. One characteristic of diffusion disks is that they affect bright picture areas more than dark ones, which may appear slightly "softened" but otherwise unchanged. Diffusion disks are most effective in conjunction with high-contrast scenes which feature sources of direct light or white, brilliantly illuminated areas that, in the picture, appear to radiate into adjacent darker subject parts. This effect, depending on the nature of the subject and the purpose of the photograph, can enhance or ruin the picture. Most suitable for this kind of treatment are subjects like the sun glittering on water or sources of direct light, and romantic portraits of women.

Going one step further into fantasy, you can create even stronger illusions of luminosity by throwing the entire picture out of focus. Normally a fault, under certain conditions this technique can yield almost magical results. In night photographs taken in a city, for example, streetlights would be turned into globes of softly glowing light, windows lighted from within would have their corners rounded, and mystery would pervade the entire scene. By eliminating sharpness (of rendition), you eliminate the feeling of reality which is one of the most characteristic aspects of photographic representation; and by replacing it with the dreamlike unsharpness you create a new, fantastic world. Although extremely limited in application, this technique enables sensitive photographers to create effects which are unattainable with any other means and, provided the subject is suitable, to achieve pictures filled with magic.

Assignment 10
Learn how to control reflection and glare

Glare and reflections are double-edged blessings. On one hand, they can enliven a photograph and give it added visual interest; on the other, they can obscure underlying color and detail. Should the latter be the case, glare and reflections can often be moderated or even eliminated completely with the aid of a polarizer.

A polarizer, or polarizing filter, works on the principle of polarizing sunglasses: it blocks the passage of polarized light. Now, since glare and reflections often consists of polarized light, they can be partly or completely eliminated from a photograph through use of a polarizer. The degree of reduction depends on two factors: (1) The angle between the reflecting surface and the incident (glare-producing) light—at an angle of about 34 degrees, glare and reflections can be completely eliminated by a polarizer; at 90 degrees, they are not affected at all; at intermediate angles, they are reduced proportionally. (2) The angle of rotation of the polarizer relative to the direction of the incident light.

However, only glare and reflections consisting of polarized light are subject to polarizer control. Most reflecting surfaces polarize light as they reflect it—glass, glossy paint and paper, varnish, water, polished wood, etc. But metallic reflecting surfaces do not polarize light and, consequently, highlights and reflections on metallic surfaces are not affected by polarizers except when the reflection itself consists of polarized light like, for example, the reflection of an area of blue sky on a shiny metal surface.

In addition to reflection control, in color photography, polarizers can be used to darken a pale blue sky without changing the other colors of the picture. Maximum effect is produced in a band across the sky which is at right angles to an imaginary line connecting the camera position and the sun.

The effect of a polarizer upon the future picture can be studied visually. Place the polarizer in front of the lens of your single-lens reflex or view camera (if you work with any other camera type, study

your subject through the polarizer held directly in front of your eye) and observe the image in the viewfinder or on the groundglass while slowly rotating the polarizer. When the desired degree of glare or reflection reduction is achieved, stop rotating and take the picture. If you held the polarizer in front of your eye, transfer it to the lens *in exactly the same rotational position*, otherwise the effect in the picture will be different from what you saw. And don't forget that the exposure must be increased by the polarizer factor, which in most cases is 2.5, regardless of the angle of rotation.

And now I suggest that you go out and practice. Study a variety of suitable subjects in regard to reflection elimination and glare control. See how far you can go in reducing, say, glare on asphalt on a city street, reflections in shop windows or the glass facade of a modern office building; highlights on water, polished wood (furniture, parquet floors), glass and chinaware; and so on. In each case, take a series of three to five shots, each taken with the polarizer in a slightly different rotational position for more or less effective glare control. This will teach you the practice of glare control—the How. It is a prerequisite to the WHY and WHEN. Because, as you will doubtlessly realize, the fact that you *can* control reflections and glare does not mean that you *must* exercise this privilege each time an opportunity presents itself. Sometimes highlights, reflections, and glare furnish the accents that give a rendition sparkle and life, and their elimination would "kill" the picture. In other cases, they are nuisances which decrease the clarity of the image and should be eliminated. When to do what is up to you, the photographer, the creative artist, because here, too, *you have a choice*!

Assignment 11
Learn how to control the contrast range of your picture
In creative photography, contrast control is a prerequisite for success for two reasons:

(1) If the contrast range of the subject exceeds the contrast capability of the film, the picture is bound to look unnatural. In such a case, the photographer must know how to reduce subject contrast to an acceptable level. Contrast will most likely be too high in subjects photographed in bright sunlight at distances of less than fifteen feet, particularly if color film is used. If this is the case, simul-

taneous satisfactory rendition of both the lightest and the darkest colors of the subject is impossible unless contrast is first reduced.

(2) In black-and-white photography, color contrast is automatically transformed into contrast between light and dark. But since subject colors that are different in hue but more or less identical in brightness would be rendered as more or less identical gray tones, contrast in the picture might be unacceptably low, graphic separation lost, and the rendition might appear unnatural, monotonous and "flat" unless the photographer finds ways to strengthen the contrast of the image.

In photography, contrast can be controlled at three levels:

> by manipulating the **contrast of the subject**
> by manipulating the **contrast of the negative**
> by manipulating the **contrast of the print.**

Manipulating the contrast of the subject

11-1. The most practical—and often the only—way to control the contrast range of the subject is with the aid of light. Outdoors, in daylight, if the subject is relatively close, daylight flash from a small speedlight mounted on the camera and used as auxiliary illumination (shadow fill-in light) potentially gives the best results; a large reflecting panel covered with finely crinkled aluminum foil is next. Frontlight, because it produces the least extensive shadows visible from the camera position, is for practical purposes less contrasty than sidelight or backlight, something to remember when posing people or "movable" objects outdoors. And large, immovable subjects which in bright sunlight appear hopelessly contrasty (like Roman ruins, or the facades of medieval cathedrals with their deepset, highly sculptured portals) will yield beautifully detailed pictures if photographed in low-contrast light on hazy or overcast days.

Indoors, subject contrast, of course, can easily be controlled by balancing the ratio of main-light illumination to shadow fill-in illumination.

p. 197

> *Lighting contrast ratio* is the difference between the maximum and minimum amounts of light that illuminate the subject,

the span from brightest highlights to deepest shadows.

Reflectance ratio is the difference in brightness between the lightest and darkest colors of the uniformly illuminated subject.

Subject contrast is the product of lighting contrast ratio and reflectance ratio.

To establish specific values, proceed as follows:

Lighting contrast ratio. Take a Kodak Neutral Test card, hold it first against a fully illuminated part of the subject (so that the card faces the camera) and take a close-up exposure meter reading of the card. Then, hold the card against a part of the subject that lies in the deepest shade (again so that the card faces the camera) and take a second brightness reading of the card. The difference in *f*-stops between these two readings is the lighting contrast ratio of the scene.

Reflectance ratio. Illuminate the subject uniformly with shadowless frontlight. Then, disregarding black and white if present, measure the brightness of the lightest and darkest colors of the subject with an exposure meter. The difference in *f*-stops between the two readings is the reflectance ratio of the subject.

Subject contrast. Let's assume that you found the lighting contrast ratio to be 2:1 (a difference of one *f*-stop) and the reflectance ratio 4:1 (a difference of two *f*-stops); in that case, the subject contrast ratio would be 2x4 = 8:1, a difference of three *f*-stops.

In color photography, provided we deal with subjects of average reflectance ratios, natural-appearing color rendition can be expected only if the lighting contrast ratio does not exceed 3:1 or a difference of 1½ *f*-stops. However, if the reflectance ratio is lower than average, that is, if all the colors of the subject are either relatively light or dark the lighting contrast ratio can be as high as 6:1 or a difference of 2½ *f*-stops without subject contrast exceeding the contrast capability of the film.

In black-and-white photography, due to the much greater contrast capability of the film plus the fact that papers with different con-

trast grades are available to correct unsatisfactory negative contrast while printing, the respective values can be increased by a factor of 2 to 3.

Any desired lighting contrast ratio can easily be established in the studio or home with the aid of the following table, the only condition being that identical lamps must be used for both mainlight and shadow fill-in illumination:

Desired lighting contrast ratio:	2:1	3:1	4:1	5:1	6:1
Fill-in light distance factor:	1	1.4	1.7	2	2.2

Begin by placing the main light in its proper place relative to the subject. Measure the distance in feet between subject and lamp. Multiply this distance by the fill-in lamp factor which, according to the preceding table, corresponds to the lighting contrast ratio you wish to create. Then place the shadow fill-in lamp at the so-established distance from the subject, as close as possible to the subject-camera axis and ever so slightly above the level of the lens.

Manipulating the contrast of the negative

11-2. If you work with negative color film, there is no practical way in which you can manipulate the contrast of your negative. In black-and-white photography, however, you have the choice of several options. Farthest-reaching changes in negative contrast, of course, are obtained by combining two or three of these methods. Since, as I said before, this book is primarily intended for people who do not wish to do darkroom work, in the following discussion I'll outline only briefly the respective techniques. Readers who wish to know more are referred to my book, *The Complete Photographer* (Prentice-Hall), where these techniques are fully described.

Choice of film. Black-and-white films vary considerably in the way in which they handle contrast. As a rule, general-purpose films more or less preserve the contrast of the subject; fine-grain and thin-emulsion films increase subject contrast (and are therefore particularly suited to the rendition of low-contrast subjects),

and high-speed films decrease subject contrast (and are therefore particularly suited to the rendition of high-contrast subjects).

Choice of film developer. Rapid developers and, to an even higher degree, high-contrast developers, produce negatives in which contrast is relatively high; standard developers produce negatives of average contrast; and fine-grain developers generally produce negatives of somewhat lower-than-average contrast.

Exposure in conjunction with development. Basically, increasing the exposure beyond the light meter value in conjunction with shorter-than-normal film developing times decreases negative contrast. Conversely, decreasing the exposure and prolonging the time of film development increases negative contrast. In these respects, exposure increases of up to 500 percent and decreases of 50 percent from the exposure meter values, and development increases of up to 100 percent and decreases of 30 percent from what is standard for the respective developer, define roughly the boundaries within which extreme though still usable results can be achieved.

Choice of filter. Use of an appropriate contrast filter, by transforming specific colors into gray tones which are either lighter or darker than they would have been if no filter had been used, leads to negatives of higher-than-normal contrast. This method of contrast control is particularly effective in extreme telephotography, where atmospheric haze often reduces subject contrast so much that only application of every available means for increasing contrast can produce satisfactory negatives.

Manipulating the contrast of the print

11-3. I'll limit myself in the following to a summation of the available options. Readers who wish to know more are referred to my books *The Complete Photographer* (Prentice-Hall) and *Darkroom Techniques* (Amphoto), where they are fully discussed.

Choice of paper gradation. In black-and-white photography, the simplest way to control contrast on the print level is through

use of a paper of appropriate gradation. Most papers are available in four, many in five, and a very few in six different gradations ranging from very soft (very low contrast) to ultra-hard (very high contrast).

Dodging and burning-in. When making an enlargement, by giving less exposure to negative areas which otherwise would print too dark (dodging), or giving additional exposure to negative areas which otherwise would print too light (burning-in), you can change the contrast of a negative locally and thereby improve the quality of your print. This technique is applicable to both color and black-and-white photography.

Assignment 12
Learn how to use filters in color photography
The purpose of a photographic filter is to change the response of the film to light and color. In color photography, this may occasionally become necessary for the following reasons:

As I told you before, each type of color film—Daylight film, Type A, Tungsten (Type B)—can give natural-appearing color renditions only if used in the specific type of light for which it is intended. The reasons for this are technical and need not concern us here. What is important is the fact that only three types of color films exist, but there are dozens of different types of light. Now, while small deviations from the exact type of light for which a film is balanced are harmless and will not cause noticeable color degradation, more extensive differences invariably lead to color changes which would make the color picture appear more or less "unnatural." Transparencies, slides, and color prints on paper thus affected are said to have a *color cast*, that is, all of their colors are distorted to a greater or lesser degree toward blue, green, yellow, purple, or red, as the case may be.

p. 108

Now, in most instances, such a color cast could have been avoided if the photographer had used the appropriate color filter, thereby making the spectral composition ("color") of the light that reaches the film conform to that of the light for which the film is balanced. In this respect, we must distinguish between three different situations, each requiring the use of a different type of filter.

(1) The picture should be made in a type of light that is different from the one for which the film is designed.

(2) The picture should be made on daylight color film in daylight that is not "white" but more or less tinted.

(3) The photographer wishes to give his picture a specific overall color tone.

12-1. Color-conversion filters make it possible to take photographs on one type of color film in different types of light and yet get pictures in natural-appearing colors. This may become desirable if a photographer wants to shoot pictures on the same roll of film alternating in, say, daylight, photoflood illumination, or with flashbulbs—something which normally would require the use of different types of film. However, with the aid of the appropriate color conversion filters, he can temporarily convert, say, daylight color film to Type A or Type B film, as the case may be; or Type B film to Daylight Type film. The following list describes the appropriate Wratten Filters which must be used:

80A if Daylight Type color film should be converted to tungsten Type B

80B if Daylight Type color film should be converted to Type A

80C if Daylight Type color film should be exposed by clear flashbulbs

85 if Type A color film should be converted for use in sunlight

85B if tungsten (Type B) color film should be converted for use in sunlight

Since all these filters absorb a certain amount of light, to avoid underexposure, the exposure must be increased in accordance with the filter manufacturer's recommendations, unless, of course, you use an exposure metering system that reads through the lens—and any filters in front of it. Automatic cameras will compensate automatically.

p. 81

12-2. Light-balancing filters. Only "standard daylight" is "white" and therefore suitable for taking pictures on daylight-type color film. All other variations of daylight have more or less pro-

nounced overtones of yellow, red, purple, or blue, and pictures shot under such conditions on daylight color film would have a corresponding color cast—that is, unless the appropriate light-balancing filter was used.

Light-balancing filters are available in two series:

> *Wratten No. 81 Filters* are reddish, come in eight different densities, and are used if the daylight contains excessive amounts of blue.
>
> *Wratten No. 82 Filters* are blue, come in four different densities, and are used if the daylight contains excessive amounts of yellow or red.

Both series come in a variety of densities and are supplied by several different manufacturers.

Light-balancing filters, too, require certain exposure increases. Automatic and through-the-lens metering cameras adjust automatically; for others, the respective factors can be found in the manufacturer's instructions.

The task of selecting the appropriate light-balancing filter has been simplified enormously through a classification system based upon *decamired* values. How these values are established need not concern us here. What is of interest is that specific relationships exist between type of light, type of color film, and type of light-balancing filter. Each has its own specific decamired number or value. These are given in the three accompanying tables.

To find the appropriate light-balancing filter, calculate the difference between the decamired values of the type of incident light and the film type you intend to use. The resulting figure is the decamired value of the filter you need. Now, if the *light* has a *lower* decamired value than the color film, you need a *red* filter (Wratten Filter Series 81 in the correct density). Conversely, if the *light* has a *higher* decamired value than the color film, you need a *blue* filter (Wratten Filter Series 82 in the correct density). That's all there is to it.

12-3. Color-compensating filters enable a photographer to control the overall color of a transparency or slide and to balance the

Decamired values for typical light sources

Light source	Decamired value
candle flame	66
100 watt general-purpose lamp	35
500 watt professional tungsten lamp	31
500 watt amateur photoflood lamp	29
250 watt amateur photoflood lamp	29
clear flashbulb	26
daylight photoflood lamp (blue glass)	20
daylight flashbulb (blue lacquered)	17
electronic flash (speedlight)	16
standard daylight	16
morning and afternoon sunlight	19
sunlight through thin overall haze	18
noon sunlight, blue sky, white clouds	17
light from a totally overcast sky	15
light from a hazy or smoky sky	12
blue skylight only, subject in shade	9
blue sky, thin white clouds	7
clear blue northern skylight	5

Decamired values for color films

Daylight-type color films	16
Type A (3400K) color films	29
Type B (3200K) color films	31

Wratten numbers for light-balancing filters

Reddish filters	Exposure increases in f-stops	Conversion power in decamireds
81	$\frac{1}{3}$	1
81A	$\frac{1}{3}$	2
81B	$\frac{1}{3}$	3
81C	$\frac{1}{2}$	4
81D	$\frac{2}{3}$	4
81E	$\frac{2}{3}$	5
81EF	$\frac{2}{3}$	6
81G	1	6

Blue filters	Exposure increases in f-stops	Conversion power in decamireds
82	$\frac{1}{3}$	−1
82A	$\frac{1}{3}$	−2
82B	$\frac{2}{3}$	−3
82C	$\frac{2}{3}$	−5
82C plus 82	1	−6
82C plus 82A	1	−7
82C plus 82B	1-$\frac{1}{3}$	−8
82C plus 82C	1-$\frac{1}{3}$	−9

enlarger illumination when making color prints. They are available in yellow (Y), magenta (M), cyan (C), red (R), green (G), and blue (B), most in six or seven different densities—for example, a CC M40 is stronger than a CC M10. While their proper applications lie outside the scope of this guide, any interested reader can experiment with them in his or her own way. How about giving a romantic scene a rosy glow with the aid of a CC M10 filter, or the portrait of a haughty lady a glacial tone courtesy of a CC B20?

A note of caution. An almost infinite variety of different, sometimes subtle, sometimes stronger color shades is one of the delightful attractions of daylight, making it rich, surprising and "alive." To eliminate these color shades summarily in every instance by bringing light and color down to the same denominator—standard daylight—seems to me foolish. Light, as I pointed out before, is the greatest creator of mood. But photographers who, with the aid of filters, mindlessly "correct" all the different shades of daylight, thereby automatically also kill the corresponding "moods."

p. 81
p. 74

Evaluation. I realize that an outdoor portrait with overtones of blue or green may seem "unnatural" to most people. They don't consider that such color casts may be the perfectly natural consequence of the prevailing light conditions—the portrait was taken in the open shade illuminated only by blue skylight, or underneath a tree in light filtered by green leaves. In reality they wouldn't have noticed such color casts or would have accepted them as normal, but in picture form they object to them—just as they would object to "converging verticals"—because they never learned to "see." Evaluated in this sense, every color photograph that has a color cast is an invitation to "seeing." Why did this picture have overtones of blue, green, or red? What was the nature of the light by which it was taken? Let's check it out next time we have the opportunity. . . . let's widen the realm of our visual awareness . . . let's *learn* from color photography. . . .

While the untrained eye is blind to the changing colors of daylight, painters have long been aware of this fact. Already in 1886, Emile Zola, a French novelist, described in his book *L'Oeuvre* ("The Masterpiece") the conflict between reality and appearance in a

scene dealing with the reaction of a painter's wife to the "impressionistic" paintings of her husband:

> And she would have been entirely won over by his largess of color, if he had been willing to finish his work more, or if she had not been caught up short from time to time by a lilac-toned stretch of soil or a blue tree. One day when she dared to permit herself a word of criticism, on the subject of a poplar tree washed in azure, he took the trouble of making her verify this bluish tone in nature itself; yes, sure enough, the tree was blue! But in her heart she did not accept this; she condemned reality; it was not possible that nature should make trees blue.

Assignment 13
Learn how to use filters in black-and-white photography
In contrast to filters designed for use with color film (their purpose being to make color appear *more* natural than would have been the case if no filter had been used), the purpose of most filters used in black-and-white photography is exactly the opposite: to make the transformation from color to gray tone *less* natural than would otherwise have been the case. If this sounds paradoxical to you, consider this:

In black-and-white photography, colors different in hue (say, red and green) but *similar or identical in brightness* are transformed into *similar or identical shades of gray*. As a result, the contrast (between red and green) which caught the eye would be missing in the picture, separation between individual picture elements based upon color contrast would be lost, and the subject would appear "unnatural" and drab *even though the rendition would actually be correct in terms of brightness.*

To avoid such pictorial disappointments and present the impression made by the (colorful) subject as well as can be done in black-and-white, knowledgeable photographers deliberately falsify the translation from color to gray tone by rendering one of the two colors of equal brightness in a *lighter* gray tone than the other. By doing this they are able to preserve the character of the subject—color contrast has been transformed into brightness contrast. The means by which this feat is achieved are the contrast filters.

Contrast filters, in conjunction with black-and-white film, work in accordance with the following principle: To render a color in a *lighter* gray shade in the print than would have been the case if no filter had been used, use a filter in *the same color* (or a closely related color). Conversely, to render a color *darker* in the print than would have been the case if no filter had been used, use a filter in *the complementary color* (or a near-complementary color). Complementary color pairs are

> red and cyan (blue-green)
> blue and yellow
> green and magenta (red-purple)

To familiarize yourself with the effects of color filters when using black-and-white film, I suggest you perform the following experiment: Get yourself a bright red pepper or tomato and place it on a bright green cabbage or lettuce leaf. Then photograph this set-up three times to produce a series consisting of five prints in which the fruit and the leaf, respectively, appear as white-on-black, black-on-white, white-on-white, gray-on-gray, and black-on-black.

How do you do this? Shoot the first picture through a light red filter, the second through a deep green filter, and the third without a filter. Then print or have your photo finisher print, negatives 1 and 2 on a medium-contrasty paper; negative no. 3 on a high-contrast paper (giving the print an exposure short enough to make it turn out almost white); then make two more prints on a low-contrast (soft) paper, timing the respective exposures in such a way that the prints turn out almost uniformly gray or black, respectively.

The experiment described above produces extremes—it is a "finger exercise." However, any imaginable combination of gray tones could have been produced through appropriate changes in filters (for example, with a yellow instead of the red filter, or a light-green instead of a deep-green filter), in paper gradation (by using harder or softer paper for greater or lesser contrast), or in print exposure (shorter or longer for lighter or darker overall tone). I suggest that you extend your experiment by making a second series of pictures to explore these subtler possibilities.

Filters absorb a certain amount of incident light. Therefore, to avoid underexposure, if a color filter is used, the film exposure must be increased accordingly (either by using a larger diaphragm aperture or a slower shutter speed). The degree of increase depends on the color and density of the filter, the type of light, and the type of film emulsion. The factors by which the exposure must be multiplied therefore vary considerably but are always listed in the filter manufacturer's instructions, either packed with the filter or obtained free of charge at any photo store. If a filter is used with an automatic camera or one featuring a built-in exposure meter which measures through the lens, however, the filter factor is taken into consideration automatically and no further action on your part is needed.

The following summary lists the most popular filters used in black-and-white photography together with their most important applications:

Light yellow. The effect of this filter is so slight that I consider it practically useless.

Medium yellow. A good all-purpose filter which slightly darkens a blue sky (making thereby white clouds stand out more prominently in contrast), lightens green foliage and reduces the veiling effect of haze.

Dark yellow. The purpose of this filter is similar to that of a medium yellow filter but its effects are somewhat more pronounced.

Orange. A rarely used filter (exception: aerial photography) whose effects lie halfway between those of a dark yellow and a light red filter.

Light red. Effectively darkens blue sky and counteracts the veiling effect of blue haze (white haze is not affected by any filter). Excellent for long-distance views, tele-photographs of landscapes, and aerial photography. Unsuitable for portraits and close-ups of people because it renders skin tones unnaturally light, creating a chalky appearance.

Dark red. The purpose of this filter is similar to that of a light red filter but its effects—the desirable as well as the undesirable ones—

are considerably more pronounced. Renders green and blue as black.

Light green. Slightly lightens green foliage and improves contrast in landscape photographs with much greenery taken on panchromatic film. Slightly darkens blue sky. If a shot requires filtration, this is the best filter if close-ups of people are involved because it does not make normal skin tones appear either too light or too dark.

Dark green. Considerably lightens green foliage and improves definition. Renders red as black.

Light blue. In black-and-white photography, a rarely used filter except for portraits of men, in which case it gives reddish skin tones a darker, more rugged appearance.

Dark blue. For normal photographic purposes this, too, is a rarely used filter except in cases where a sky—cloudy or cloudless—must appear uniformly white in the picture. Renders red as black.

Assignment 14
Subject-to-camera distance and its effects on perspective and scale

Perspective is the means by which three-dimensional objects and their spatial relationships can be transformed into two-dimensional representations.

Scale refers to (1) the size in which a subject is rendered in the negative or slide; and (2) any standard of measurement.

This assignment requires a subject consisting of two parts: a large, immobile object in front of an immobile, not too distant background. An excellent example would be a large abstract sculpture in a public square surrounded by sufficient space to allow for the required variation in subject-to-camera distance; buildings in the background provide a good point of reference for the evaluation of the resulting changes in perspective.

p. 116

Take three pictures with a lens of standard focal length: (1) Distance between the subject (the sculpture) and the background

should be so great that the image of the sculpture in the viewfinder is smaller than the buildings behind it (long shot). (2) Distance between subject and background should be chosen so that the sculpture appears in the viewfinder about as high as the buildings behind it (medium-long shot). (3) Distance between sculpture in the viewfinder is considerably higher than the buildings in the background (close-up).

Evaluation. Changes in the subject-to-camera distance manifest themselves in four ways: (1) The shorter the subject-camera distance, the larger the image of the subject on the film. (2) The shorter the subject-camera distance, the larger also the scale of the background, although this increase in image size is proportionally much less pronounced than that of the subject. (3) Variation of the subject-camera distance causes changes in the subject-background relationship, that is, in the perspective of the picture. (4) It also causes changes in the perspective of the subject itself—the way in which the various subject components overlap one another changes together with the degree of foreshortening and diminution: the shorter the subject-to-camera distance, the higher the degree of perspective distortion.

The concept of perspective. Before we continue, I want to say a few explanatory words about *perspective* and *distortion.* Strictly speaking, all manifestations of perspective are distortions of reality, whether they appear to us "normal" (like the convergence of railroad tracks toward the distance) or "distorted" (like the convergence of the actually parallel sides of a building in an angle shot taken with the camera tilted up). "Undistorted" or "distortion-free" rendition is possible only if the subject is either two-dimensional and flat (like a painting or a wall), or three-dimensional but has a flat side which is shown in the picture, and if, in addition, this flat surface and the film inside the camera are parallel to one another. Only if these conditions are fulfilled will a rectangle (say, a window) be rendered in the picture as a rectangle (and not "in perspective" or "distorted" in the form of a trapezoid, a rhomboid, or a trapezium, as would be the case if the window were photographed at an angle). And only then would, say, a wheel be rendered as a circle in the picture (instead of an ellipse, "distorted" or

"in perspective," as would be the case in an angle shot). Likewise, actually parallel lines can be rendered parallel in the picture only if they are parallel to the film inside the camera. Otherwise, they would be shown "in perspective," that is, more or less converging or "distorted" since *actually* they are parallel. Whether a subject appears natural in an angle shot (seen "in perspective") or unnatural ("distorted") depends on the degree of distortion. If the manifestations of perspective (convergence, diminution, foreshortening) are no more pronounced than what we are used to in reality, the rendition would be considered "natural." If the degree of distortion exceeds what we accept as "natural," the rendition would seem "distorted." Nonetheless, perspective and distortion are one and the same phenomenon, their only difference being one of degree.

Whether a subject is rendered distortion-free, in "normal" perspective, or more or less "distorted " depends basically on the photographer, who has the choice of many options. The following assignments will show him how to proceed.

The concept of scale. Photographically speaking the term "scale" has two meanings: the first—*image size*—has just been discussed; so let's talk about the second—scale as a means of indicating *actual size*.

We assumed in the above example that our subject, the sculpture, should be standing alone in a public square. The viewer of the resulting picture thus photographed would be unable to assess the sculpture accurately in regard to its size. Not knowing from how near or far the picture had been taken, and lacking any possibility for comparing the sculpture with a familiar object (say, an automobile parked near it), the viewer would be left in the dark as far as the subject's actual size is concerned. Such a photograph is said to be *scaleless*.

If, on the other hand, a person had been leaning against the sculpture at the moment the picture was taken (or a car had been parked next to it), the rendition would have had *scale*—the viewer would have been able to precisely ascertain the actual size of the sculp-

ture by comparing it with the person (or the car)—"yardsticks" of known dimensions in comparison to which the sculpture's size could have been assessed precisely.

In cases where a subject's actual size is not obvious, it is up to the photographer whether or not to give his pictures scale; *he has a choice*. Which of these two possibilities he should choose depends basically on the nature of the subject, the purpose of the picture, and what the photographer wants to say. In photographic form, towering redwood trees, for example, would look as unimpressive as any ordinary trees unless the photographer gives his pictures scale—perhaps by having a human figure rest against the base of one of the gigantic trunks. In commercial product photography, a hand or two fingertips holding a small object are often indispensable to give a picture scale. But even here, the photographer has a choice. If a refined impression is required, the elegant, manicured hand of a young woman will do the trick. If, however, the smallness of a new product must be emphasized (in comparison to the clumsiness of earlier models), the larger hand of a man would make the object appear even smaller than it actually is.

If a photographer wishes to indicate scale in an otherwise scaleless picture, he must consider two things: (1) the *type* of the scale-indicator, and (2) its *placement* within the picture. For example: one of the best means for giving a landscape picture scale is the human figure. Now, such a figure can be placed at any desired distance from the camera anywhere in the picture. Nearby, it would be rendered relatively large, dominating the landscape by sheer size and thereby dwarfing it. Far away, it would be rendered small in the picture, making the landscape appear in contrast the way we experienced it in reality—big, wide-open, breathtaking, and magnificent.

Effective scale indicators are, among others: the human figure, hands, and fingertips; automobiles (a distant car on a winding country road far down in the valley can make a landscape appear big; without it, the shot might have been nothing but another pretty picture); ships at sea (nothing is more likely to give a seascape scale and symbolize the vastness of the ocean than the tiny

silhouette of a steamer crawling along the horizon, making the sea appear immense in contrast to the steamer's smallness); cattle grazing in a meadow or out on the open range; a line of telephone poles or the masts of a power line stretching across a vast, wide-open western landscape like toys stuck in the sand by kids. Familiar, although pictorially less appealing units of scale, are the hammer of the geologist and the foot rule of the botanist—generally accepted scale indicators in scientific field photography.

Where to place your scale indicator? That depends. . . . On or near the center of the picture it would be more obvious and seem more important than toward an edge or a corner. The toylike car going down the country road might conceivably appear more or less in the center of the picture without appearing too obvious or contrived since it would be a natural part of the scene. On the other hand, the figure of a girl sitting on a rock gazing out over the landscape—a more contrived picture element—would probably look better "played down" near one of the picture's corners. Again—it is up to you. *You have a choice*!

Assignment 15
Lenses of different focal lengths and their effects on perspective and scale

For this assignment use the same set-up as in assignment 14—a large immobile object in front of an immobile, not too distant, background. With the camera mounted on a tripod and from the same camera position, at an "average" distance (medium-long shot), take three pictures: one with a lens of standard focal length, another with a wide-angle lens, and a third with a telephoto lens. Compare the resulting pictures. They will differ in two respects but be identical in a third one:

15-1. The longer the focal length of the lens, the larger the scale in which the subject is rendered on the film, but the narrower the angle of view and the smaller the depicted area.

15-2. The wider the angle of view of the lens, the smaller the scale in which the subject is rendered on the film, but the wider the angle of view and the more extensive the depicted area.

15-3. But—and this may come as a surprise to many photographers—despite these obvious differences, the perspective of all three pictures will be the same since all were taken from the same camera position. It is the *camera position* (subject-to-camera distance in conjunction with the direction of view) which determines the perspective of the rendition, and *not* the focal length or angle of view of the lens.

If you compare the three pictures point by point, you will see that they are identical in regard to overlapping of form, diminution, and degree of foreshortening and convergence of actually parallel lines. Their only differences will be in regard to scale and encompassed angle of view. However, if you would take from the wide-angle shot the area that corresponds to the area depicted in the telephoto shot, and enlarge the first to the scale of the second, you would get a picture in identical perspective. And if you would superimpose one upon the other, they would register perfectly. Their only difference would be one of sharpness; because it had to be enlarged more than the telephoto shot, the corresponding section from the wide-angle shot would be less sharp and more grainy. But as far as their perspectives are concerned, they would be identical.

Evaluation. The subject-to-camera distance determines the perspective of a photograph. Taken from the same camera position, all pictures will be identical in regard to perspective, no matter whether taken with a wide-angle, a standard, or a telephoto lens.

The focal length of the lens determines the scale and the encompassed angle of a photograph. Taken from the same camera position, the scale of rendition will be the larger, and the angle of view the smaller, the longer the focal length of the lens; and vice versa.

Assignment 16
Lenses of different focal lengths in conjunction with different subject-to-camera distances
For this assignment, use the same set-up as in assignment 14. Again, take three shots of a large, motionless object in front of a motionless background, the first with a lens of standard focal length, the second with a wide-angle lens, and the third with a tele-

photo lens. This time, however, vary the subject-to-camera distance for each shot in such a way that the image of the sculpture always appears in the same scale in the viewfinder. In other words, take a close-up shot with the wide-angle lens, a medium-long shot with the standard lens, and a long shot with the telephoto lens, making sure that the same point of reference in the center of the background appears in the same place in all three pictures.

Evaluation. Note that this time, differences in regard to *both* scale and perspective are apparent in the picture. Even though the height of the subject is the same in all three shots (this was one of the prerequisites for the test), the scale in which the background is rendered will be different, and so will be the manifestations of perspective in terms of *overlapping* of the various picture elements, *foreshortening, diminution,* degree of *convergence* of parallel lines, and *apparent distance* between sculpture and background (which in the wide-angle shot will seem unnaturally long, in the shot made with the lens of standard focal length more or less as it appeared to the eye in reality, and in the telephoto shot unnaturally short).

Consequently, through appropriate selection of subject-to-camera distance in conjunction with lenses of different focal lengths, a photographer can control the perspective of his pictures to an astonishingly high degree and create precisely the impression his ideas demand.

Assignment 17
The four types of perspective
Unlike the human eye, which shows us our surroundings always in the same perspective, the camera offers the interested photographer a choice of four different forms:

true rectilinear perspective
academic rectilinear perspective
cylindrical perspective
spherical perspective

Since actual exploration of these four involves equipment most of you probably don't have—such as view camera, panoramic cam-

era, fisheye lens, or an enlarger that allows for restoration to parallelity in the print of actually parallel lines that converged in the negative—the following is intended simply to offer information you can use later when the occasion requires, either to do yourself or to instruct a photo-finisher or custom printer.

7-1. True rectilinear perspective is characterized by the following "rules":

Actually straight lines must be rendered straight in the picture.

Actually parallel straight lines which are not parallel to the plane of the film inside the camera converge toward vanishing points. Only flat, two-dimensional forms parallel to the plane of the film inside the camera can be rendered distortion-free. All other forms, as well as flat forms not parallel to the plane of the film inside the camera, are rendered as more or less distorted (that is, parallels will not appear parallel in the picture but more or less converging; squares and rectangles will be rendered as trapezoids or trapeziums, circles as ellipses, and so on).

Evaluation. True rectilinear perspective is what you get when you shoot with a conventional camera and lens without giving a thought to "perspective." It more or less corresponds to the way we see things in reality, but there is one exception. In photographs of buildings or other structures with vertical lines taken with the camera tilted either upward or downward, no matter how slightly, verticals will no longer be rendered parallel but more or less converging, the degree of convergence being proportional to the degree of tilt of the camera. Since we know that the vertical elements of a building are parallel, seeing these same elements converge in a picture seems somehow "wrong" to most of us—the building looks cockeyed, unnatural, as if it were about to collapse. And strangely, this impression is more pronounced when the degree of convergence is relatively slight than when it is more obvious (as in "angle shots"), where it evokes the feeling of height, of looking up toward the roof. Fortunately, this convergence of vertical lines can be avoided if the photographer chooses to render his subject in academic rectilinear perspective.

17-2. Academic rectilinear perspective is characterized by the following "rules":

> Actually straight lines must be rendered straight in the picture.
>
> Actually parallel straight lines which are not parallel to the film inside the camera converge toward vanishing points *except when they are verticals*, in which case they *must be rendered parallel in the picture.*

Evaluation. Academic rectilinear perspective is what you get when you shoot architectural subjects with a conventional camera and lens while *holding the camera level.* In that case, verticals will be rendered parallel in the picture—no convergence here. Unfortunately, this procedure is not always possible since it might lead to pictures that show too much empty foreground and only the lower part of a building, the upper part of which was too high to get on the film. In such cases you have a choice of two possibilities:

(1) Shoot with the camera tilted upward, get "converging verticals" in the negative, and have this "fault" corrected later during enlargment—this is done by tilting negative and sensitized paper in opposite directions when making the print.

(2) Shoot with a view camera, the individually adjustable front and back of which enable a photographer to exert a high degree of perspective control.

17-3. Cylindrical perspective is characterized by the following "rules":

Either the verticals (in horizontal views) *or* the horizontals (in vertical views) are rendered straight in the picture, *but never both at the same time*; the other set of actually straight lines which is *not* rendered straight appears in the form of curves. The degree of curving depends on the distance of the respective line from the center of the picture: The line that bisects the picture will be rendered straight, while the line closest to the long edges of the picture shows maximum curvature.

The curving of actually straight lines is the price which the photographer must pay for abnormally wide angles of view. Such curving of actually straight lines must *not* be considered "distortion" in the sense of a fault that should be avoided; it is a natural manifestation of perspective.

p. 209

Evaluation. Cylindrical perspective is the result of shooting with a panoramic camera (Panon, Panox) whose lens describes an arc during the exposure. These are highly specialized wide-angle cameras encompassing an angle of view of 140 degrees. The unique nature of cylindrical perspective becomes apparent only in cases which involve long straight lines like street scenes and architectural subjects but is virtually unnoticeable in landscape photographs.

17-4. Spherical perspective is characterized by the following "rules":

All straight lines except those that radiate from the center of the picture like the spokes of a wheel (which are rendered straight) appear as curves in the picture. The degree of curvature varies depending on the distance of the respective line from the center of the picture: the closer to the edges, the higher the degree of curvature.

Spherical perspective can be produced only with the aid of a fisheye lens. As in the case of cylindrical perspective, the curving of actually straight lines is the price the photographer must pay for the almost unbelievably large angle of view covered by this form of perspective—180 degrees or more. Like cylindrical perspective, spherical perspective is not a form of "distortion" in the negative sense of the word—a "fault"—but a valid form of perspective in accordance with specific optical laws.

Evaluation. Spherical perspective is what you get when you shoot with a fisheye lens. Such lenses are highly specialized instruments of very short focal length and limited applicability which encompass angles of view of as much as 200 de-

grees. In my opinion, fisheye lenses are best suited for oblique over-all views taken from a vantage point and for low-level aerial views of cities where they yield pictures which seem to depict a minor planet entirely covered with buildings. To visualize how a certain subject would appear when photographed in spherical perspective, look at its image reflected in a mirrored sphere (for example, a Christmas tree ball); the picture you would see is identical in every respect to that produced by a fisheye lens.

Assignment 18
Explanation of non-rectilinear perspective
This exercise has to be executed in your mind and not with camera and film. So listen carefully.

Imagine you are walking across an endless plane until you come upon an immensely long building that blocks your progress, stretching from left to right as far as you can see, disappearing on either side beyond the horizon. It has a straight front, is six stories high, and has a flat roof. You want to take a photograph of this fantastic structure but, not having a fisheye lens to include this immense, 180-degree view in its entirety in one shot, decide to use your most extreme wide-angle lens (which covers 90 degrees) and take the picture in two parts. Accordingly, you turn 45 degrees to the left and photograph the left half of the building, then turn to the right and photograph the other half. Naturally, having been shot at an angle, each of these two half-pictures will show the building "in perspective," that is, its roof and baselines will converge toward vanishing points at the left and at the right. This seems entirely normal—until you try to join the two halves and complete the view of your subject. Then you will find that the roof and baselines of the structure, which in reality were straight and parallel, would be neither parallel nor straight but would converge toward the right and left and thereby form an angle in the center of the composite view—an angle which didn't exist in reality and would make the picture look unnatural.

To get around this difficulty, you decide to take the picture in three parts: a central "head-on'" view, a shot toward the left, and an-

other one toward the right, each encompassing an angle of 60 degrees. The first photograph, being taken head-on, would, of course, be distortion-free, its roof and baselines rendered parallel in the picture. But each one of the two "angle-shots" would again be rendered "in perspective," their roof and baselines converging. Consequently, when you assemble your triptych, you will have two angular breaks in the horizontal lines of the building instead of only one.

This gives you an idea: by taking an infinite number of shots, each covering only an infinitely narrow angle of the building, and joining them to form a composite picture, you could avoid these unnatural angles and arrive at a view that would correspond to reality. Bravo! You are absolutely right. But can you imagine how such a view would look? Perhaps you guessed it—it would look precisely like a picture taken with a panoramic camera, that is, the roof and baselines of the building would appear as curves—perspective would be cylindrical.

How else could it be? Because, right in front of you, the building has a certain height, while at the vanishing points where it meets the horizon, its apparent height is null. And since there obviously is no break in the roof and baselines in the center of the view, how else could the transition from zero at the left-hand horizon to the height in the center of the view and from there again to zero at the right-hand horizon be accomplished except in the form of two curves?

And if you still think this apparent curving is a form of "distortion" because in reality these lines were straight, perform, either actually on any street or in your mind, the following experiment:

Take a yardstick, hold it vertically at arm's length, and read off the apparent height of the building directly in front of you. Let's say that, measured in this way from the point where you took your shot, its apparent height is 36 inches. Next, take another apparent-height measurement of the building with the yardstick held at arm's length, but this time turn 10 degrees to the left. You will get a somewhat smaller figure. Now repeat this procedure, turning your body at invervals of 10 degrees until you reach the end of the

building where its apparent height is, of course, zero. You don't even have to repeat this performance by measuring the other half of the structure because the result would only mirror the first one. Then plot your findings on paper in graph form. Now, when you connect the upper and lower ends of the vertical lines which represent your measurements, you would again get two many-angled lines which, adjusted to take into account all the intermediate steps not measured by you, would take the form of curves.

Such curving of very long straight lines is therefore not a fault of the camera or lens, but a natural and inevitable manifestation of perspective which we normally don't see in reality because the angle of view encompassed at one time by our eyes is too small to make such curving obvious. However, it is real, and we better get used to it in order to be able to correctly evaluate—and enjoy—pictures in cylindrical perspective. Accepted in this sense, photography—through cylindrical perspective—can make us aware of phenomena we couldn't experience otherwise, or couldn't see as clearly, thereby sharpening our concept of reality.

In cylindrical perspective, only straight lines parallel to the plane of scanning (by the lens) appear in the photograph as curves while straight lines at right angles to this plane are rendered straight. The explanation given above makes this seem perfectly natural, so you may rightfully ask: But what about spherical perspective, which renders *both* horizontal and vertical lines as curves? Isn't this "distortion"?

No—and the following explanation should make this clear. Imagine standing in front of a narrow skyscraper 100 stories high (something like the World Trade Center in New York). Take a ruler, hold it horizontally at arm's length, and measure the apparent width of this building, first at eye level, then at every tenth floor until you reach the top. You will find that the higher the floor you measure, the narrower the building appears to be—an optical illusion caused by perspective (in the vertical plane) which makes receding parallels appear to converge. This phenomenon is, of course, familiar to everyone from experience with parallel lines in the horizontal plane (for example, railroad tracks), but is often considered a form of "distortion" when manifested in the vertical

plane. Strange, isn't it, that we apply this double standard to per-spective—accepting convergence as normal in the horizontal plane while rejecting it as "unnatural" when it occurs in the vertical plane?

Now, if you analyze your findings more closely you will discover an even more curious phenomenon: Measuring the angle which the walls of the skyscraper form with the sidewalk you will, of course, find it to be 90 degrees—a "right angle." But if you would photograph this skyscraper with a wide-angle lens corrected to yield pictures in rectilinear perspective, and tilt the camera upward to include the full height of the building in your shot, in the rendi-tion, the angle between the walls of the skyscraper and the street would no longer be 90 degrees, but smaller (acute), and the front of the building would assume the shape of a tall and narrow trape-zoid. This is decidedly "unnatural"—the walls obviously don't meet the street at an angle of some 70 degrees as in your picture, but at 90 degrees. However, if you would photograph the same building from the same camera position with a *panoramic camera* turned to scan vertically (instead of using it in the more normal horizontal position), you would get a picture in which the sides of the skyscraper form an angle of 90 degrees with the street and yet converge toward the top—in the form of curves! This, of course, is cylindrical perspective manifested in the vertical plane. And strange as it may sound, this rendition corresponds precisely to reality, while the shot taken with the "normal" wide-angle lens which produces a rendition in the more familiar form of rectilinear perspective is *distorted.* And if you plot your initial ruler measure-ments of the tower in the form of a graph, the result would confirm this statement: you would see two lines (representing the sides of the skyscraper) emerging from the base line (the street) at angles of 90 degrees and gently curving toward the roof.

As these discussions show, cylindrical perspective can manifest it-self in the horizontal as well as in the vertical plane. Now, if you would combine the two, what would be the result? You guessed it—*spherical perspective*! And if a rendition in cylindrical perspective is not a "distortion" of reality, neither is spherical perspective. Ac-tually, if anything, spherical perspective is an even truer represen-

tation (projection) of reality than cylindrical perspective, because the latter renders only one set of straight lines as curves while spherical perspective renders both horizontal and vertical lines as curves in the only completely true and scientifically correct representation of three-dimensional space in two-dimensional form.

Why did I devote so much space to discussing such "outlandish" phenomena as cylindrical and spherical perspectives? Because these are relatively new forms of photographic expression, much misunderstood and often misused, yet they are capable of widening our visual horizon. Similar to pictures taken with extreme telephoto lenses, photomicrographs, infrared and X-ray photographs, etc., images created with the aid of panoramic cameras or fisheye lenses can show us things we otherwise would never have been able to see, thereby helping us to acquire a better understanding of our world.

Assignment 19
Learn how to deal with subject motion in a "still"
Motion, obviously, cannot be rendered directly in a still photograph, yet it is an important aspect of many subjects. When confronted with a subject in motion, how should you proceed? You should first of all ask yourself two questions: (1) should I "freeze" movement, or (2) should I indicate motion in graphic symbolic form? The answers to these questions will depend on three factors: the nature of the subject, the purpose of the picture, and the kind and degree of motion.

19-1. "Freezing" motion is usually preferable to symbolization where it is more important to see precisely how the subject looked while in motion than to graphically "prove" that it actually moved. For example: a horse jumping over a hurdle is so obviously in motion that it seems unnecessary to prove this to be a fact. On the other hand, it might be interesting to know precisely what position the legs are in at the height of the jump. Therefore, in this case, "freezing" motion would normally yield a better picture than "symbolizing" it. And the same would probably be true of pictures taken during a boxing match, or of a golf ball at the moment of contact with the club. In such cases, too, motion is so obviously in-

volved that the photographer does not have to prove this graphically.

As a photographer, you have the choice of "freezing" motion graphically in three different ways: by using a high shutter speed, using electronic flash, or panning.

High shutter speed. Select a shutter speed high enough to "stop" the subject's motion on the film. What is "high enough"? That depends on three factors: (1) The actual velocity of the motion—the higher the speed of motion, the higher the shutter speed required to yield a sharp picture. (2) The direction of the motion relative to the camera, the so-called *angular velocity*—a much higher shutter speed is required to stop the motion of a subject moving across the line of vision at right angles than to stop the same subject moving at the same speed toward or away from the camera; and the same subject moving at the same speed at an angle of 45 degrees relative to the line of vision would require a shutter speed somewhere between these extremes. (3) The distance of the moving subject from the camera—the closer, the relatively higher the shutter speed required to stop the subject's motion on the film. These factors are, of course, taken into account in the table of suggested shutter speeds listed earlier, which I advise you to consult in this connection.

Electronic flash (speedlight). Subject motion is "arrested" on the film with the aid of a high-intensity flash of extremely short duration. In this case, it is the flashing light which determines the duration of the exposure, not the shutter. Shutter speed depends on the type of shutter. If the camera is equipped with a leaf-type (between-the-lens) shutter, any shutter speed including the highest can be used. If, however, the shutter is of the focal-plane type, the highest speed that still can be synchronized with electronic flash is normally 1/125 second; consult your camera's instruction booklet.

If the picture is taken in relatively bright light, the highest permissible shutter speed may not be high enough to "freeze" the image of the subject produced by the existing light, which would superimpose itself upon the sharp image produced by the speedlight in the form of a blurred "ghost image." This can be avoided in two ways: either by taking the picture with a camera equipped with a

leaf-type shutter set at its highest speed, in which case the ghost image will probably be so weak as to be virtually unnoticeable and may even be rendered sharply; or, by taking the shot in a relatively dim surrounding, in which case the existing light would be too weak to produce an objectionable ghost image.

Panning. Whereas the two previously described methods for "freezing" motion yielded pictures in which both the moving subject and the stationary surrounding or background would be rendered sharp, panning produces pictures in which the moving subject appears sharp and the background blurred. This has two potential advantages: (1) despite its motion, the subject can be clearly seen in detail; and (2) out of the contrast between sharpness (the subject) and blur (the background) evolves a feeling of motion.

The technique of panning is simple: center the image of the approaching subject in the viewfinder, hold it there by following through with the camera and, at the moment the subject passes you, release the shutter while still swinging around on your follow-through. Best results are usually achieved with relatively slow shutter speeds of 1/5 to 1/15 second, provided, of course, you have a steady hand and keep the moving subject at exactly the same place in the viewfinder during the relatively long exposure. The longer the exposure time, the more blurred the background and the stronger the feeling of speed. This technique gives best results with subjects that don't change shape while in motion (like automobiles—horses or people, for example, constantly change shape while in motion) and that move at a uniform rate of speed across your line of vision.

19-2. "Symbolizing" motion is usually preferable to "freezing" in cases where it is more important to convey a feeling of motion and speed than to produce a clear picture of the moving subject. For example, when photographing a stock car race, *you have a choice:* either you use the highest shutter speed and "freeze" the cars as they pass you or you can use a somewhat slower shutter speed and show the racers slightly blurred against a sharply rendered background. In the first case, don't be surprised if the cars

seem to stand still in the picture, even though they may have whizzed past you at 140 mph. In the second case, you will experience an exhilarating feeling of speed, because blur is the graphic symbol of motion.

Blur as indicator of motion. Successful motion symbolization by means of blur depends upon timing, which in turn depends on the moving subject's speed: you must choose a shutter speed slow enough to render the moving subject blurred, but not too slow because excessive blur would make the subject unrecognizable. In other words, the shutter speed must be selected in accordance with the *apparent* speed of the moving subject—its *angular velocity*— which is the combined result of actual *speed, distance* from the camera, and *direction of motion* relative to you.

p. 223

By correctly choosing the degree of blur you not only provide pictorial proof of motion, but can also control the resulting feeling of speed: the more pronounced the degree of blur, the faster the subject seems to have moved in reality. In other words, it is completely up to you which speed effect you want to achieve; you can make motion appear fast or slow simply by setting the appropriate shutter speed.

Motion graphs—time exposures of moving lights. Familiar examples of this technique are photographs of traffic at night in which the headlights and taillights of moving automobiles trace linear designs. Although the cars themselves are invisible, pictures of this kind evoke in our minds images of cars moving through the streets and over highways at night. Also in this category belong time exposures of fireworks in which moving dots of light ejected by bursting rockets form patterns against the night sky. Still other applications of this technique are pictures of lightning strokes after dark and time exposures of the clear night sky revealing the concentric tracks of wheeling stars.

The technique itself is simple: mount your camera on a tripod and focus on the spot where the action is, set the shutter on "time," and expose anywhere from seconds to minutes in accordance with the respective circumstances. Making a few tests before you attempt "serious" pictures is advisable. Prerequisite for success is that the

moving lights are small but bright and that the background against which they are seen is dark. Otherwise, all you would get would be smears of colors or gray tones.

Motion symbolization through multiple images. The ability of the camera to record within a single picture any number of different images can be put to practical use with the aid of stroboscopic light. This technique implies motion graphically by, so to speak, "chopping movement up" into single phases and presenting these as a series of images which, in staccato form, effectively suggest the flow of motion. Prerequisite for success is that the camera be tripod-mounted and its position remain unchanged until the entire sequence is complete. Furthermore, the moving subject must be relatively bright and the background dark, and care must be taken that the strobelights don't accidentally illuminate the background, too; otherwise, the background would shine through the subject, which would assume a semi-transparent, ghostlike appearance or, in more severe cases, be burned-out entirely.

Assignment 20
Learn how to crop and compose
No matter how interesting a subject is, how well conceived, or how perfectly rendered from a photo-technical point of view, unless it is also presented in a graphic, aesthetically attractive form, it can never fulfill the hopes of its maker. To be completely satisfactory, it must also be *well-composed.*

My dictionary defines "composing" as "giving form by putting together." Giving form to what? Obviously—the ideas, attitudes, concepts, intentions, etc., of the photographer. Putting together what? All the ingredients that go into the making of a picture and contribute to its effect—the subject, foreground, and background; light and color, sharpness and blur, perspective and scale; the consequences of focusing, exposing, developing and, if images on paper are involved, printing. In short, all the elements and aspects which, together, create the impression which a photograph makes upon its beholder. Obviously, composing is not something that should be taken lightly or attended to as an afterthought. To be effective, it must be on the photographer's mind from the moment he contemplates making a picture.

Composing and cropping are related, but they are not the same. Composing implies taking into account *everything* that contributes to the effect of the picture. Cropping—eliminating pictorially superfluous or undesirable negative areas by excluding them from the enlarged print—is merely a rescue operation intended to make the best out of material that isn't quite up to scratch, not to mention the fact that cropping is applicable only to enlargements but not to slides. Cropping may enable a photographer to coax an acceptable print from a poorly composed negative; a poorly composed slide is beyond help.

Composing, then, can be said to be an embodiment of the approach to photography as a totality, the approach which demands that *all* the factors that go into the making of, and determine the effect of, a picture must be considered together because each may affect the others in some more or less decisive way. This concept is analogous to that of a picture puzzle where a single missing or wrongly placed piece, apparently insignificant by itself but sticking out like the proverbial sore thumb, can spoil the finished picture.

Composing is a subject so large and involved that I cannot treat it here in depth. Instead, I'll do my best to give you an idea of what is involved, suggesting that, if you want to know more, you consult my book *Principles of Composition in Photography* (Amphoto), which I recommend as supplementary reading.

Personally, I start "composing" the moment I get an idea for a photograph. My first concern is with organization: how can I create order out of the natural chaos of my surrounding, where everything interacts with everything else, where things blend, overlap, and compete with one another for my attention, where a welter of color and forms vie for the interest of the observer—how can I separate the wheat from the chaff, isolate my subject, simplify my picture, and present what I see and feel in the graphically most effective form?

Edward Weston once said that good composition is merely the strongest way of seeing things, to which I can only add: "amen." Consequently, I begin with a general analysis: What are the characteristics of my subject, the qualities that turned me on? What is important, what is unimportant, what is distracting, and what is

228

p. 66

downright bad (like, for example, an objectionable background)? I ask myself: How can I emphasize important picture aspects and play down or eliminate superfluous ones? I consider my options:

pp. 62, 83, 64, 69

p. 199

subject distance, angle of view, direction of light; background and foreground; lenses of different focal lengths from wide-angle to telephoto for control of perspective and scale; filters for color control and, if I work in black-and-white, improved graphic separation; and so on. And not before I have decided what I want my picture to "say" do I assemble my "tools" and go on to the next question:

Horizontal, vertical, or square picture? The answer to this fundamental question depends on the nature of the subject and its "design" in terms of dominating lines and masses. A seascape with its dominant horizon, for example, would normally be conceived as a horizontal picture. However, if it were important to emphasize vastness by means of "depth," expressed perhaps in the form of an endless succession of whitecaps rolling toward the shore, or the tiny silhouette of a steamer riding the distant horizon, a vertical picture could conceivably express the photographer's feelings more strongly. In other words, rid your mind of photographic clichés, take nothing for granted, think before you act, consider all sides of your problem, weigh one advantage against another and, when still in doubt, experiment and try different solutions.

Static or dynamic composition?

A static composition is graphically balanced, it is in equilibrium. Equilibrium implies stability, and the most stable line is the horizontal; the most stable forms are the horizontal rectangle and the square. Verticals are also lines of stability because they are in graphic equilibrium, though the impression which they convey is not quite as "stable"; one always has the feeling that they may topple and fall. Motion, although not obvious, is at least not unthinkable.

A static composition therefore is one consisting primarily of horizontal and vertical lines and forms, arranged straight up-and-down like building blocks. Any head-on view, any "distortion-

free" rendition in which vertical lines are rendered parallel instead of converging toward height or depth, and most pictures made with one of the more extreme telephoto lenses are by their own nature static in contrast to, say, pictures taken "at an angle," "distorted" views, and shots made with a wide-angle lens, which are more or less dynamic. And pictures with a centrally located subject make a more static impression than those in which the subject is placed off-center, toward a corner or near an edge.

A static composition is likely to be most effective when the photographer intends to express intangible qualities like rest and inactivity, stability, solidity, permanence, security and peace, calm, quiet, and latent power.

A dynamic composition consists primarily of lines and forms that imply movement, action, instability and change. "Stable" lines and forms like horizontals, horizontal rectangles, and squares become "dynamic" when they appear tilted in the picture. Merely tilting the camera vertically or laterally transfers an originally static composition into a dynamic one where "stable" horizontal and vertical lines turn into slanting lines of action. It is for good reason that the diagonal, the longest possible straight line in any picture, is the line of drama and action. For example, photographed straight up-and-down, a locomotive coming around the bend seen in semifrontal view appears to be standing still. But shown ever so slightly tilted, the engine seems to be moving, coming toward you in a headlong, thundering rush; motion is implied by its tilting lines— unstable lines that evoke the feeling of motion, of sliding down a hill, implying that the subject moved. It is for these reasons that all angle shots, most views "seen in perspective" instead of head-on, all "distorted" renditions in which perspective and the subject's proportions seem "exaggerated," all arrangements in which the subject proper is not more or less centered but closer to one corner or edge, are dynamic as far as composition is concerned.

p. 232

A dynamic composition is likely to be most effective when the photographer intends to express intangible qualities like motion, action, passion, drama, violence, tension, excitement, speed, or raw and brutal power.

Symmetry and asymmetry. The highest form of order (and static composition) is expressed by symmetry as manifested in the facades of Greek and Roman temples, the mirror-image design of butterflies, and the radial symmetry of many flowers. These are static designs brought to the point of perfection. But precisely because of this perfection they may also seem monotonous and boring. In photography, a horizon dividing the picture into two equal parts, for example, is traditionally frowned upon as a "fault" although, as I pointed out before, in cases in which intangibles like boredom and monotony should be expressed with photographic means, this approach could provide a perfect solution.

p. 54

Asymmetry, on the other hand, can easily deteriorate into pictorial chaos, and although a chaotic composition may occasionally be the most effective way to graphically express certain intangibles (for example, a chaotic situation), it normally leads only to confusion. However, between the two extremes of perfect symmetry on one hand, and chaotic asymmetry on the other, a third form of composition exists which could be called "dynamic symmetry."

Dynamic symmetry can best be visualized by comparing it to the state of balance which exists between the two pans of an old-fashioned scale loaded with substances of equal weight but different specific gravity, like iron and wood. The scale is in balance—conceptually symmetrical—because the two weights are the same; but at the same time it also appears asymmetrical—visually dynamic—because the piece of iron is, of course, much smaller than the piece of wood. In photography, this state of "dynamic balance" would manifest itself in, say, a picture showing a single person close (and therefore large) on one side, and a whole group of people farther away (and therefore smaller) on the other; or in a view of a farm with the tall, slim form of the silo on one side and the short, squat form of the owner's home on the other; or in a photograph showing a small black shape on one side and a larger white one on the other, the visually "heavy" but small black mass balancing the visually "lighter" but larger white one. This concept of "dynamic balance" is easier to grasp intuitively than to express in words, but I hope you get the idea. Once you are aware of this concept, you will find it easy and rewarding to apply to composition.

Asymmetry, of course, is the normal state of the overwhelming majority of photographic compositions. This is understandable and even desirable because it reflects the dynamics of action and life—the subjects of most pictures. However, since asymmetry implies a lower degree of clarity, order, and organization than symmetry, to avoid such pictures from becoming too "undisciplined" and therefore confusing, a certain restraint on the part of the photographer is desirable—a restraint which should take the form of editorial simplicity: *don't show too much within a single picture!* Go close enough to your subject to fill the entire frame of the viewfinder with pertinent subject matter—close enough to exclude extraneous, unnecessary, and distracting detail. Condense and thereby simplify your visual statements to the point where everything you show counts. Remember, where clarity is of the essence, less is more.

p. 31

Subject position within the frame of the picture. Beginners invariably try to center the image of the subject within the boundaries of the picture, while more experienced photographers know that centering is only one of the many options they have. In this respect, you should consider the following:

Most pictures have what is called a "center of interest." Although the visual and pictorial importance of this center of interest may vary, it can be found in almost any photograph, from the rendition of an entire landscape (where everything shown is pictorially and emotionally of more or less the same importance) to portraiture. In the first case, a particularly interesting rock formation or group of trees may be that part of the landscape which draws attention first and thereby becomes a focal point for the rendition—its "center of interest." In the second case, the picture obviously consists of two elements—the portrait which, of course, is the "center of interest," and the background against which the portrait is seen, which plays an emotionally subordinate role. In both cases, however, a focal point of attention exists, and it is the position of this picture element within the frame of the photograph which to a very high degree affects its impression. Specifically:

Centering the focus of attention makes a composition static; assigning it an off-center position makes it dynamic. There are, of

course, any number of intermediate positions, of degrees: more or less centered, which is more or less static; more or less off-center, which is more or less dynamic. Again, you have a number of choices.

However, there is still more to consider. For placing the center of interest high in the picture creates a very different impression from placing it low. The first would evoke feelings of height, lightness, elation, dynamic tension (the center of interest appears suspended, in dynamic equilibrium, but it also could fall—hence the feeling of tension). Placing the center of interest low would evoke feelings of heaviness, complacency, stability, and security (the center of interest rests firmly on the ground; it cannot fall).

p. 229

Placing the center of interest somewhere along one of the diagonals of the picture (either real or implied) would make the composition even more dynamic. Diagonals, as I said before, are lines of force and action, slanting planes along which the image of the subject could be imagined to slide down, to move.... The picture of a car photographed during an auto race, seen in side view, centered in the picture, and rendered in sharp detail, would, of course, appear to stand still, even though it actually might have flashed by at 160 mph. The same car rendered blurred would appear to have been in motion, its actual velocity symbolized by the degree of blur: the more blurred, the faster. Now visualize the slightly blurred image of this racing car placed near the upper left-hand corner of the picture, with the empty track ahead of it stretching toward the lower right; the impression would be that of a car approaching at high speed. Next, visualize the slightly blurred image of the car near the lower right-hand corner—the car at the near end of the track analogous to an arrowhead at the front end of the shaft; the impression would be that of a car having arrived, victoriously.

Thinking in terms of such images and analogies should help you to feel intuitively, and assess correctly, the various emotions and associations which differences in the position of the center of interest within the frame of the picture can arouse. And once you are aware of these possibilities, you can utilize them as valuable means of creation.

Conclusions

I believe in analogies as aids to clarification. So I hope you will bear with me if once more I cite an analogy, this time between photography and painting.

In both fields, creativity is inseparably tied to craftsmanship—unless they are given concrete form, even the most creative visions are useless. Now, craftsmanship—the means and methods of implementation—can be taught; creativity can only be stimulated if already present in the student's mind in latent form. This book, of course, was written to do both. However—and this is the point I wish to make—while specific rules can be laid down for acquisition and perfection of craftsmanship, no such aids exist in the realm of creation. In painting, for example, the rules pertaining to craftsmanship are basically the same today as they were centuries ago. How to apply this "technical" knowledge is, however, a very different matter. A style or "school" of painting acclaimed at one time sooner or later becomes old-fashioned. Rembrandt, using basically the same means and methods as Picasso, painted in a style totally different from that of modern artists. The same phenomenon can be observed in photography: "techniques" remain but styles and attitudes change, and while there is no difference in technical respects between the works of, say, Alfred Stieglitz, Edward Weston, and Jerry Uelsmann, the "styles" of these masters of photography are vastly different.

What I want to get across is this: Although I can teach you craftsmanship, I cannot give you a blueprint for creation. All I can do is share my experience with you, hoping that what I have to say may stimulate your mind, stir your imagination, and develop your creative faculties. But I am fully aware of the fact that what I have to offer are only today's views, and particularly my own opinions which are not always shared by everybody even today and doubtlessly will be considered old-fashioned tomorrow. In other words, take everything I said with a grain of salt. Rules are for technicians; the creative spirit must be free.

VII. The Viewer's Point of View

The way I see it, photographs are made for two reasons: (1) to please the photographer, and (2) to "tell" something to somebody else. This has important ramifications:

If you photograph only to please yourself, you have an easy life insofar as you always know what your "audience"—yourself—thinks of your work. If *you* are satisfied—fine; if not, at least you know what you don't like and in what respect your pictures fail to please you, and you can act accordingly. Photographs belonging to this category are primarily snapshots intended for the family album, records of your travels, vacations, birthday parties, and so on.

If you make photographs to "tell" other people something—that is if you consider photography picture-language and use it as a means of communication—you have a problem: how can you attract and hold the attention of your intended audience? This means that you no longer are the sole judge of your work, but have to consider the attitudes and reactions of others. If you neglect doing this, you risk having your work either completely overlooked or rejected as being of no interest. You can avoid embarrassment and frustration by putting yourself in "the other guy's shoes"—by trying to assess your work from the point of view of the viewer.

As a "viewer," I expect any worthwhile photograph to have certain qualities. First of all, of course, it must be able to attract my attention—dullness is the surest way to ensure that a picture will be overlooked. Having caught my attention, the picture must have "something" to hold it—it must be informative, it must touch me emotionally, it must "speak" to me. Any gimmick or trick can momentarily catch my eye; but if that's all there is to it, I'll only get

annoyed and resent having my time wasted, or even feel cheated. And finally I expect a "good" picture to deliver its "message" in a form that is graphically effective and to the point. In short, to deserve the label "good," a photograph must have the following qualities:

stopping power
purpose and meaning
emotional impact
graphic interest.

Stopping power
Modern man is surrounded and continuously assaulted visually by photographs—by newspapers, magazines, and book illustrations; advertisements; the movies and TV—everywhere pictures, pictures, pictures. . . . No wonder we feel satiated and pay little or no attention unless there is a good reason—something unusual that attracts our eye and lifts the respective photograph at least temporarily out of the mass of nondescript pictures. This something is stopping power.

The essence of stopping power is visual shock—anything that is unusual, surprising, jarring, new; anything intriguing, imaginative, or bold; anything that differs from what we are used to or have already seen before.

This includes a lot of territory—anything from a stroke of genius to the ludicrous. As a result, giving a photograph stopping power is easy, but giving it the right kind may be difficult. Stopping power, misused, defeats its own purpose and repels rather than attracts the viewer.

Here are some of the means which I have found particularly effective in regard to supplying a photograph with stopping power:

Contrast between sharpness and unsharpness or blur (selective focus and panning). The sharper and more detailed the principal subject, and the more indistinct the rest of the picture, the stronger the effect which, at its best, can make the subject appear to "leap off the page." *pp. 137, 172*
p. 224

Telephoto perspective—the longer the focal length of the lens, the more monumental the perspective of the picture—a never failing means to attract attention and increase impact.

Extreme wide-angle lenses, properly used, "distort" reality in a way that symbolizes and suggests intangibles like nearness, depth, and space in a way impossible to achieve with any other photographic means. In contrast to telephoto lenses misusing wide-angle lenses is much easier than using them correctly: a pointlessly distorted rendition is visually offensive, whereas an undistorted pointless picture is merely dull.

pp. 216, 217 *Cylindrical and spherical (fisheye) perspectives* are infallible attention getters yet just as difficult to use successfully (or just as easy to misuse) as extreme wide-angle lenses of rectilinear design. In their proper place, they can show us our world in a form which widens our visual and conceptual horizons.

Color in its many manifestations can give any picture stopping power. While, in this respect, everyday naturalistic color is boring because it doesn't show us anything we hadn't seen or known before, unusual color, creatively used, can make any photograph exciting and capture the attention of anyone. Unusual in this sense is color that is exceptionally bold and saturated, or exceptionally muted and pale (pastel shades); color used sparingly in conjunction with large areas of black and white; compositions in related colors only (like yellow, orange, red, and brown; or blue, blue-green, and green); compositions consisting mainly of two strong complementary colors (like red and green, or yellow and blue); and deliberately distorted yet meaningful color.

Contrast that is abnormally high or low will always attract more attention than contrast that is average. To be effective it must, of course, be pictorially justified—a means deliberately chosen for better subject characterization.

Picture proportions that vary from the norm automatically attract a certain degree of attention—the more so, the more elongated they are in either the horizontal or vertical dimension.

The horizon, if present at all, normally divides a picture into two unequal parts of ground and sky in the approximate proportions of one-to-two or five-to-eight. Varying these proportions by placing the horizon either very low or very high in the picture creates dynamic tension that attracts the eye because the effect is unusual and thereby invests a photograph with stopping power. Needless to say, such abnormal placement must be pictorially justified: a high horizon, by emphasizing the ground, symbolizes the earth, nearness, and materialistic aspects; a low horizon, by emphasizing the sky, symbolizes distance, space, and more spiritual aspects. pects; a low horizon, by emphasizing the sky, symbolizes distance, space, and more spiritual aspects.

The unexpected or incongruous basically attracts more attention than the common. For example: a single white flower in a bunch of red ones; a small patch of brilliant color in an array of grays and white; a single child in a crowd of grownups. Experimental photographers in particular have made use of this device for infusing a picture with stopping power, as exemplified by Jerry Uelsmann's trees hanging in the sky, Wynn Bullock's nudes among monstrous trees or seen through the empty windows of decaying shacks, and Bill Brandt's close-ups of nudes on stony beaches where breasts and thighs appear as monumental as the rocks, and the rocks as smooth and rounded as a woman. . . . By surprising us with the unexpected, these masters of photography introduced us to new perspectives of reality as well as insight, opening new vistas of awareness. However, to use such powerful means successfully, sensitivity must be guided by understanding, and daring cautioned by restraint. For in the realm of surrealism, only a hairline separates the sublime from the absurd.

Framing the center of interest of the picture with suitable subject matter rendered in a darker tone than the rest, although a photographic cliché, always provides a certain degree of stopping power. Views through arches, windows, screens, and openings of any kind are examples.

Extreme close-ups in near-natural, natural, and more-than-natural size are almost unfailing attention-getters. By

showing us aspects of our world which we otherwise couldn't see as clearly (or not at all), they can enrich and stimulate our mind, extend our knowledge, and provide us with visually and aesthetically satisfying experiences.

p. 191

Glare, flare, and halation, creatively used, not only symbolize graphically the brilliance of radiant light, but, as unusual and unexpected phenomena, also attract attention to a photograph and make it stand out of the mass of otherwise ordinary pictures.

Pronounced "graininess," although normally a fault that ought to be avoided, can, under certain conditions, be used to give a picture stopping power. Photographs of violent events, especially,

p. 109

may acquire an added intensity if film grain is visible, its grittiness matching the coarseness of the scene. Deliberate use of film grain is particularly effective if clouds of smoke or dust are involved; in such cases, granularity gives the picture an almost tangible texture, suggesting the particles of dust or smoke.

Unusual light or atmospheric conditions will always attract attention. Few devices are more likely to catch the viewer's eye than an illumination which shows the subject in a dramatic light.

Gimmicks and tricks, on the other hand, should be strictly avoided by any photographer who expects to be taken seriously. Foremost among these are "interesting" but meaningless distortions, overfiltered ("black") skies in black-and-white photographs, indiscriminate use of colored light, the use of pseudo-solarization (Sabattier effect) in color or black-and-white merely for novelty's sake, photographing through trick devices such as multiple-faceted prisms, diffraction gratings, or exposure meter grids, and so on. Although any of these "eye-stoppers" momentarily attracts attention, the effect rapidly wears off and the viewer, realizing that he has been taken in by a meaningless trick, will resent this and condemn the picture.

Purpose and meaning

Though an eye-stopping graphic effect is a desirable quality in any photograph and sometimes a necessity, by itself it doesn't suffice to

make a picture "good." Its function is to attract attention. But once attention has been aroused, the viewer expects to be rewarded for giving interest and time to the picture—he expects to learn something from it, to be amused, stimulated, or to derive aesthetic satisfaction. Satisfying the viewer in one way or another is the purpose of any photograph. A picture that has nothing to "give" is wasted.

A photograph—any photograph—is a means of communication. It is the carrier of a message, and in this respect no different from words. Unfortunately, many photographers combine graphic elements to form pictures which are meaningless.

While it is easy to see that the purpose of a photograph is communication (which, of course, implies meaning), it is impossible to lay down rules for the creation of meaningful photographs for the simple reason that what is meaningful to one person may be meaningless or even offensive to another. A softly diffused portrait admired by a romantically inclined photographer or person may be sentimental trash in the opinion of a realist. A sensuous nude which evokes feelings of reverence for femininity, beauty, and life in an enlightened mind may be labelled obscene by a prude. An X-ray diffraction photograph that delights a physicist with its informative value may be visual gibberish to the layman. And so on.

Don't ever take a photograph unless the subject *means something to you*, and unless you want your picture to *say something* to other people. The nature of the message is immaterial, and what you want your picture to express is something only you can know. What matters is that you realize that making photographs for other people to see carries with it the responsibility of having a point of view, of being involved in the subject, and of being graphically articulate.

Anything in which you are genuinely interested is worth photographing, no matter how unusual or apparently absurd. No one is so unique that he cannot find another person to share his interests. Therefore, it does not matter *what* you photograph, nor *how* you photograph it, as long as you know WHAT you want to do and WHY you want to do it. If you are serious about your work, not swayed by others, do not imitate, are honest about your motivations, and

true to yourself, although some people may disagree with you and deride your work, no one can question your integrity as a photographer—and your pictures will be valid.

Emotional impact

As the same event can be reported in an objective and factual or a subjective manner, so it can be photographed in either a matter-of-fact or emotionally more or less dramatized form. Each alternative is equally valid, though different from the others. Which one a photographer should choose depends on his attitude toward his subject, the purpose of his picture, and the audience for which it is made.

In cases where precision of information and therefore clarity of rendition are of primary concern, a matter-of-fact form of graphic presentation will of course give the best results. But in cases where a more emotional approach to a subject is indicated, only a picture which conveys emotional impact can produce the effect its creator had in mind when he made it.

Nobody can create photographs with emotional impact without first experiencing the emotions which he wishes to convey to the viewer. This is why I consider genuine interest in the subject an indispensable prerequisite for making effective photographs. If a photographer does not respond in a personal way to his subject, he cannot possibly produce work which elicits an emotional response in other people. In essence, if you don't love it, leave it alone.

Emotional responses vary as widely as the people or subjects involved. To give only a few examples: compassion for children whose only playground is the street; the serene, almost religious feeling experienced in the presence of California's redwood trees; the sex appeal of a desirable woman; the overwhelming sense of total perfection when contemplating objects of nature like flowers, dandelion seeds, seashells, crystals, feathers, or bones; love of a person or a pet; disgust over a demagogic politician; hate of corruption, violence, and war. What matters is not *what* you feel, but *that* you feel something when confronted with your subject. If you get involved with your subject, you may succeed in transferring to the image you are about to create something of what you felt and

thereby enable the viewer of the photograph to participate in your experience. However, if you shoot the picture only as if it were part of a job, you would only produce another undistinguished photograph.

How do you bring off the miracle of enabling a viewer to share your experience? First, just feel. Then analyze your feelings and try to give your intangible emotions concrete form. If this sounds vague, I'm sorry—it is because there are no guiding "rules." But an example may help. You want to make a portrait of the woman you love. Pose her in a natural way against a suitable background. Make sure the light is right. Then talk to her. Tell her how much you love her, how beautiful she is, how sexy, how generous and kind; how lovely her eyes, her hair. . . . Then, when you feel she is responding, when you see your feelings mirrored in her eyes, when she begins to glow with happiness at your love—take the picture.

Occasionally, of course, expressing emotions on film and sensitized paper may be difficult, if not impossible. To me, the most beautiful of all objects of nature is the globule of a dandelion in seed. I see in it ultimate perfection and heavenly beauty. Again and again, with all the means at my disposal and drawing on my considerable experience, I have tried to express this feeling in picture form—to no avail. No matter what I did, I never completely succeeded in capturing that feeling of airy delicacy, of sheerness combined with precision and functional ingenuity which I've experienced a thousand times. Compared to the original, all my images were crude approximations at best, mocking the real thing. Perhaps it cannot be done; perhaps dandelions in seed are truly "unphotographable." *pp. 51, 55*

Capturing an emotion with photographic means is often a matter of timing. For example, I remember seeing pictures of Hitler making a speech in which his face was so convulsed with hate, emanating such an aura of viciousness combined with stupidity, that contemplating the photographs made me shudder with revulsion. Those portraits, perfectly timed by the photographer, carried a wallop of emotional impact. Other times, say, in landscape photography, it is timing in regard to light and atmospheric conditions that makes the difference between a picture which conveys a mood, and one which doesn't.

Graphic interest

No matter how valid in regard to purpose and meaning a picture may be, its ultimate effect on the beholder depends to a considerable degree on the graphic form in which the photographer presents his subject. In this respect, a picture is analogous to a letter which contains an important message. If this letter is sloppily scrawled, its impact on the recipient will be considerably weaker than if it were expertly typed on a typewriter, even though in both cases the message is the same.

Graphic impact depends on two factors: technique and taste. The technique is responsible for the How of the presentation, the taste for the Why and What. For no matter how motivated and sensitive a photographer may be, unless he is also able to express his feelings and visions in a graphically effective form, his talent will be wasted. In order to be considered good, a photograph must not only have something to say, but must also say it well.

In this respect, taste decides What should be done in accordance with the purpose and meaning of the picture, the Why. And not before this has been established to his satisfaction is the photographer ready to consider the last step in the making of a picture—implementation. This is the realm of technique, and the more knowledgeable a photographer is in this respect, the greater the number of options from which he can choose, the greater the variety of his graphic means of expressions, the greater the chance for subtlety.

For practical reasons, I have found it advisable to distinguish between two aspects of photo technique, "basic" and "selective." Basic techniques are focusing, exposing, developing, and printing. They are "basic" because they are indispensable prerequisites for making photographs—the photographer has no choice but to employ them. What is "selective" are the specific forms which these techniques can take and the specific means on which they rely. For example: Although no picture can be made without film (a "basic"), a photographer has the choice of many "specific" types of film—color or black-and-white; high, medium, or low speed; roll film or sheet film; small, medium, or large format, and so on. Al-

p. 106

though no picture can be made unless the film is exposed (a "basic"), it can be exposed selectively in many different ways by *p. 59* making use of the fact that many different combinations of *f*-stop and shutter speed are available, the results of all being identical in regard to exposure (color rendition or negative density), yet very different as far as extension of the sharply rendered zone in depth or rendition of subject motion are concerned. Furthermore, different types of developers are at any photographer's disposal, different types of color filters, sensitized papers in different gradations, *p. 205* different types of lenses for creating different forms of perspectives and space renditions, different types of photo lamps for achieving *p. 88* different lighting effects, and different devices to symbolize the *p. 189* radiance of direct light. Not to mention that, although there obviously has to be a certain distance between subject and camera (this is "basic"), this distance can be selectively varied to an infinite degree, as can the direction and angle from which the subject is seen. And so on. In short, although the number of basic techniques is small, the number of options based on the selective aspects of photography is endless.

Most students of photography are convinced that they have "arrived" as soon as they have mastered the basics of focusing, exposing, developing and printing. Because, by then, they are able to produce "technically perfect" photographs. Unfortunately, this view completely neglects two vitally important facts: (1) A technically perfect photograph can be the world's most boring picture. (2) Technical perfection can be achieved in innumerable different ways, some of which produce more effective results than others in specific cases.

Summary
In this book I have dealt with all the aspects of photography, creative as well as technical, which I consider important for the making of *good* photographs. Consideration of the creative aspects should insure that your work will be valid; consideration of the technical aspects that what you want to say is said well.

The total view of photography demands that all the aspects which influence the outcome of a picture must be considered together.

According to this view, any *good* photograph is a successful synthesis of four mutually dependent factors:

the photographer
the subject
the technique
the viewer (audience).

The photographer, if he takes his work seriously, is not only a collector, but also a disseminator of facts as well as opinions. This, of course, carries with it a considerable responsibility. For by choosing one subject over another, a photographer makes a judgment, and by making his photographs available to other people, he disseminates what in effect are his personal views. To be able to live up to the responsibilities of one who has the power to inform and influence people, a photographer therefore ought to have certain qualities:

He must take a genuine interest in his subject, no matter whether a person, a landscape, an object, or what have you—he must be able to form a valid personal opinion of anything he is about to photograph.

Furthermore, he must be able to see his subject not only in terms of photography—that is, be "visually literate"—but also with the eye of the mind—he must be aware of its ramifications.

So that he can express himself precisely in picture form, he must be an accomplished photo technician—he must be visually articulate.

He must be a keen observer in order not to miss significant, but perhaps not obvious, aspects of his subject.

He should be gifted with daring and imagination so he can render familiar subjects and events in graphically new and captivating forms.

He should be curious, inquisitive, and open-minded, able to profit from mistakes, learn from experience, and let himself be stimulated by other photographers' work without succumbing to imitation.

In short, he must be truly dedicated to his work.

The subject is the most important aspect of photography—the basis for its existence, the reason why we photograph. In the realm of photography, everything starts, stands, or falls with the subject. If the subject lacks viewer interest, not even the technically most perfect rendition can turn it into a worthwhile picture. Since photographic subjects vary enormously in regard to their nature, different subjects, for most effective rendition, may require different photo-technical means. In other words, not every camera nor every technique is equally suited to photographing any kind of subject—a point consistently overlooked by most photographers.

Any subject has innumerable different sides—literally as well as figuratively speaking. Therefore, aware photographers are not content to accept the first view of a subject as final, nor are they satisfied with taking only a single shot of it. Instead, provided, of course, that circumstances and time permit this, they study their subjects from all sides and angles and in different kinds of light before they start exposing film, and they document their subjects in depth by taking many different pictures, well knowing that another opportunity may never again present itself.

Since photography is picture language and every picture contains a message, the subject of a photograph is analogous to the content of a written statement. And like a written communication, it will be of interest to the recipient and "read" only if it has something to say.

Photo technique is only a means to an end, albeit a vitally important one. But a technically perfect photograph is *not* ipso facto a good picture; unless it also has content and meaning, it would be exceedingly dull. The true value of good photo technique lies in the fact that it gives a photographer a better chance to express himself precisely because, as I said before, a good photograph must not only have something to "say," but must also say it well. And since any subject can be photographed in a literally unlimited number of different ways, the greater a photographer's command of the means and methods of his craft, the greater his choice in regard to the technical options of rendition, and the greater his chance of imaging his subject in the form most likely to implement his intent. Excessive preoccupation with photo-technical matters, however, is

counterproductive because it diverts the photographer's interest from where it belongs—the creative aspects of his work.

The viewer (audience) for which a photograph is intended strongly influences its form. A photograph intended for, say, a commercial product catalog must, of course, be simpler, clearer, and more to the point (a fact which also tends to make it duller) than a picture intended for general magazine or quality book illustration (where artistic values count even though they must never affect the clarity of documentation). And the visual interpretation of an emotionally charged subject stands or falls almost entirely on its artistic merits.

Conclusion

What does this mean to you, the reader? It means that no photographer can please everybody, and no photograph can satisfy or even be of interest to all people. Therefore, the best advice I can give you here is this:

Be yourself. Listen to other voices with patience and attention but remain critical—they could be wrong, at least as far as your aspirations are concerned.

Find stimulation in other photographers' work but beware of imitation—it would be the end of your creative career.

Consider all aspects of photography each time you take a photograph because a *good* photograph is *more* than merely the sum of its parts. And keep in mind the following:

Any subject can be photographed in many different ways, some of them, of course, more effective than others. Remember, you always have a choice!

Any good photograph is a successful synthesis of *technique* and *art*.

Know-how is worthless unless guided by *know-why* and *know-when*.

A technically perfect photograph can be the world's most boring picture.

What matters is not what you photograph, but why and how you photograph it. Even the most controversial subject, if depicted by a sensitive photographer with honesty, sympathy, and understanding, can be transformed into an emotionally rewarding experience.

Index